Unquiet Landscape

UNQUIET LANDSCAPE

Places and Ideas
in Twentieth-Century
English Painting

CHRISTOPHER NEVE

faber and faber

LONDON · BOSTON

First published in 1990
by Faber and Faber Limited
3 Queen Square London WC1N 3AU

Phototypeset by Input Typesetting Ltd, London
Printed in Great Britain by
Clays Ltd, St Ives plc.

A CIP record for this book
is available from the British Library

ISBN 0-571-15291-0

Contents

CONTENTS

The Landscape as Emotion

Landscape painting has always been about what it is like to be in the world and in a particular condition. What is really important? Not the large events, or the plot that develops, but the day to day. Far better to think of life as a series of states of mind experienced in changing circumstances and in differing places than as something that always has to have direction. Landscape painting catches at those unexpected ideas and emotions that come, and so easily go, on days of no particular importance. It shows life not as a development but as a condition. How often have you sworn to yourself that this is the most beautiful day you have ever seen, on no particular day, on a day like, and yet entirely unlike, any other? This, in the end, is worth living for.

The painter goes through the land and sees what nobody else has seen because landscape painting comes from inside and not out. It depends entirely on who he is. Nature is stronger than the strongest man and there is no going against it. It finds its way into his imagination via all his senses; it becomes part of his spirit, and then, with great care and sensitivity, it may be brought back again by hand into the visible world and somehow recognized.

Many of the artists in this book, whom I have asked about this, do not know how it happens. They have within themselves an unexplained ability to darken or lighten other people's feelings through pictures. Many have said that they try not to interpose themselves too consciously between the landscape and their work, but let it flow through them unobstructed by their intellect. They try to act intuitively

rather than by will. On the most unlikely people a most beautiful expressiveness has fallen like a divine insight. It is as though the energy of the landscape had found its way up from their imagination at sufficient strength to be clearly expressed, without inhibitions.

The process does not have to be explained. There are plenty of books now, and catalogues, that will provide you with the art-historical background to English landscape painting this century. If you want that, you can go to them. But they do nothing to touch the only crucial fact, which is the pictures themselves. There is really nothing to be said about pictures because they have their own meaning which will not accept words. No one can transfer this from one medium to another. The illustrations used here are only for reference. Pictures have to be seen, at first hand, and felt, so that they give back their layers of meaning, which are experienced but may not be described.

So what does this book try to do? It is not an art history book. It deals only with a very few of the artists who have worked in the English landscape during the last sixty years. They are not contemporary, but they are modern in the sense of old-fashioned modernism, which still looks newer and more original than most of the work produced now. Each is discussed because he or she represents a particular idea. It is a journey in the imagination through the English landscape, thinking in paint. Painting is a risky process precisely because of the trials and errors and intuitive revisions that this kind of inarticulate thought involves. But the truth strikes you, when you see it, as unmistakable because it represents not just a way of seeing landscape but a state of mind. It is such half-formed ideas that painters will sometimes discuss because their thoughts are at an angle to the pictures themselves and do not impinge too much upon them. Painting is a process of finding out, and landscape can be its thesis, the ever-potent old catalyst used to map out our universal view.

The book is certainly no gazetteer either. By looking at painters' places and trying to understand the condition the pictures convey, I have done my best to get at what the paintings do, while leaving their way clear to do it. This has involved writing a good deal that is not about pictures themselves. As far as I know, no one has written about painting in this way, except sometimes artists, and I think it is far

preferable to discuss painting in relation to thought in general (as literature has always been discussed in literary criticism) rather than spending time on the paper-chase of categories, dates and influences.

The idea for this book came, at least partly, from a number of long talks with Ben Nicholson. He was much more likely to talk about pictures in terms of tennis, jazz or ping-pong than in terms of how they were done or what they meant. There is no understanding pictures any more than there is understanding the song of the grass-hopper or the sound of the sea. There is no end to the landscape or to the colour of the days. The imagination goes through them. In most departments of life it is imagination that is missing.

Landscape has been, and is, endlessly and thoughtlessly trivialized by people who suppose it is enough to paint views. Landscape is treated by them and their public as if it were decor or background. The notion of country lends itself easily to sentimentality. In fact, it is never to be trifled with. The land is the foundation on which everything stands; the ground of all action and all feeling. Pictures of it cannot be caged any more than the landscape itself can be caged. They have a life of their own, which is the life of the spirit. Too often museums are zoos which rob them of their freedom to act. Dealers and auction houses frame them in gilt and make them merchandise. I have seen Nicholson angrily break the frame off one of his pictures displayed in a gallery, and let it fly out.

Must we think of all landscape painting as subject to the often ludicrous esperanto of art history, or all landscape as designated national parks? Paintings are about feelings not rationality; about imagination not common sense. The best I can hope to do is to discuss some of the ideas that English landscape may have given rise to, and then leave it to you to look at the pictures, testing them against what you know of life and death. The landscape commits suicide every day.

PART I
Tangible Places

1 The Problem of Time

Paul Nash

Paul Nash's places have in common a dumb brightness and a sense of concealment. He had an orderly mind and a consistent view of the world that was part poetry and part graphic design. His fragile method was to apply to English landscape a form of ancient surrealism, like a water diviner or a finder of ley-lines on chalk, who does not actually alter anything but who has some odd quality that enables him to hint at what may be hidden.

It meant that all his life he had to look for places and objects which carried for him a particular charge. He found it, as you would expect, in ancient sites, in clumps and standing stones, where the enormity of what had passed was still in the air like electricity. But he also found it behind unexpected buildings, in gardens, or left lying on the beach.

His way of encapsulating this oddness was a kind of archaeology. Archaeology implies getting at time by uncovering something, and yet when you look at his pictures you cannot escape the curious sensation that what they are doing is *covering something up*. They litter the ground, with cylinders, flints, fallen trees, pyramids, crashed aeroplanes, tennis balls. Like the standing stones set up by primitive man to mark his place, these are plainly monuments in the landscape. But monuments to what?

Here are five uncompliant landscapes drawn by Nash. They are not intended to be seen as narrative, though written about sequentially. They are meant as a commentary on the pictures, which I hope to suggest have to do with poetry and, most of all, with time.

*

3

It was in the wire-filled and table-flat garden of his father's new house at Iver Heath, in Buckinghamshire, about 1913, that Paul Nash's pictorial imagination could be said to have first twitched and woken up. It was an impossibly starry night, and the trees that lined the edge of the croquet lawn seemed inordinately tall.

Straight paths, edged and gravelled, led from the house to the kitchen garden where his younger brother preferred to draw vegetables in the afternoons. Paul Nash concentrated on drawing the intersecting paths and the hatched rectangles of wire netting which ruled off the herbaceous borders from the cornfields out of which the new garden had been bitten. He liked their geometry. When he looked up at the house, its architecture must have produced in him a similar sensation of order. Like a dormie house or a seaside villa, it seems now more Thirties in feel than Edwardian. Some of its window-frames were placed at corners so that they faced on to two sides of the building.

But mostly he drew the trees. He drew them not at all in a generalized way but as individuals. They were elms and acacias. He showed their twigs and branches in an unblinking stare by daylight and as ink silhouettes at night, the sky behind them crowded with stars and shooting stars, star-dust.

About the same time, he began going to stay with an uncle at Long Wittenham, Oxfordshire, and drawing the twin stands of tall beeches called Wittenham Clumps [2]. He drew them always from a distance, as he saw them from his bedroom window or on bicycle rides, emphasizing the wide space they occupy on the two mounds of the Sinodun Hills. Sometimes he drew cloud shadow feeling its way across the contours of the landscape and sweeping up to cross the clumps. Sometimes he filled the air around the trees with flocks of pencilled birds, so distant that they are little gnats on a warm evening. He had noticed while drawing in the garden at Iver Heath how several trees growing together could take on the silhouette of a single one. In the Wittenham Clumps drawings he made the trees, isolated and pressed together tightly on their hilltops, into erect bundles like bunches of celery.

In Wytschaete Woods the trees were blasted apart. He drew them as

4

splinters and stumps. In the Ypres salient, near Vimy, and along the Menin road in 1917, he drew the remaining trees like broken crosses, the sky beyond them no longer full of birds or stars but of constellations that exploded.

At Dymchurch, on the Kent coast, he began to paint the bleak shore. 'A war artist without a war' he called himself in the Twenties. Instead of defences against armies he drew defences against the sea, the only bombardment the bombardment of waves. As if his mind had been emptied by the horrors of war, and by the jostling of men and transport, his preoccupation became vacancy. He showed how concrete ramps and army-grey shingle sloped into the grey sea towards France. It was a landscape that replaced the urgency of suffering with the vacant afternoon of no feeling at all [3].

He drew the sea like a frozen layered mere; as salty levels, flat as the Marsh on the other side of the coast road. Rather than show its flying movement, the way the waves run in to be bayonetted by the breakwaters, he stopped it dead and related it to the steps and wedges of the land.

Once, before the war, he had invented a subject that prefigured this. Wanting clear, architectural shapes, he had drawn pyramids, but instead of setting them on the flat surface of the sand he had placed them in the sea. He saw them as if in a dream against a night sky. Their great bulk, threatened by the humped water, had stood for impossible oppositions – the still and the moving, the live and the dead, the irresistible force and the immovable object.

The vacant stare of the Dymchurch pictures depends on their being of landscape in bland daylight, in a dead month, in a dead year, at a dead time of day: the spirit at low tide. Pursue their solid geometry west to Swanage ten years later and you find it lying in the bright light of Thirties modernism and casting unarguable fretwork shadows.

Nash greatly admired the puns and anomalies of seaside architecture, and Swanage was his favourite seaside town. Everything seemed open to scrutiny but he saw it with distinct unease, as though its very holiday air showed it had something to hide. By now he was using

the old American-made series 2 Kodak his wife had given him as an aide-mémoire in 1931, and a great deal of what he saw through his viewfinder must have struck him as irremediably odd. By slightly shifting his point of view he could make foregrounds loom, or trick unrelated lines in foreground and background into joining up. He found a strange litany of shapes along the front at Swanage, sharply lit: the amoeboid concrete curve of municipal benches, the pyramid of cannon balls on the monument, a square clock on a wind shelter, the frames of wind-breaks on the beach. Each of these innocent and irreproachable objects seemed suddenly unfamiliar, small mysteries to be treated with circumspection. None of them required explanation, or received it.

All these drawings and photographs, many of which became paintings, have something peculiar about them. In the first place they are extremely formal and orderly as pieces of design. A subject always needed to appeal to the geometric side of his painter's nature, the side that made him a modernist graphic designer and design teacher in the Thirties. He was also an engraver of adventurous geometric shapes although he could never bring himself to relinquish reality entirely. Without the geometry of the landscape he could not begin to show his essential subject, the place where something had been. It was as if, even in the first Iver Heath drawings, the geometry was the trap. The landscape was the occasion and the vessel (Anne Ridler in a surrealist poem of 1939).

Caught by it, like the ghost in the machine, was something unpaintable, indefinable. That was his true subject, but the best he could do was to mark its place; the extreme oddness of landscape is that it always marks a place. But how it keeps its secrets! How remorselessly it conceals the feelings that have exhausted themselves in it! Its age and its inertia have nothing to do with us. We can scratch it or build on it or burn it but it will no more accept our passions or our actions than a stone picked up will accept the warmth of a hand. Nash looked for this concealment in his cool and orderly English way, watching for signs.

Test this idea against the pictures mentioned so far. I have made a loaded comparison at the beginning between the trees he drew in his father's garden and the trees of Wittenham Clumps. The Iver Heath trees occupy their spaces like Nash's first personages. Behind them, defining them, are the immense starry skies that will eventually spawn the cartwheeling planets of his last pictures. Hardy is a poet who seems often to be relevant to Nash. Hardy wrote once that he could identify a mountain at night by the absence of stars within its shape. The trees of Wittenham Clumps, on the other hand, are not just any trees. The strange twin hills on which they stand are potent, dreamlike and inexplicable. They have that magnetic effect of many high places, but they also *mean* something.

From the time he first saw the Clumps, Nash never got them entirely out of his mind. He must have climbed up to them as a boy and never really escaped them. They mark an Iron Age fort, Stone Age ditches, the burial places of Roman pottery and Saxon bones, many layers of occupation, all of them hidden between roots and cowslips. Even the tree-trunks are entirely enveloped by nineteenth-century graffiti enlarged by the years into indecipherable hieroglyphics on stretched columns. The hills themselves, which he always shows at a distance, are monuments in the landscape. If he could now extend this principle so that almost any corner of a field or stretch of beach marked the site of some event buried alive, he could transfigure even the most inert countryside into a minefield of the psyche.

There were two ways open to him. Either he could paint places that had a cosmic charge because of their history and pre-history, like Wittenham Clumps, Avebury, Silbury and Stonehenge, all of which he studied, or he could use a curious landscape of natural or displaced objects. Perhaps he would not have hit on this without the example of European surrealism or without photography. The very act of squaring something up in a viewfinder marks it off from the rest of the world and gives it an unnatural emphasis. Compare his paintings of standing stones at Avebury, terrifyingly mute, with his photographs of chalk stacks at Handfast Point, in Dorset. He treated them both with equal emphasis. The stones stand for something; the stacks, shaped by the sea, have no meaning beyond themselves – though they

have a powerful presence emphasized by their human names, Old Harry and Old Harry's Wife.

Scrutinizing the landscape, he found presences hidden everywhere. Personages, he called them. Standing or fallen objects had always seemed to him to give off a mysterious power. They wait, listening: a collapsed tree, a root like a dangling man, a row of divers' suits crucified upside down to dry. None of these would be as worrying if Nash did not somehow contrive to put them out of place.

It is as though objects have detached themselves from the surrounding land and, looming, become protagonists in strange encounters. Before he moved into Swanage in 1934 he was living at a farmhouse beyond the bungaloid development of the town on Ballard Down. From his window he painted the shoulder of the down, the chalk cliffs partly masking the distant headland, on a bright day. On the grass in the foreground he showed the crabbed shape of a tree-stump which had detached itself from the row of dead tress that marches into the view from the left, and beside it, its clear circle opposed to it in every way, he placed a tennis ball. It is as white as the cliff beyond, and as large as one of his swollen moons, fallen. Across it goes the pure double curve of its seam. These two objects lie quietly next to one another, male and female, age and youth, for no apparent reason and giving nothing away.

It could be that Nash felt he might get at the mysterious essence of landscape by putting references to specific parts of it in the foreground, as though, on a cliff walk, for example, he had picked up things that were somehow representative of the whole view. His experiments in photographing groups of small related objects in close-up might well have led to this. On a doormat or a breadboard he constructed henges of his own: shaky assemblies of random objects, cardboard tubes and fragments of bark, their impermanence photographed pointblank as though they were exercises in relating abstract sculptural shapes or unexplained exhibits on a nature table. Transposed to the real landscape in paintings, they become surreal monuments which declare themselves unequivocally, pristine and specific, and yet are as gagged when it comes to expressing any real meaning as the tree-stump or the tennis ball.

Does not all landscape suggest this muteness? The state in which the world refuses to yield its meanings is described by Baudelaire as lack of grace, or spleen, the condition in which the viewer feels himself excommunicated. Nash could stiffen the sense of things being out of place by altering their element. He had altered the element of the pyramids by standing them, like the jetty he drew at Swanage, among the huge geometric slopping of the sea. Swanage Bay appears in a chalk-dry watercolour. It is drawn clearly and literally. Shown floating in the bay, with equal simplicity and conviction, as though someone giving a factual account of something were to include in passing a tremendous lie, there is a giant fungus. It needs no explanation. It does not symbolize anything. It is simply a fungus of the kind that Hardy, too, had noticed often in the Dorset landscape, describing it as looking like the liver and kidneys of dead animals. Nash transcribed it with a shock into the water.

In all these examples, the artist's lucid literary style makes the viewer feel that he should be able to read a meaning. Nash sets the meaning out as if it is plainly self-evident. But the pictures, like the landscape itself, enunciate with the greatest clarity a language beyond words. The nearest it is possible to approach is via the language of shape. That is mute, in a way that land is mute. Again, his camera may have given him his first clear realization of this. In photographs, he often discovered analogies between one shape and another, between far and near, large and small, between, for example, a foreground standing stone and a distant clump. His pictures are full of these repeated forms. At the base of the chalk stacks at Handfast Point there are long, smooth indentations, like a glazier's thumbmark in putty round a window-frame. The waves, as they hit this, move upwards and then fall back to spread out in concentric rings and lobes of foam precisely like the fungus that Nash drew unaccountably floating in the bay. The landscape both has a code and is one.

The critic is a vandal. I do not want to choose a conclusion and use any retrospective hypothesis to prove it. Only the pictures are important, but at least try the possibility that the clue to all this is time.

It is time that makes Wittenham Clumps so potent, and Stonehenge

and Silbury. It is the inordinate extent of time that makes us impotent in the landscape and aware of our own hopeless limitations in respect of it. It is time that hangs up in Nash's moons and night skies at the start of his career; time that suspends an exploding shell, a trajectory of mud, and allows fragments to settle in a changed order. In his drawings the shadow of an isolated figure on a clifftop, on a zigzag path leading to a beech hanger or on steps down to the shore, suggest remembered occasions like those in Hardy's poetry. Nash cannot have failed to notice the surreal brevity of the shutter's click in relation to the unimaginable antiquity of the sites he photographed and subsequently painted.

Life looks like painting but has the attributes of music and writing. Painting shows one moment. It is how we perceive the world to be. The characteristic of reality is that it is made up of frozen moments (discrete time), perceived one after another. Music, most abstract of all the arts, does not exist until it is heard. It depends, like life, on development, which is why it has a hotline to the emotions. Writing, in a comparable way, exists only sequentially. But paintings represent one moment, continually. That they are objects and not ideas is their strength and their limitation.

It is the moment that often produces the poem or the painting, especially the exceptional moment articulated suddenly within the everyday. Light strikes the side of a building and transfigures it. Hazlitt described this sensation in Nash's landscape when he walked from Winterslow to Stonehenge and lay, looking up at the sky, on Salisbury Plain. Hardy could make his pestered sea or full-starred heavens freeze in precisely recalled instants. Edward Thomas, whom Nash knew, could stop a summer's afternoon in the bird-filled, pre-war countryside with the slamming of a train-carriage door at Adlestrop.

Edward Thomas's poetry is about the countryside, but as Geoffrey Grigson has pointed out, his essential subject lies elsewhere, somehow beneath it. If Nash's essential subject was time, he used landscape as its marker and its monument because, as a painter, that was the limit of his resources. He was not old (in his mid-fifties) by the time he came to paint his last pictures, but there is a looseness and freedom,

almost an impatience, in their handling and design that is quite different from the clear marquetry with which he constructed his traps before. In the end he gave up the dryness which had led Ben Nicholson to remark that he could not look at Nash's work without having to drink a glass of water.

The last pictures are again of Wittenham Clumps, but this time the beech trees are not seen and drawn from boyhood bicycling distance but from very far away, from the escarpment of Boar's Hill, outside Oxford. The airy, bird-filled space which surrounded the Sinodun Hills in the first drawings has been stretched to a distance of 10 or 12 miles. The imagination goes cartwheeling into it, a space inhabited in the paintings by flowerheads, drifting seeds, clouds and equinoctial moons [4]. The pictures are such deep sloping views that they are almost entirely of air. They have none of Nash's clear angles and geometric architecture. By the time he painted them, he had been frequently in and out of sanatoria for his asthma and was finding it increasingly difficult to breathe. He carried oxygen with him in a bottle.

From Boar's Hill the clumps are so far off that he must have studied them through binoculars. He painted them from a window, or from a first-floor balcony, overlooking a particular garden. The garden, with its terraces and slanting lawn, and the fruit trees that make a tunnel in the middle of the pictures, is little changed. As a place, it remains an ideal vantage-point for the unofficial view: 'Stay away from Boar's Hill' is the advice given to Charles Ryder in *Brideshead Revisited*, because it is out of reach of the college authorities. Always alert to the correspondence between one shape and another, Nash made analogies between sunflower heads and the sun, round box bushes on the garden terrace and the moon. Convolvulus flowers at the side of the road at Avebury had suggested themselves to him for the same formal reasons, and the stone sphere on a pillar at Stadhampton; but now the idea of normally earthbound shapes flying free as the spirit seemed more than ever arresting. Like the fungus, they escape their element in a way that Nash could never do, except in his imagination. Impotent in the face of landscape, we are reminded by Empson: the heart of standing is you cannot fly.

The equinox, the astronomical event that Nash chose to concentrate

on, is one moment at which the miraculous becomes the norm. Catching at it, he painted it hastily, as drama, using autumn orange and blue. Bright light and ozone which had helped his breathing at Swanage, on the Downs and on board ship to America, were left behind now that he was on bottled air and borrowed time. The drifting seeds of plants would give the extreme transience of blooms a permanance as miraculous and unarguable in their way as that of the henges he had drawn. The Clumps, so familiar to him a few years before, were distant now and receding. Only field-glasses made them jump nearer.

This deep view across the autumn garden, near wartime Oxford, provided Nash with his last chance to think of English landscape as an aspect of time. The year was advancing towards winter. The war was advancing. He had drawn the tanks exercising behind the house, surreal monsters on the side of Hinksey Hill. His death was advancing. Death, he wrote, would release him to a kind of weightlessness. But the landscape would last, and in their curious way the moments would last which in his pictures he chose to show as places.

> The sunlight on the garden
> Hardens and grows cold,
> We cannot cage the minute
> Within its nets of gold,
> When all is told
> We cannot beg for pardon.
>
> Our freedom as free lances
> Advances towards its end;
> The earth compels, upon it
> Sonnets and birds descend;
> And soon, my friend,
> We shall have no time for dances.
>
> The sky was good for flying
> Defying the church bells
> And every evil iron
> Siren and what it tells:

PAUL NASH

The earth compels,
We are dying, Egypt, dying

And not expecting pardon,
Hardened in heart anew,
But glad to have sat under
Thunder and rain with you,
And grateful too
For sunlight on the garden.

Louis MacNeice

2 White. The Chalk Landscape

Eric Ravilious and Lightheartedness

One of the problems about painting is its ambiguity. It does not provide a clue in the paint which says, either, I mean what I say, I mean the opposite to what I say, or I mean anything you take me to be saying because I am deliberately open to interpretation. People are reluctant to accept that an apparently lighthearted artist is not somehow more serious than he seems. A garden hose on the floor of a greenhouse may look threatening. In a drawing of it by Eric Ravilious, the unravelling hose would be open to that interpretation, but I think the interpretation would be wrong. It is not the picture but life that is more serious than it sometimes seems. That is why it is the Marx Brothers and not D. H. Lawrence who get closer to being right.

That Ravilious was essentially lighthearted in no way diminishes his point of view. It was simply in his nature. Like those tricky attributes, talent and panache, lightheartedness was not acquired but thrust upon him. There was something in his sensibility that makes his watercolours and drawings lastingly satisfying and enjoyable, an affecting quality that is unmistakable. What is it?

At first he can look almost natty, not so much lighthearted as lightweight, and then you begin to see that all his drawings are compact and strong in much the way that a kite is light and strong. However airy and amused his arrangements, they are also spare and complete. His designs are exceedingly well made. Just as some people have the capacity of seeing the point, or seeing the joke when it is not apparent to the rest, he had the capacity of seeing design all around him. Most artists take an aspect of the real world and use their

imaginations to impose design upon it. Ravilious had an eye that effortlessly identified design in landscape and objects where it already existed, whether in the emblematic whiteness of chalk hill figures or in the jam spiral on the end of a Swiss roll.

With the apparent ease of this goes an irresistible dryness. Except for one failed attempt at the end of his life, he did not use oil paint. He did not like it. He said it was like toothpaste. A paradox of watercolour is that it soon abandons its fluidity to make a surface that is dryer than oils. He used it in a way adopted from Paul Nash, his design tutor at the Royal College of Art, with an almost empty brush which allowed the white of the paper to glitter through. Sometimes he hatched one colour across another to make a kind of tartan glaze. Crisp, clear passages of painting, high in spirit and mostly high in key, enabled him to set up his sensations on the page exactly. His subjects were all around him and he had an excellent appetite. His whole approach to landscape reminds me of the sensation I had when waking as a child in someone's unfamiliar spare bedroom and looking very closely at the wallpaper for the first time. The pleasures of his water-colours are those of feeling well, of being young, and of seeing, for once, absolutely clear-eyed.

The short distance from Alfriston west towards Lewes has in it a stretch of archetypal downland. Its particular quality has to do with scale and atmosphere. The path that runs on the landward side of the big swell where the Downs crest up towards the sea is a field away from them, warm enough to make the stubble glitter and to dry the ragstone wall that goes round Firle under cover of beech trees. At intervals along this path, isolated and inaccessible except on foot or by tractor, and well away from the Lewes-Eastbourne road, are farm cottages. It was to one of these that Ravilious came in 1934, and it provided him with a base for many of his best watercolours.

It is not hard to see why this was in most ways his ideal landscape[7]. He had been brought up at Eastbourne, and while teaching there in the mid-1920s he used to take his students to draw on the Downs on expeditions by bicycle or Southdown bus, so he felt downland to be to some extent his own country. But he had never been to this part

before. The view was firm and clear, even orderly. On one side the cottage had its end to the tall horizon of the nearest Downs, and on the other there was open farmland, a strip of trees and a copse. The place was simple, the warm sea-light was bright and emphatic, and within the clean lines of the immediate surroundings were the design patterns with which he had a natural affinity: the corduroy of plough, the chevrons of post-and-wire fencing, the ridges of turf that had slipped or been washed down slopes to reveal the chalky earth beneath. There were white-rutted paths, grey and white flint walls, the striated sky. All this he could set down directly, knowing the measure of it, the white chalk showing through the nibbled grass as the white paper shows through his watercolours. In this place he had perfect pitch.

Is painting better adapted to static images, being itself static? Is permanence moving? Downland outlasts the emotions expended on it, but is painting the Downs painting the scenery rather than the play?

The watercolours are somehow larger than you would expect. Encountering them produces a distinct shock which seems part of their effect. About 19 by 21 inches was the rather square shape on which Ravilious worked; sometimes a few inches bigger. Compared to the cramp of small wood engravings, the scale of the watercolours must have felt expansive. It led him to make much freer and riskier marks than you might suppose from the compactness of the designs. Although he always drew out of doors, the scribbled colour notes which are easily legible beneath the paint suggest that he often finished the work inside. If so, he was good at getting back to the freshness of his first sensation when remembering it in his room, as though expressing it all of a piece gave him few problems. In fact it was done with great difficulty. He spoilt and destroyed two watercolours out of every three, and there are pasted-on corrections to some of the survivors.

Still lighter, whiter in tone and spirit and a natural extension of the chalky landscape itself, were the new cement works which Ravilious found a short walk away from the cottage at Firle. The grass and trees in its vicinity lay under a fine white powder. The freshly opened chalk

cliffs were dazzlingly bright. Sheds and machinery, rails and wires, were dredged white. The powder suffocated anything that persisted in trying to grow, but it was strangely beautiful, it made a mysterious dry veil, and he returned to paint it repeatedly.

In *Afternoon Men*, by Anthony Powell, which has lighthearted Downs in it of the same date as Ravilious's, Pringle's view from his holiday cottage is marred by the domes and towers of a pumping station. It is one of the attributes of Ravilious that he looked with just as much delight at the cement works, at all kinds of intrusions into the landscape, as at the Downs themselves. He did not differentiate between an ideal setting and the light-industrial encroachments of the thirties. It simply was not in his nature to consider their consequences and, as for their shape and pattern, he positively enjoyed them. His first subject at Firle was not the Downs alone, but the Downs seen beyond the vanes and armature of a nearby wind-driven water pump, and he never tired of drawing farm machinery, derelict or otherwise.

All this produced good pictures and so did the cottage itself. Life there was primitive. When I saw it, it was still lived in by Ravilious's friend, Peggy Angus, the painter with whom he first went to stay there in 1934. She made little distinction between indoors and out. The rooms when Ravilious was there were bare, furnished chiefly by the light that came into them, by the shadows behind doors or cast by the few pieces of furniture which he had helped to buy. The effect this spareness had on him was exactly similar to the effect of the surrounding landscape. Within the simple arrangement of each room he looked for patterns: in lino, in counterpanes and wallpaper, in the grain of scrubbed table tops, the shapes of bentwood chairs and the ironwork of bedsteads. The result was compact and entirely satisfying pictures of almost empty rooms which evoke the landscape and the time to which they belong. The fields outside come into them with the down-land light. Windows are not like pictures on the wall. Doors stand open to admit the sun. The landscape belongs in the cottage quite as much as the cottage belongs in the landscape.

The watercolours convey a simple, early-rising, no-electric-light, cold-water, picnic existence, often redolent of summer, which seems to heighten not just your sight but your other senses as well: looking

at them you know the small indoor/outdoor smells of hay, of wild flowers in a wash-jug, of leather and of tea.

There is one other variation of Ravilious's room pictures which seems to epitomize him as a landscape painter brought indoors: his watercolours of greenhouses. The interior of a greenhouse contains more light than any other structure you can imagine. He always liked structures you can see through, admiring, for example, what he called 'the transparent architecture' of jellies.

On a walk to Firle in 1935 he discovered some glasshouses which greatly appealed to him. They had cyclamen and tomatoes in them, which repeated their pots and leaf-patterns down long enfilades of staging. Having drawn them, he found still better glasshouses in 1938 near Wittersham, in Kent. Unimpeded this time by the bines of tomatoes, light poured into them on to white-painted woodwork and on to the formal greyish foliage of carnations, lightly touching their pink and white serrated blooms. It is not difficult to see why, on wet days when he could not work outside, he would sit drawing in here with the rain thrumming on the glass, surrounded by exactly the design and brightly lit structure that he always looked for in the landscape. (The glasshouses are still there, derelict and empty now, but a recognizable remnant of his pristine versions of them. His own survives too: after his death it was moved to the garden of his friend John Nash at Bottengoms.)

Ancient hill figures, gigantic creatures cut into the chalk on the sides of Downs, look as if they were designed by Ravilious. Instead of making compact heraldic motifs for the sides of his Wedgwood mugs, it is as though he drew them very large on extensive green escarpments. The chalk figures of his watercolours have the air of being lighthearted incursions into the country, brandishing sudden and fantastic tricks of scale [5].

If he was looking for design in the landscape, rather than imposing it, the figures gave him an ideal pretext, but they also show very well the curious way in which his expertise as an engraver seems always to affect his watercolours. It does not require very much imagination to look at the crisp shapes of the watercolours as though they were

printed, the white representing the negatives in wood-engraving. The delicious sharpness of the chalk figures is surely the same line that widens and narrows throughout Ravilious's work, this time cut as a white trench in coloured turf.

But where is the gravitas, where are the profound reflections on time and history that Uffington, in particular, that strangest swelling of ancient places, might be expected to provoke? Why did ancient, earth-bound man lay his insect-horse almost out of sight along the top of the hill, like a fallen constellation, so that it can only appear whole from the sky? Such questions were certainly not for Ravilious. It was not in his nature to take them too seriously, so he drew and painted the figures in the spirit of delighted surprise with which their appearance invariably affects you, and without a hint of mortality. And of course in one sense he was right. Each day on which he saw the familiar two-poled giant of the Long Man of Wilmington it existed in the present. The Cerne Abbas giant appeared essentially the same to him as it had to anyone looking up at it on a sunlit day in the eighteenth century, and on the day it was first cut, which was just as much its present then.

Below the Westbury Horse, as he perched beside it, watching for the way chalk from its hooves had been washed in triangles down the slope by the rain, the diminutive trains went back and forth across the plain under their canopies of chalk-white steam. He bought return tickets between the nearest two stations and travelled forward and back repeatedly until he had drawn the horse again, this time from a distance, through the window of his third-class carriage with its star-patterned seat-covering and bold railway numbers on the door[6].

But it was 1939, and quite soon afterwards all chalk hill figures disappeared, covered up with scrub for the duration, so that they should not be used as navigation markers by enemy aircraft.

No one who knew Ravilious could imagine him middle-aged, let alone old. He was buoyant, and boyish. He had an extraordinary way of whistling. It sounded as if he could whistle in thirds, and he did this all the time. He liked simple things and informal occasions. Though he was shy, he made an enthusiastic companion because there was

invariably some small aspect of the appearance of almost anything which amused or interested him. As he never learned to drive, he often went in search of his subjects on a bicycle or walked to those nearest at hand. While asleep he would sometimes burst out laughing as though unable to contain his amusement at whatever he was dreaming.

His familiar landscape was drawn again by Ravilious, the same country but now stiffened and darkened by war. The odd thing was that, because of his nature, he drew it in exactly the same way as before. England was suddenly no longer a picnicking and bicycling place, but in his watercolours the war looks like an accident, like a harrow left in a field. This was a subtly enjoyable form of existentialism which must have come quite naturally to plenty of people apart from the totally unpolitical Ravilious. In landscape painting he seems to sum it up: no presentiments, no consequences. The easy clarity of his pictures from the thirties should not be interpreted as though the days he painted are mementoes of a lost world. They did not exist to prefigure anything. Nor do his war landscapes, painted with cheerful absorption from what was in front of him day by day, carry portentous historical overtones. They will not be leaned on in this way. Being light in spirit, they deliberately do not accept the weight.

The war invaded his landscape with an apparently endless column of tempting new shapes. His peacetime appetite for farm machinery, traction engines and steam trains, cement works and water pumps, was augmented before long by all the machinery of war. He had always drawn things for their shapes without necessarily understanding how they worked. As far as he was concerned, the more bizarre and incongruous they were the better. Barbed wire was on the Downs. He found himself on a hilltop near Castle Hedingham. Hilltops all over southern England now had a new function. Instead of being for looking at the view, they were used by the Observer Corps to watch the sky for enemy planes. Ravilious, on his, saw mostly blackberries, brilliant moonlit nights and spectacular sunrises, but he was not supposed to draw. So in early 1940 he was relieved to be working as a war artist, attached to the Admiralty. Despite constant interruptions from saluting, because he was thinly disguised as a captain in the Royal

Marines, he began his last sustained series of most un-warlike water-colours. Temperamentally, he belonged in the mess playing progressive ping-pong, with the noise of boots round the table like thunder, or dancing to the gramophone. Country pubs were for him, with shove ha'penny, and not the war at all. In effect you can watch him redraw-ing most of his peacetime subjects but now in altered circumstances.

Fireworks over the landscape, a favourite subject before the war, became the more deadly fireworks of shelling. He drew the shelling of the channel ports, flashes reflected as starburst patterns and chev-rons by the sea, and the wandering probes of searchlights. His cottage rooms, which seemed so silent in the afternoons before, now vibrated their lino in bombing; and seaside houses, blown open like dolls' houses, displayed his old subject of their private wallpapers to the street. Drawing the coast is probably what he would have chosen to do anyway, though it did not come naturally to him to confine himself to the serious subjects expected of him by the Admiralty. A yellow ship's propeller, abandoned like a fish out of water on a railway truck in a snowy siding near Chatham dockyard, was exactly the sort of intrusion into landscape he had always enjoyed. He drew it avidly, during a spell of the coldest weather for fifty years. A group of round sailors, with round barrels and oars, seemed to him to make a good pattern on the near-deserted beach at Sheerness. That they were de-fusing a German mine seemed incidental. A beached rowing boat in bright colours has cheerful peacetime connotations until you notice the unearthly patterns on the horizon. And always the tide provided him with its own Ravilious-like still life: not just chains and buoys, which he loved, but a bizarre flotsam of coloured wreckage from ships and aircraft. At Chatham, what he most wanted to draw was the admiral's bicycle.

An artist who so passionately enjoyed drawing everything in the landscape and seascape, from cats and crocuses to battleships, was not easily to be distracted by the horrors of war. He seems positively to have enjoyed returning to Newhaven at the very moment that France had fallen and invasion was thought to be imminent, to make watercolours of coastal defences. When the weather improved, he worked happily, going up the cliff to his vantage-point twice a day,

as he said, 'like a man to the office'. He thought the place every bit as good as it used to be, with some modifications, and his sunlit coastal and harbour views make much of the patterns of earthworks and the concrete geometry of gun implacements and fortifications. His only concession to difficulties was to wear his tin hat while drawing in air raids. It obstructed his vision and crammed his neck into his coat like a tortoise.

It was as he went further north that the watercolours became darker, lowered in tone by a combination of night scenes, bad weather and camouflage. He was concerned about making his colour richer. What had before been the white of chalk on the Downs became patches of snow on mountains in Scotland and Norway. His old room picture reappeared in a new form as the equally empty RNAS sick-bay at Dundee, except that now the counterpane on the metal bed had an anchor worked on it, and beyond the window, in place of the Sussex landscape, there were sea-planes moored on grey water. The transformation looks as natural as that of the greenhouse pictures into their war-time equivalent, the interior of Corporal Steddiford's mobile pigeon loft. In place of farm implements and the wind-pump, whose audible turning was inseparable from the cottage at Firle, his landscape contained the plump sausage-curves of barrage balloons and the straight spars and stays of biplanes.

Because he was always up early and liked to catch the countryside at its first freshness, he had often drawn the sun. For many of his watercolours he looked directly into it: the sun over the shoulder of hills, across a garden, a white disc reflected in the estuary at Rye harbour, more radiant even than his riotous thirties wallpaper in the nearby William the Conqueror. Later he had drawn the midnight sun as he sat on deck in the Arctic Circle. Thinking of watercolours of plum skies, he was determined to go to Iceland. He was lost during an air-sea rescue operation there, in September 1941. He was thirty-nine. Peaceful English landscape and his toylike war, pristine, light-hearted, without getting any older, stopped.

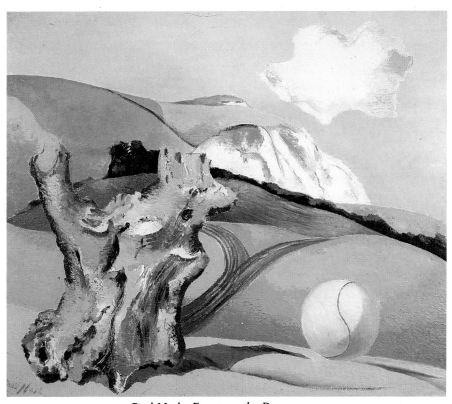

1 Paul Nash, *Event on the Downs*, 1934

11 Graham Sutherland, *Welsh Landscape with Roads*, 1936

III Edward Burra, *In the Lake District, Number 2*, 1973

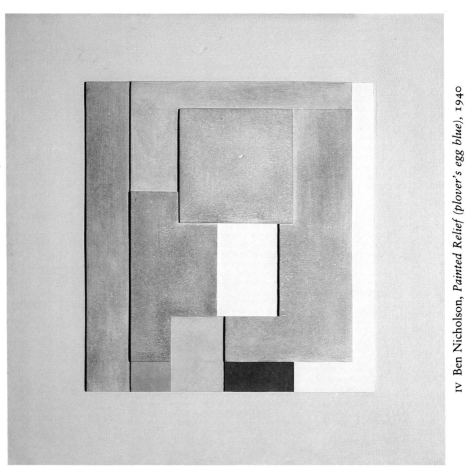

IV Ben Nicholson, *Painted Relief (plover's egg blue)*, 1940

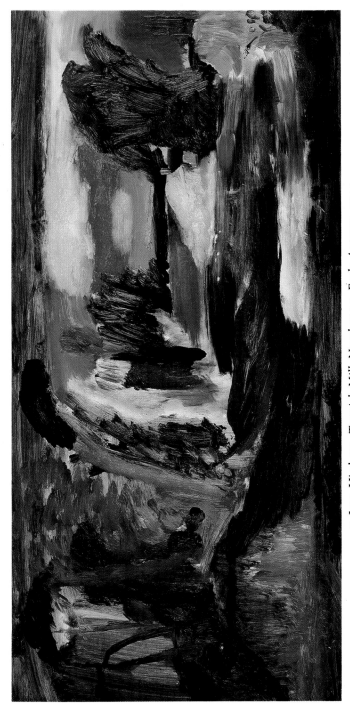

v Ivon Hitchens, *Terwick Mill, Number 11, Early Autumn*, 1944

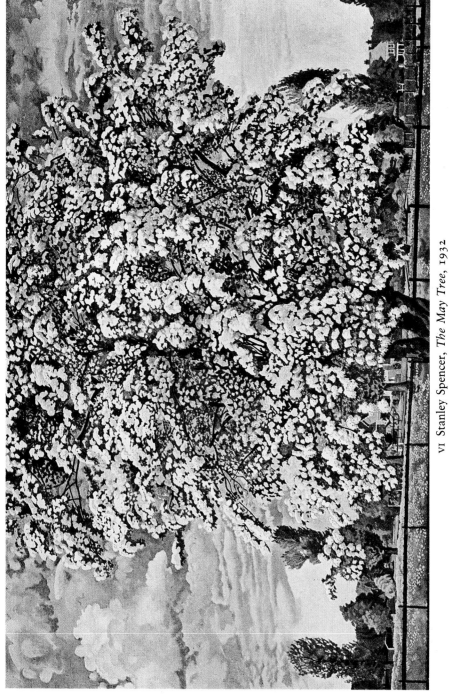

VI Stanley Spencer, *The May Tree*, 1932

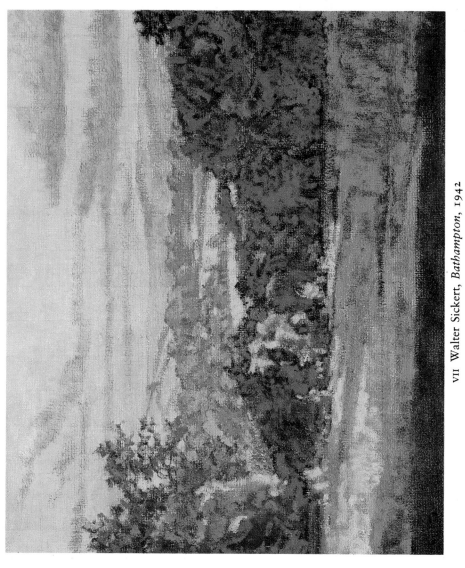

VII Walter Sickert, *Bathampton*, 1942

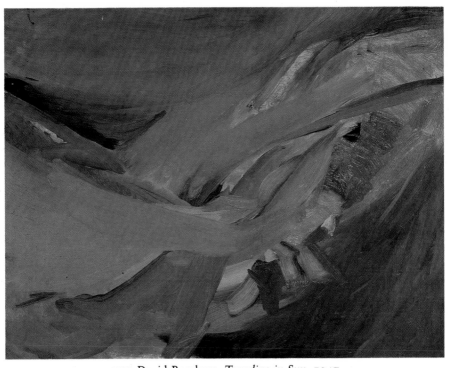

VIII David Bomberg, *Trendine in Sun*, 1947

3 Black

F. L. Griggs: Lost England

I would like to write about black. The black of etchings is blacker than ink. A very diminutive etching can contain, within a few centimetres, more darkness than is enclosed at night by a Gothic cathedral.

At first, when F. L. Griggs went down English lanes in the first summers of the century, the darkness was hidden, just as darkness does hide in daytime. Griggs was in his mid-twenties and his brief was to draw black and white illustrations for the new Macmillan series of unhurried country guides called *Highways and Byways*. The task must have seemed a godsend. He had studied architecture and worked as an architectural draughtsman, but he was by nature a passionate lover of the English countryside and the way in which it gently contained its old buildings. He was not a builder but a recorder.

The counties of England lay spread out in the sun. No traffic to speak of, no arterial roads, no pylons. To us it would have seemed almost imperceptibly quiet. At first on a bicycle and then by Rex motor-tricycle, he made his way slowly about, observing and drawing, county by county, starting with Hertfordshire in 1902 and concentrating all summer on Sussex in 1903. He had a fastidious nature and believed in topographical accuracy. He admired architectural complexity but he was eager to show buildings clearly and as simply as possible, revealing their logic. It was the last chance to show England as it was, and in him the moment had its ideal illustrator.

He drew what he could see as truthfully as possible, but at least part of what he drew was atmosphere. If you start with the first of the

23

Highways and Byways books in 1902 and follow Griggs's illustrations through (there are thirteen volumes) until he died while at work on Essex in 1939, you can watch this atmosphere change. He begins innocently enough, inclined to play up the drama of high towers and the scale of extensive views by using tremendous piles of cumulus or radiating shafts of theatrical sunlight. But he had no real need of draughtsman's tricks and when drawing Sussex he started to abandon them. Hot afternoons on the Downs, the view from Firle Beacon, he drew in pure delight, in a spirit of celebration. Oxford and the Cotswolds followed, then Berkshire, Buckinghamshire, Cambridge and the Isle of Ely. Inn yards and colleges, quiet broad streets in market towns, cottages and churchyards, slow reaches of rivers, slumbering woods and great summer trees, all were studied painstakingly with a rising feeling of attention and respect, and eventually reproduced after much re-drawing and argument with the printers, almost never to his satisfaction.

Griggs must have been permanently disappointed by the results of so much effort. His open enjoyment of countryside and buildings, at first so sunlit and unaffected, began to change. By 1910–12 he had abandoned ink drawings in favour of pencil, with many more gradations of shadow; and by 1914, when he was working on Lincolnshire, he had developed a tendency to draw buildings directly into the light so that their bulk was amplified and the side towards him was partly obscured by gloom. After the war, when every village had its own war memorial and Griggs was struggling to record the buildings and landscape of Northamptonshire and Leicestershire, he drew looking into the sun increasingly often.

We are used to builders now and to the soulless and ill-informed process that passes for restoration. So much of our architecture, like our paintings, has been over-cleaned till it looks like cheese, and the patina of age scrubbed away. Medieval carvings decaying on our great cathedrals have been hacked off and replaced by new carvings that ape them. Old inns have been demolished, or all but demolished, to be replaced by spurious modern reproductions of age. The sounds of demolition and reconstruction are to be heard in every street; and, in the country, conversions of all kinds have meant that agricultural

buildings are seldom what they appear to be. Barns are no longer barns, or oasts oasts. The terrible arrogance with which this period has inflicted its brashness on an inherited landscape is positively Victorian.

Watching the beginnings of this process, Griggs became depressed. The Cotswolds were his adopted area (he lived at Chipping Campden from 1904) and he spent much time and energy trying to defend them from developers. In his drawings for *Highways and Byways* he continued to show roads empty of traffic, the sort of roads in which a dog gets slowly up from its sleep and moves to the shade, and to concentrate on medieval buildings. He hardly ever drew a building put up after 1800. But it was not the same. Whereas before his subject had been an untrammelled countryside open to the sky, he was forced now into concentrating unnaturally on the past, to draw an idyll which had already largely disappeared and for which the evidence existed only in untouched buildings and forgotten corners of the landscape. In his mind, the real England he had studied on his tours with such scholarship and attention to detail was increasingly overlaid by a half-imagined land, a place with its back to the sun, a country of buildings and hills glimpsed with great tenderness and nostalgia as if in a dream. His view became dark. And in this half-imagined landscape he began to think of etching.

What is it that has made the broad and sappy countryside of England into a fit subject for small, black images? The darkness of printing, the struggle brought about by having a mechanical process between the artist and the work, makes it an emotional medium. Even benign landscape, lying out in the sun, becomes caught up in human feelings when transferred to etching. Etching, like poetry, depends on compression.

Growing up in the pleasant small town of Hitchin, Hertfordshire, Griggs had seen etchings by Samuel Palmer in the local institute. He must have recognized that within those small rectangles is re-imagined a whole world. He experimented, at first unsuccessfully, with the process himself. By 1912 he was ready to try again. Although it remained his livelihood, drawing the landscape with topographical

accuracy as an illustrator was not enough. He loved the things he drew but was well aware of what they stood for as well as how they appeared. He was a visionary as well as a realist. The England he wanted to preserve was silent and secret, hushed in twilight, sunk under hot afternoons or under snow, a place of accumulated history and gothic buildings, hidden or partly hidden beneath ivy or behind walls. He must have been haunted by its completeness and spiritual self-sufficiency. He loved the juxtaposition of farm buildings and churches, hay ricks and chapels, the past revealed by shadowed mounds in the earth. In his late thirties he became a Catholic and, the same year, began the slow process of etching a lament for this remembered land.

He was in no hurry; drawings which had to be summoned up to meet a publisher's deadline were too quick for him. In etchings he did not look for sudden revelations or spontaneous effects. He was able to return to the same subject repeatedly, finding his way deeper and darker into the plate both literally and metaphorically, lingering and hesitating, sometimes for years.

God becomes a preoccupation in the landscape more easily than in the town. The fact that the land is instinct with suffering and hardship induces it. Griggs's first etchings were based on places he had drawn as illustrations long before, like the little Norman chapel at Stanley Pontlarge in the Cotswolds which he had first seen in 1905, or the churchyard of Gray's *Elegy*, at Stoke Poges, in which he drew the great porch. But he began to transfigure other subjects until they became in effect his own inventions.

He produced fifty-seven etchings in all, two-thirds of them of places that do not exist. An artist can have a view of a place that is stronger and more permanent than the place itself. Griggs's half-remembered, half-invented country is so persuasive that it is what we have come to look for, and often think we see. So convincingly is it drawn that it is hard to accept it as imaginary. In fact, like characters in a novel, his places are usually a combination of different sources. Anyone who has seen snow on the hedges and façade of Fountains Court, or pigeons on the old gables of Owlpen Manor against the high-summer woods, will recognize the absolute truthfulness of his view of the English

manor-house. The delicately etched haze with which he drew church towers, seen beyond tall elms or over the heavy, uneven roofs of farm buildings, is not hard to trace to particular illustrations. What he was etching was the humanity of buildings in the landscape, their look of being used and loved.

The most beautiful example is his *Maur's Farm* [8], an etching begun in 1913 which went slowly through eight states between then and 1925. The first idea for it is traceable to a sunlit pencil drawing of a spire beyond haystacks, made at Helpringham, Lincolnshire, in 1912. But, as Griggs's imagination began to transform it, evening seemed to be coming on. He gave the altered farmyard the name he had chosen for himself on becoming a Catholic, that of St Maur, the sixth-century Gallican saint. The print grew at first darker and then more luminous, sinking into a religious twilight so tender and strange, so serious and subtle, that it becomes a vision, in the final states, of the real world sleeping, transfigured by an exact sentiment that was Griggs's alone.

Robin Tanner: The Idea of Fruitfulness

His corner of north-east Wiltshire was re-imagined by Robin Tanner in the 1920s and 1930s as the setting for a pastoral golden age. It comes over you like the smell of a church interior at harvest festival. Griggs had cast a sad look back at a twilit, receding England, but Tanner was far less melancholy. Visionary, to him, implied looking forward. You would think that the promised land could never be as beautiful in reality as in the imagination, but Tanner's local country-side is recognizably the land of Blake's *Virgil*, the place among enormous grapes and productive beehives that you find in Edward Calvert.

From 1931 until his death in 1988 he worked in a cottage near Kington Langley, hidden in a shallow combe on a tributary of the Avon. When I first went there, with the help of a map in the endpapers of his book called *A Wiltshire Village*, of 1939, I knew at once that this was the state of mind represented by the etchings. When plenty was summoned up in the English landscape by Blake and Palmer it appeared in the embalmed darkness of the ink in which ideas germinate, enabling light to seep in. It only seeped at first, extinguishing

Palmer's morning star; then the rising sun squeezed between saplings, the sunburst of its rays like the squeal of a trumpet. I suppose that anyone who watches the countryside constantly cannot fail to realize the sheer abundance of its evidence for the seasons, their plantlife and weather. The profusion that Robin Tanner saw everywhere went like a thick vine through his etchings. He knew Griggs from 1929, but Griggs's sensitive Catholic vision, compared to his, is reserved, even severe.

The countryside *is* like this, if seen from a sufficiently generous point of view. In much art, especially in music and literature, there is the poignant sense that the strange external god whom man has made is then clouded, and hides his face from him. Man has the baleful experience of the living dead. He is excluded. It is an idea expressed often in the psalms and then suddenly and resplendently refuted in Psalm 65, in which the earth is visited and blessed and made very plenteous. The psalmist evokes the brimming, harmonious landscape which, especially in times of alienation, man's repeated imaginings devise, its valleys thick with corn. Palmer reiterated it at Shoreham, and, exactly a hundred years after he was there, Graham Sutherland, Paul Drury and Robin Tanner in their different ways began to dream of it again.

In Tanner's case, the profusion of the etchings half buried the artist in reality. His steep-pitched roof was sunk in vegetation. Trees grew up to blot out the view of Downs he knew as a child. Enormous flowers and vegetables fattened in the sandy-acid soil of his garden, spilling across mossy paths, blocking mullioned windows, even barring the door. No wonder that in his etchings he made the valleys laugh and sing. It is his domestic version of Marvell's garden. Apple trees do not carry just one or two apples, they strain under massive crops; hedges are choked with flowers; chestnuts blaze with candles.

His *Wiltshire Rickyard* (1939) [9] is a comparable arrangement to *Maur's Farm*, but consider the contrasts in imagination. Do Tanner's cornucopias turn over-ripe when left too long in the real world? They might were it not for the radiant optimism and difficulty, the vegetable slowness, with which they were grown. Quaker and socialist, Tanner was saying in effect: this is the ideal world that could be ours if we had the will and courage to work for it. And now here is precisely

what it is made up of. It has the velvety bee orchis in it, the butterfly orchis, white helleborine, and fleshy toothwort the colour of a dirty white pig. It has gate latches that are made like this, stone walls constructed like this, ricks thatched like this. The information he collected and made into etchings over a long period is exacting, detailed and precise as well as poetic, in the way that Geoffrey Grigson's observation of the same (but to him, adopted) landscape was exact, and Kilvert's before that. Kilvert is everywhere in Tanner's woods and Downs.

The promised land has a particular poignancy when the model for it is on the very point of extinction. Since he began work in it, this landscape has always been threatened – by developers, by traffic, by agricultural chemicals, by war. I could not enter his cottage until I had willingly signed an anti-nuclear petition. Even while he was etching in the late 1930s a military aerodrome was established noisily 5 miles away, beyond elms common as weeds. But the overwhelming countryside that Tanner so loved to pull out of the peaceful darkness in his etchings was drawn on the persistent evidence of what he saw.

4 The Need for Roots

Stanley Spencer

Have you known the life-long power of a place? Does a place have a hold on you? Such a place can look harmless enough: its very benignity may be all that is necessary. All it need do is exist. Seasons give way to others indiscernible from those gone before. Events happen or do not happen, about equally. Options diminish and landscape will have nothing to do with getting older. How, if you do not know this, can I convey to you the depth and poignancy of the hold that Cookham had on Stanley Spencer?

He was born in it and learned it slowly and in detail as a child does, not just with his eyes but with all his senses. He learned it back garden by back garden. He knew the warmth of sun on particular walls, the rancid smell of may blossom, the plash of oars and the wooden bumping of punts on the river, the way curtains flew out of windows in a breeze. With the places he learned the names: The Nest, Bellrope Meadow, Pound Field, Turk's boatyard, Wistaria Cottage, Quarry Wood. All this became far more than familiar to him. It took on the miraculous intensity of a novelty that never wears off. It became his own charged territory. He wanted to draw it repeatedly, so that he could go on and on looking at it, so that he could commit it to memory exactly and possess the ultimate knowledge of it, as though the abundance and complexity of his village might somehow reveal the world to be intelligible.

How close to this is a simple sense of sanctity? It was a state of mind that he would surely have experienced anyway, unarticulated, but, as it was, the particular circumstances of his childhood made it

unmistakable. The eighth of eleven children, he was taught by his two elder sisters in a corrugated-iron shed adapted as a schoolroom at the foot of the garden, but the part of his education that chiefly caught his imagination and shaped it absolutely was his father's readings from the Bible. Charles Spencer was a piano teacher and church organist at Hedsor, up near Cliveden Woods, an imposing bearded man whom his son would have had no difficulty in thinking of as something like God the Father. The poetry and thunder of language in the King James Bible was his reason for declaiming it to his large family. The words must have rattled the dishes in the kitchen of their redbrick semi-detached villa in the high street, and set the Pre-Raphaelite reproductions awry on the front-room walls. As a small child Stanley Spencer inevitably picked up long passages of the Bible by heart: as well as the language it was the stories that impressed him. Like all great stories, their essential nature belonged not to another country and to long ago but to the present and to him. Some children know from an early age the thing it is they are going to love. Stanley Spencer already knew that it was to be Cookham, and that his drawing was inextricably bound up with the village. It was the Bible that suddenly seemed to him to give this point and to make it infinitely more than a process of recording.

His absolute happiness as a child he took for holiness or sanctity. He thought that happiness was synonymous with being in God, the way that only mystics and simple people do, and children. He felt that, by drawing it, he had the power to reveal holiness in landscape. This was because he could see the sanctity of quite ordinary things in a way that other people were entirely unable to do. He was in love with the physical fact of the world, of *his* small world, its turmoil of shapes, even its apparent muddle. He began to draw and paint with this sense of the miraculous in the everyday. It made him happy and persistent, and it made Cookham into a holy suburb of heaven.

Such an intense vision is exceedingly rare. He took it with him to the Slade in 1908 when he was sixteen, and it was already strong enough not to be spoilt or diminished. It was added to. Imagine Spencer leaving his village to go to London; but only for the day. He would walk the 2 miles to Maidenhead station in time to catch the

8.50 train to Paddington and was always back in time for a late tea and painting at home in the evenings. He was teased at the Slade for his shortness and boyish, untidy appearance and high voice, but also because what he mainly talked about was his abiding passion: Cookham. 'Cookham' became his nickname. He could hardly contain his impatience to be back there. Up to the time of the First World War, he thought of Cookham as paradise.

I have begun like this deliberately because, whatever else he thought he was, Stanley Spencer would never admit to being a landscape painter. Set subjects at the Slade on biblical themes, and the rigorous course of life-drawing he pursued under an appreciative Professor Tonks, encouraged his convictions and his technical expertise in the direction of a highly idiosyncratic kind of figure composition. The Bible had shown him that he needed people to express godliness. He needed people and he needed, as the stories did, particular events. His fiercely exact imagination required no justification whatever for placing such events in his own familiar setting. The events were active. Precisely one of the things he most loved about Cookham was that it was passive. He spoke longingly, when he was away, of its 'unhappeningness'. What he so greatly admired in it was not that it contained incidents and altered circumstance but that its cottages and street and river banks were a continuing presence. It is that which takes hold of you when a place overpowers your imagination in childhood, and why, ideally, for fear of change you should never go back. It is why Stanley Spencer could still be met with in the 1950s, as an oddly boyish old man pushing his pram-load of painting equipment round Cookham, still painting the village and repainting it in an attempt to get it clear.

So his earliest biblical subjects had to be set in Cookham: *The Betrayal* behind the schoolroom in the back garden of Fernlea; *Joachim Among the Shepherds* beside the 'bread and cheese' hedge along the Strand ash path; *The Annunciation* in a local garden where the gardener showed him how worms pull leaves down folded into the earth; *The Last Supper* in Cookham malthouse; *Christ Carrying the Cross* past Spencer's own home, with all the curtains bursting

suddenly from the windows like angels' wings; and the great *Resurrection* in the churchyard, with the internal wall of Cookham church cunningly turned inside out, and himself, his friends and village characters erupting from the graves. Cookham, his exact and unremitting observation of it, lies behind and under all of these. To alter in any part its physical appearance would have been to damage its spirituality and to lessen its emotional tension.

What Ruskin had called for, for intellectual reasons, had come to Spencer entirely naturally: a revival of the force of religious painting, in an unspiritual age, by the use of contemporary settings. The Pre-Raphaelites had exercised it; the Italian primitives were masters of it. Spencer saw very few pictures in childhood except in reproduction, but he was aware of these antecedents and they affected him. In later life he much preferred small monochrome reproductions to seeing other paintings in the flesh, and the atmosphere of black and white plates illustrating the work of Giotto, Piero and Duccio in sixpenny pocket editions published by Gowans and Grey is easily discernible in his early work, even to the extent that his own pictures reproduce best in this form themselves.

He painted what he knew, and everything seemed fresh to him. He had no need for properly fitted-up studios. He was entirely happy working out of doors or in the kitchen or in his bedroom, as he did until the end of his life. For larger pictures before the First World War he used the Ship cottage or the barn at Ovey's farm across the road from Fernlea. His ideas came easily and well, as integral parts of their settings. He felt completely confident of the holiness of all he saw. That Cookham lies like an island surrounded by low water-meadows meant that often he worked sunk in wild flowers. It added to his elation at being part of creation, and made him feel that painting was in some easily definable way part of the creative process. 'The marsh meadows full of flowers leave me with an aching longing,' he once wrote, 'and in my art that longing was among the first I sought to satisfy.' The *Nativity*, of 1912, he described as celebrating his marriage to the Cookham wild flowers. Everything contributed to his sense of sanctity and, because of that, to the pent-up exhilaration with which he painted his surroundings. When he was in church and the doors

stood open because of the heat during matins, he could hear punts being launched from the landing-stage at Turk's boatyard, and even that, the sound, became sacred. The white cowls on the oast houses, visible above the orchard trees close behind Fernlea garden, seemed to him to be holy presences which swung round on the breeze to watch him. He felt their awesome presence observing him as he worked in his bedroom.

Can you begin to understand the intensity with which he observed this place? He must have thought his state of grace as an artist would never end: but, having hardly left his village before and certainly never having seen the sea, he found himself in transit to Salonika as a hospital orderly in 1916. His books and letters were destroyed on official orders in the advance but he still carried with him his inalienable passion. His view of the war was not so much of heroic action as of scrubbing the floor between baths and of kit inspections, the menial things from which much of the best war painting and poetry was made, while his thoughts were at home. In a letter to Desmond Chute, who was instructing him in Catholicism at the time (an inappropriate discipline for Spencer), he enclosed an essay in total recall. His handwriting, confused syntax and spelling, indicate that sudden bursts of vivid recollection fell across the pages without constraint. All Spencer was doing was articulating what was always on his mind: what Cookham would be like at precisely the moment he was thinking of it, at 3.30, as it happened, on a Tuesday afternoon in May.

He imagines himself walking across Cookham Moor. He can see the white posts at the eastern end of the Causeway, the blacksmith's shop in the shadow of its pollarded elms, the redbrick wall round Mr Waller's house, the single cedar tree above it, and so on. His sharp child's eye and equally sharp memory take him past every much-loved detail on his way back to, and into, Fernlea. Nothing escapes him. This memory of Cookham is the same as the picture, painted much later, of the view across the Moor [11], but done in words in Salonika in 1917, even to the bright wink of light off a slate roof beyond the gardens that flashes like a greenhouse in the sun.

It was three and a half years, and he was twenty-seven, before he returned. Cookham had changed, and he had changed. This was so

much of a sadness to him that he chose simply to ignore it. A man can do the same thing in his relationship with his mother. The strange thing was that he could avoid without difficulty any reference to change because, as well as his extraordinary memory, he had a backlog of drawings and subjects from before the war that provided him with several years of work. He went on painting Cookham with concentration as though he had never broken off, as if it still belonged to his time of innocence, to the time when, as he said, his work and ideas rested 'in the lap of the morning sun'.

This could not last indefinitely, and by 1923 he was aware that something was slipping. Never having had to question the source of his natural inspiration before, because it had been around him since childhood, he began to worry that his vision might desert him. Such a man stares harder than ever. Can a child avoid relinquishing his childhood vision by refusing to get older?

A split occurs, about here, in the middle twenties. Spencer himself would vehemently deny it, but look with attention at the work and I believe you can see what happened. The great beauty of his earliest landscape paintings had depended on their being inseparable from his religious subjects. It now began to seem to him that what was important in his pictures was what he called his 'notions', events, religious, secular or profane, acted out by figures. Meaning for him had essentially to do with the presence of people. 'I need people in my pictures as I need them in my life,' he said. The events they acted, like miracle plays or Edwardian regattas, would still be in a Cookham setting. All his life he would not have been in the least surprised to meet the disciples in a tea-shop in the street, and he referred to them unselfconsciously as J.C. and Co., as though they had been a firm of local builders. The Cookham setting would remain but it no longer seemed to be on a divine equal footing with events, or to occupy quite the odd enchantment of circumstance that it had earlier, because it was the notions, increasingly, that were uppermost as subjects. It never seemed to him remotely ironic that, into a place he liked chiefly for the fact that nothing happened, he should introduce events that were utterly momentous.

Notions, as George Eliot remarks in *Middlemarch*, are like dropped needles. They make you nervous of treading, of sitting down, even of eating. Spencer's uneasy imagination began to race with them and, as it did so, he periodically shook himself awake, like a man starting from a daydream, and looked about him. Breaking off from subject pictures, he would devote himself to bouts of figureless landscape painting like a man taking deep gulps of the real world. His was a passionate character. The passion that went into the tumult of the subject pictures and into the confusion of his domestic life was suppressed and constrained by landscape painting, leaf by leaf, but it was still there. He was seen sometimes to throw himself down and sniff the grass hungrily. This damp valley, this river place, was after all his first love despite the notion pictures: as he told his wife, no love he had for people could compare with his love of place.

Cookham in May. The white of posts reflected in the river, cow-parsley, elder-flowers, chestnut candles. With relief he began to paint again out of doors as soon as the weather improved, and many of his best landscapes belong to early summer. That is, they were begun then, but often he worked so slowly that he was able to add later flowers as they appeared. It is the brimmingness of white and new green; tall trees, tall grass, tall flowers, the freshness of new boat paint for the summer season, with which he seems to sum up the village. Horse chestnuts, much painted by the Pre-Raphaelites but considered unacceptably glaring when in bloom by the theorists of the Picturesque, he painted in full sail, bright as lit cumulus. May blossom pleased him for the same reasons. He described how he would tuck himself away in a deserted corner of a Cookham field, a field already white in the sun with sheep and lambs and whiter still towards its edges where cow-parsley stood in the ditch, to paint the may. The affectingly beautiful picture of a single may tree [VI], its bloom filling the whole canvas except where he makes the analogy between its blossom and the clouds beyond, the river running from one side of the bottom of the picture to the other, concealed by deep grass and flowers, is typical of his appetite for new summer landscape in the early Thirties.

It is worth remembering that, because he was a small man, not

much over 5 feet tall, he liked to get up on top of things to find a higher viewpoint. He was fond of riding on the tops of buses, which enabled him to look over walls and down into gardens. For example, he would paint from the vantage-point of Cookham Bridge, looking down into the punts and on to the boatyard. The effect was to lengthen the foreground of his landscapes and to extend the distance to the top edge of the canvas, dispensing with the sky. The first landscape paintings leave this big foreground empty; it is taken up by empty fields, empty river, the empty high street or the empty causeway across Cookham Moor, as though the village cast is entirely indoors, out of sight, listening to the wireless or having tea. Only the afternoon sun is about, and there is no traffic. I say these foregrounds are empty, but they contain passages of pure observation set down in Spencer's clean and orderly paint as though he relished them quite as much as the complexity of distant roofs and shop awnings, chimneys and trees. Without the distractions of people, without diversions of the kind he liked (a girl passing in a shiny new pair of shoes), he would carefully note down the exact colour and texture of the street, the barely perceptible web of marks left by wheels in the dust, the exact conformation of a drain cover. In the first pictures, where the paint is thicker and the neat, emphatic touch juicier and with more oil in it, these open areas of painting can be very beautiful when they have nothing to do but find out and celebrate the simplest physical facts on their way to the horizon.

To paint like this is to be in love with the whole of the physical world; not to discriminate against parts of it. His home life and his domestic drawings show that he was in many ways more interested in the richness of detritus than in domestic order, and his appetite for landscape subjects extended just as naturally to rubbish – in one case to the profusion of rubbish left in the grass after a Bank Holiday – as to cottage gardens. 'I am on the side of the angels and of dirt,' he once explained, and it was the dirt, the confusion and the normally unconsidered, that gave him his bearings in the real world.

It took time. As he went on, those empty foregrounds began to fill up. Very often his view was partly impeded by the stems of tall plants in front of him, or by fences, garden furniture, a scarecrow on its stick

armature like a crucifixion, the Tarry stone that used to be on a road island at the top of Cookham street. He painted the things around his feet, flints round a circular flower-bed, nettles and brambles in a hedge, bricks in a wall, the things that appeared to hem him in or to get in his way. The passionate observation he had expended earlier on apparently vacant foregrounds was now brought to bear on under-growth, vegetables, flower-beds, single blooms, the small distinctions between grasses.

He would look along a row of paved front gardens, the view filleted by their fences or by railings, and painstakingly describe their differ-ences, watching for the changes of pattern and texture set up by ceramic kerbs and paths. High-summer cottage gardens he painted in about 1930, lingering like a pollinating insect over hedges, topiary, fruit trees and cottage flowers, but enjoying quite as much the brambles outside their white-painted fences as the luxurious cultivation within. In that picture, so that his eye could run from side to side the length of the ditch, he used a long canvas that he had first adopted in 1924 for a marsh painting in which he wanted to show how a row of foreground undergrowth echoed the shape of a line of distant trees.

His idea of looking between stems at an extensive view could greatly add to his designs because of the way in which flower heads are held up to divide the picture at eye-level. In a view painted in 1934 from the garden of a house called Rowborough, just off the road between Cookham Moor and Winter Hill, he chose to scrutinize the vegetables and the fields leading down to the river through a screen of sunflowers [10]. The woods on the far hill he made to echo narrow, packed-down lines of cumulus, a device he had first used in a view of Cookham meadows before the First World War, but it was the things immedi-ately in front of his easel that seemed chiefly to interest him. Asked, in 1950, to paint the view from the garden of Englefield House towards Hedsor church (the church where his father had been organist) he spent a long time lavishing dry brushwork on foreground hybrid teas, the short arcs of grass and blue dianthus leaves, and the fresh white woodwork of the nearby greenhouse, so that the distant church tower on its wooded ridge beyond the river was in the end quite forgotten.

There is an atmosphere to all these pictures which acts on the

memory as quickly as a smell. Is it that waiting within us is the knowledge of just such a place on just such an afternoon? He defines something we need no encouragement to recognize.

Sometimes it is necessary to make up your mind whether you accept the ideas conveyed by pictures independently of what the artist may have to say about them. The split in Spencer's work in the twenties had left him feeling that his notion pictures alone expressed his religious and sexual convictions and that landscape, pure landscape, was more to do with observation than with passion. He still painted landscapes in order to establish the setting for subject pictures, for example the study of flowers and trees in Bellrope Meadow relating to a picture called *By the River*, but at a time when his imaginative figure pictures were not taken seriously it annoyed him that people preferred to buy landscapes. By the late 1930s he had begun to speak against his landscape painting, saying that he only did it against his will, for money because he was in debt, and that it wasted valuable time which should have been spent on his real work with the subject pictures. The landscapes themselves contradict this. Whether he chose to recognize it or not, his long scrutiny of the river village and its surroundings produced strange and passionate painting precisely because it was not imagined. What he called his 'queer' pictures can sometimes lack tension and force, but those of his wives, children and surroundings never fail to pin them down with a fixity and uncontainable tension as if his unblinking reaction to things seen was a kind of belief. Seeing was believing when what he could see of the world coincided with the view in his own soul. If Spencer thought that his notion pictures were his great contribution and that the landscapes showed no imagination, he need not have tormented himself. His oddness of vision, his queerness, was not separable from him. His methodical way of working, his way of focusing on one small object at a time instead of holding the whole picture in his mind, had a way of making for fish-eyed compositions, the sensation of detail wrapping round you. Nothing appears like this in reality. In the pictures it has been altered by the hardness of his looking.

Towards the end of his life it was still possible to see him painting in Cookham churchyard with a notice propped beside him asking that

he should not be disturbed. There are many late garden pictures and tree pictures, with magnolias, lilies or wistaria in the foreground, painted slowly and with attention in places that he had first learned in boyhood. 'One or two or five or seven weeks', he said, he would stand on the same patch of ground. That dry, thick paint went on extremely slowly. He called it his knitting. The blandness of oil paint, which can be a pleasure in Paul Nash, is not always a pleasure in Spencer. If it was necessary to wait for the light on a puddle to become what it had been when he left off painting the previous day, then he would stand and wait for it. Summers went past. In mid-July the thrushes fall silent and birdsong starts to fade. Do not be misled by the fact that he disclaimed his landscape painting, that when visiting friends he would sometimes ask to sit with his back to the window so that he did not have to look out at the view. His landscape is the more beautiful for his contradictory attitude to it. It was the child's insistence on the continuity of the place, the refusal to let it go, that was his subject. As he said, he loved the chestnut trees for 'just being'. To be rooted is a human need. On the evidence of the pictures, landscape was his long passion, a religious impulse quite as forceful in its way as that expressed by the notions. To give your heart to a place to this extent means that you have given a part of yourself away and are no longer complete. But to scrutinize one place this hard is to make the world in some degree intelligible.

5 The Idea of the Garden

John Nash

What is it about these pictures? The small exoticisms of the English landscape are set down by John Nash with only the very slightest of flourishes. Their beauty and the clarity of their patterns are observed by him with a reticence and detachment that produce something particular and idiosyncratic. It is a hard quality to describe. Nash himself would not discuss it, but I suspect there was a peculiar process of transmission at work, which even he probably did not fully understand, that was somehow rooted in his country nature, like having green fingers.

His pictures occupy a delicate area between the painter and the subject. There is a gap, a little no-man's land there, which is never visible in the profoundest painting where paint becomes idea, but which can be moved about in with the very greatest care by an exceptionally observant lesser painter who is always alert and persistent and who never turns quickly. In this place, contrary to expectations, there is a spark of life, and things grow.

He watched for the spark sometimes patiently and sometimes in some irritation. It requires practice to see the second spring hidden in fine weather towards the end of September; the many un-named seasons that take their places in the intervals between those that are named; the overlap or coincidence of one season with another – January thawing noons already suggestive of spring, April dusks that breathe high summer. All these belong to a curious in-between part of landscape painting which can only be injured by emphasis or frightened off by too personal a gesture. Nash saw that they contain quirks

41

of decoration hidden among the stooks or under a light dusting of snow. Given fresh air and light, they could make a small demonstration of feeling of their own.

His method looks straightforward. He drew constantly in the open air at all times of year, not searching for effects in dramatic skies or grand changes of weather, but noting down the habit of particular trees and the curve of particular lanes. In undemonstrative landscape it was necessary to watch for the smallest peculiarities, as he would in drawing the innocent countenances, as he would call them, of daisies and anemones. These landscape pencil and wash drawings, sometimes added to with cryptic written colour notes ('rocks like whalemeat'), would then be taken, during the last forty years of his life, into a rather dark upstairs studio and transferred into paintings and watercolours unruffled by temperament, with a light firmness and order. Concealed in this unexceptional process there was something that made the difference, an edge that sharpened the truthful facts seen that afternoon in the field or by the river, and set them down again, redesigned and slightly simplified, their romantic overtones scraped firmly out to show the sprung bones underneath.

It was not a tremendous thing, but a subtle and surprising one, to see with such clear eyes. The difference he made could almost have consisted of no more than his handwriting as a painter, his ability to write down landscape from what he saw but to leave it a little trans-figured. The distinction between a truthful drawing and a drawing that also has a spark of life is something that has to be sensed and not analysed. In a case like Nash's, where it seems to depend less on an effort of imagination than on a quiet process more like trout-fishing or the study of botany, it may just be possible to see where it comes from.

Paul Nash, who felt responsible, was sometimes sceptical about his younger brother's qualifications as a painter, thinking he might not have sufficient imagination. He was wrong. You can see the difference in personal style between the two brothers in old photographs as much as in their paintings: Paul, with his sleeked-back hair, hawkish face and bow ties is the international poet, full of flights of air-borne psychology; John, in well-worn country clothes, a fishing-fly in his hat

and in his mentality, is the earthbound boy who went in for the botany prize at Wellington to get out of compulsory cricket, who does not much like abroad or change, or architecture or talking about pictures, but who paints in the same spirit of observation with which he grows flowers and vegetables. This required a poetic imagination of its own.

It was not overt, but an uncorrupted vision that was to become his chief asset. There was no fat. He did not run the gauntlet, as Paul did, of art-school influences and he did not see Fry's exhibitions. The instruction he picked up and used was chiefly to do with method. Gilman wisely suggested he avoid the use of oil, so he painted drily and opaquely; he liked the practice, adopted by the other members of the Cumberland Market Group, of meticulous squaring up, and must have found their objective approach matched his own. His brother's friend Claughton Pellew Harvey had encouraged him, on a walking tour of Norfolk in 1912, to look at landscape simply and clearly. (He also, quite unintentionally, taught Nash another lesson – that of diligence. Pellew Harvey was a man who got less than he intended done and stood for Nash as a dreadful warning.)

Otherwise, apart from looking with wonder at Cotman, Cozens and Girtin, Nash depended on his own innocent eye. It made him primitive and acceptably modern at the same time. His work had a quirky, linear, child-like quality that appealed to other painters. When the Nash brothers went into a lampshade shop in Pelham Street in 1914 and suggested they show their pictures there (the Dorien Leigh Gallery), the results at once had the approval of Sickert. John Nash's style came to be thought of in relation to the surrounding French influences as a form of home-grown Post-Impressionism, dry, but sufficiently colloquial.

It grew best, from 1929, in Suffolk farmland, in fields and on riverbanks that must have been familiar to Constable and within a short walk of Gainsborough's Cornard Wood. It was not the painters who attracted him there – he never referred to them – but the place. 'Good river scenery,' he wrote on a postcard that July from Wormingford. 'Think we might stay.' He worked during the summer of 1929 by a watermill off the lane below Wormingford church, where a white-railed bridge crosses the Stour. The house he and Christine Nash

rented was burned down; the place, with its enormous willow and the mill pool skimmed by swallows, is recognizable from the paintings. But his home for forty years, until his death in 1977, is on the other side of the village, entirely hidden.

Farmland in this area, so much painted by him, does not conceal easily. It tilts its patterns, exhibiting them. The Stour is in the bottom, in grey and green, but the landscape surrounding it, the landscape of the pictures, is characterized by single trees silhouetted against plough, wriggling hedgeless lanes, the stripes and cubes of stubble or bales, clumps of willow and alder by rush-choked streams, thistles in rough ground, black clapboard barns in sloe thickets, the geometric shapes of dark woods on distant ridges.

In the middle of all this, in a place so overgrown that he could hardly see out, Nash hid. It is one of his strengths that his garden and immediate surroundings, which are picturesque and deeply romantic, were repeatedly painted by him without a hint of sentiment. There is everything about them to have softened his style.

The house, called Bottengoms, is wedged into a small valley, little more than a gulley, that points like a finger down at right angles towards the more expansive valley of the Stour. As you approach it down a track beside a stream (there is no road), you enter an orchard of old plum and greengage trees, overgrown and suckered. The undergrowth, as you go lower and emerge from the orchard, gives way to a jungle of tall plants, gunnera, euphorbia and clumps of cane, which wedge themselves on either side of the stream and arch over it. These in turn are superseded in a random way by garden flowers, roses and pinks, and by vegetables. So deep is the planting that at first there is no sign of the house as you approach. A simple and atmospheric small white farmhouse with low vine-blocked windows, it lies along the axis of the valley, its far end gable towards the thick willows and hazels that exclude the view.

The whole garden, with its ponds and small barns, is so sunk in its surrounding screen of willows and alders that only occasionally do you see out between them to the steep banks of corn that slope up on either side like breakers about to roll over on top of you. In one of these fields, the rectangular foundations of a long-disappeared farm-

house appear and disappear like a scar, depending on the time of year and the state of the crop.

In this place Nash was best able to get on with his work. The studio was an attic, an L-shaped room off his bedroom, that was not only dark because of a creeper which grew across the window but was usually filled with a haze of cigarette smoke. In it, pile upon pile, were the drawings he had to go on, the dead and dying plants – he called them his 'models' – which he had drawn but forgotten to throw away, and the jumble of his equipment, paint mixed in tin lids, in contrast to the orderliness of what he produced.

The orderliness did not come easily. Although the considered surfaces of the pictures betray no signs of battle, he often complained of difficulty. The English landscape, he said, was too green, although he got round this, like Alexander Cozens, by seeing trees as much blue as green, especially in July and August. As he got older, he was seriously concerned that he was repeating himself. If he had to refer to his painting he called it, ruefully, his 'artwork'; his early drawings he called 'scratchings'.

I think, in the honest surfaces of the pictures, it is fair to detect an undertow of loneliness, even of melancholy [14]. His landscape is essentially a man-made one: the evidence of man's detailed and persistent cultivation as hedger, ditcher, sower and ploughman, is everywhere, but it is as though man himself has just left the scene. You do not meet him in the lane or at the corner of the field as you meet villagers in poems of a more benign country by Nash's friend Edmund Blunden. The only figure in the landscape is Nash himself, the viewer, and the degree of introspection implied by the paintings makes the possibility of intrusion by other people almost alarming. It is a tamed landscape and he shows it without interruptions.

There is also his particularly beautiful and poignant way of painting the bare winter fields, and especially snow. There are many winter pictures in his work, probably because his output went up at that time of year: he had been gardening all summer. Deep snow provided the forlorn and bitter setting for his best war painting, *Over the Top*, but he liked it later for other reasons. A light snowfall not only obliterated the too persistent green and returned the landscape serenely to the

colour of his page or canvas, it put a sudden unfamiliar mask on familiar things and produced the change that he otherwise lacked. He liked it for the way it made ridges and banks, branches and furrows, clearer and more orderly, showing the rib-cage of the land. It was a surprise in the morning. On such days he would draw the ponds in his own garden [13], when frost had stopped them rippling, and the frozen puddles on the ploughland beyond.

If it is true that this slight chill had to do with a melancholy side to his nature rather than just with an impulse towards clear design, its origin is likely to be at least partly to do with the war. He had a way of making the banks and ditches of the English landscape into his own no-man's land. His war pictures were painted, with his brother, in a disused herb-drying shed at Chalfont Common, Buckinghamshire; the War Office sent round duckboards, barbed wire and corrugated iron for them to make certain their details were correct. But his own experience of the trenches was so appalling that, when he was able to return to landscape painting, his subjects were the very quietness and vacancy of English farmland, a place where the loudest noise was birdsong or the ticking of crickets. He said that the Tate picture, *The Cornfield*, was painted in 1918 out of amazement at finding himself in the English countryside again and still alive, and perhaps there was something of this in his work for the rest of his life.

A further deep sadness was the death of his only child, a son who rolled out of Nash's borrowed car when five and whose pathetically small grave under forget-me-nots is in Langley churchyard. In the landscape, another absence.

Anyone who knew Nash well will immediately say that he was a convivial man who, all his life, wrote comic letters, but I do not think that the pictures themselves show any sign of this.

It is true that, when he came down after a day in the studio, he wanted to talk and to play the piano and that he liked to see people. They were an antidote to the isolation of the studio and the isolation of the landscape. The last thing he wanted to talk about was painting. His setting in winter was a snug one of fireside and oil lamps (for years Bottengoms had no electricity), of cats and of Christine's needlework. She had given up her painting to look after him.

His ideal day spent drawing in the open included visits to friends. Sketching expeditions, in the early years with Eric Ravilious (he and Ravilious produced some marvellous pictures of Bristol Docks on an expedition there in 1938) and later with Edward Bawden or Carel Weight, certainly did not lack light relief.

The paintings show how widely he travelled, with repeated journeys especially to the Gower Peninsula, Cornwall and Scotland. It was Christine Nash's job to go on forays beforehand to find suitably simple and pleasant old-fashioned hotels where the three of them could relax in the evenings.

Through his mother's family Nash had a glancing connection with that loneliest of men, Edward Lear (Lear had wanted to marry Nash's grandmother), and Nash's own prolific comic drawings, both in letters to the friends he called his 'dear ones' and for book illustrations, are somewhat in Lear's vein. If you wonder where the people, so conspicuously absent from his landscape paintings, have got to, they turn up in humorous predicaments in countless drawings.

I suspect the best clue to Nash's work lies in the connection in his mind between painting and gardening. He once remarked that, if he could choose again, he would be a musician first, a gardener second and a painter third. The rooms at Bottengoms were full of books about flowers and gardening (and fishing) but there were very few about painting. One of his earliest scratchings, which he kept in the studio until his death, was a big ink drawing of his father's garden at Iver Heath, Paul's first familiar subject, complete with cabbages and a pool. In fact, botanically it was not a garden of much interest because it was largely dominated by a croquet lawn, but he always remembered the clump of *Campanula rapunculoides* by the morning-room wall, and the combination of *Eccremocarpus scaber* and Gloire de Dijon which he liked so much that, much later, he grew them running into each other at Bottengoms.

The connection between growing plants and painting is a common one, just as writing and gardening also often go together, or, for that matter, mathematics and music. Each pair provides the clue to a particular cast of mind. Writers tend towards gardening partly because it is a contemplative activity which has to do with time, and which

also involves beautiful words with precise meanings. Painters like it for similar reasons and also, I suspect, because it has to do with imagination, patience, cunning and the element of surprise, with making something of beauty out of the dark, from almost nothing.

Nash shared his passion for gardening with other artists who lived not far from him, with whom he could swop plants, notably Cedric Morris, at Hadleigh, and John Aldridge, at Great Bardfield. All three had deeply romantic gardens but of very different kinds. You might expect colour to be a main preoccupation with painters' gardens, and the blue and copper-purples of his irises certainly found their way into Cedric Morris's palette, but I think, especially in Nash's case, it was chiefly the architectural and structural qualities of plants that attracted him. His landscape had never been concerned with general effects, and for him plants provided the well-grown component parts of his view of the countryside.

Because of this, he was always as likely to be talking to nurserymen as to other landscape painters. From the time that he had his first cottage garden at Meadle on the edge of the Aylesbury Plain, below the Chiltern escarpment, after the First World War, he made careful studies of the plants he grew. A small engraving of a bee orchis, which he sent to Clarence Elliott because he admired his Six Hills Nursery catalogue, led to a long sequence of commissions for botanical illustrations. In 1926 he not only illustrated the Six Hills Nursery catalogue but, with Christine's help, coloured a hundred copies by hand. His wood-engraved illustrations for the book *Poisonous Plants*, with an introduction by him, appeared the following year. The same propensity that led him not to sentimentalize landscape often prompted him to draw plants with a slight frisson about them, a hint of menace, like the hooded labiates, helmeted monkshood and balsam, foxglove and penstemon.

Over the years his method of painting landscape changed hardly at all, though I think it grew technically richer; it was only the seasons that changed. He persisted with beautiful linear shapes and soft colours, a man as unlikely to embellish or falsify anything he saw as he was unable to embellish an anecdote in conversation. At Wormingford, in the churchyard under the big square brick-and-flint tower, there are

tabletombs of members of the Constable family in nests of honey-suckle. The grave of John and Christine Nash, its headstone carved with flowers, is nearby, at the edge of the churchyard. Often he sat a few feet from the place it occupies, just the other side of the hedge, drawing the trees in the strip of woodland facing him, and the field glittering with the curved parallel lines of stubble.

Cedric Morris

How do they work, these connections between gardening and paint-ing? Mark the way this box hedge or these roses have been used to work upon the imagination.

When society is functioning correctly, the garden stands for order, reconciliation and harmony. Outside is a place where the world teems, where nothing may be controlled except by the imagination. When a man has part of the world under his hand, to re-order it as something according to his own nature, it becomes like a painting or a poem. His conscious actions are not at all like the unconscious effects of mists and mountains. The random landscape does not easily yield up its meanings, but the gardener, like the painter, selects, discards and rearranges, revising as he goes. Enclosing part of the landscape, he makes of it his own world.

There is nothing fastidious about this. Anyone who has seen a painter struggling with the tools of his trade, with the voluptuous qualities and good smell of oil paint, knows that it in part answers an unappeased appetite but that it also brings him up all the time against limitations of expression and physical constraints, with which the gardener also works. It is as if each of them were to say: act on a piece of the world with your imagination, alter it by accident or design to express what you feel or what you think you need. And then recognize that, whatever you may have done, and especially if you have worked well, it has a life of its own.

I like to think of the garden as having been treated much like a picture. It has a dominant mood and often a particular colour. Its edges determine to a great extent the build-up of shapes within it. Everything in it can be touched or reached easily by walking – not at

all like the big vista of a landscape – just as you move about within a picture with your eye. The sensation that you have in each, of being enclosed by a firm order and yet at liberty to move about within it, is one of the pleasures of both pictures and gardens. It is an architectural sensation, albeit a roofless one. Views and axes suggest themselves though they can be cut across and still give pleasure. The receiving instrument, the self, is cumbersome in a garden at first, as awkward and distracting a companion as it is in front of a picture or at a concert, but the assault on the senses is so potent that self-consciousness is usually very soon forgotten. Finally, pictures have the difficult virtue of permanence, and there is the knowledge that the garden, which feels so transient, which breathes by night and fades by September, is more lasting in its elements than we are. The frailest of flowers that stares us in the face may have stared back at Pliny.

Now, there is also something head-on about gardening, to do with the need to scrabble in the earth and to know plants from the root up or the seed down. When he was an old man I was able to discuss these ideas with Cedric Morris. He would sit in the barn-like, primitive kitchen of his big old brick house overlooking the River Brett in Suffolk, the place where he gardened and painted uninterrupted, except by his own journeys, and where he ran his school, from 1940. In the 1950s the garden would contain a thousand iris seedlings, many of which he had bred himself and which often took the RHS Iris Show by storm. Here was a painter who gardened furiously and produced shrieking likenesses of people and countryside.

Look at his landscapes. They seem to have been pulled from the earth like vegetables. He was not an intellectual man, in fact I would say that his well-guarded idea was always not to become too sophisticated but to look and paint with as much directness as possible. He saw things from the front. He looked four-square at the swell of a hill and painted it heraldically, as if for an inn sign [15]. He dug in his paint, which was pudgy and clotted, as if digging his borders. He did not, for most of his life, make preliminary drawings: he began in the middle with what interested him most and worked outwards towards the edges until the canvas was wedged tight with shapes. The opacity

of his colour was added to by his old habit of mixing up oxide of zinc and linseed oil in a jar to make his own particularly tacky zinc-white.

Part of the vitality of his landscapes derives from the fact that, in their awkwardness and vigour, they are almost disastrous. But does not good painting often seem to risk being bad? The fact is that paint used as unashamedly as this somehow sticks to the nervous system, by virtue of its strength and generosity of spirit. He was a man who happened to have an intuitive grasp of the nature of things, and painting and gardening seemed to him to be two parts of the same activity.

Mauve and a milky green that he liked in his plants found their way into many of his landscapes, a bruised palette. He liked tall bearded irises for the reason he liked pictures: for their architectural qualities, their look of being strong, sappy and statuesque. He admired them for their ferocity. In the landscape his own plants were his most persistent sitters: the probably now extinct purple-spotted and double forms of the madonna lily; the purple-brown *Arum dioscoridis*; the iris Benton Cordelia, a milky mauve, and the green-splashed white arum, Green Goddess, which was introduced by him from Africa in the 1950s. They all appear in his paintings, often with stretches of landscape or garden visible beyond their stems: flowers painted as part of landscape, part of its architecture [17]. Yuccas he liked, for the same reason, and euphorbias and ferulas. You can see how large their forms are, and how tree-like, when reconstructed in the clotted paint. The countryside seemed to him to be full of stiff vegetable forms. The spectator is left behind like an insect, crawling among them, losing his way in a jungle of stems and only sometimes able to see the countryside as a whole.

If Morris's instinct as a landscape painter was to seek out the big pattern and deposit it resplendently on the canvas, it was an attitude that went through his approach to anything in nature, from irises to the bold patterns on birds' eggs and the bright shapes of generous vegetables. He watched the natural world in much the same spirit that he observed the human comedy. A garden does not need to be thought of as a setting for events. It may be used as a form of theatre: for forty years the garden at Benton End on fine days was full of easels

and students, conversation, al fresco lunches and parties. Like a picture it is in the end its own subject. The same may be said of the landscape.

I remember Morris's fury at the effects of pesticides on the farmland of East Anglia, and how he angrily dedicated a picture of a barren landscape littered with the pathetic corpses of dead birds to a chemical company [16]. The wasteland may be the dominant image of the twentieth century but, in painting and gardening, man's effort and imagination still go over the landscape to make it his sanctuary. The impulse in each case is similar. It is an optimistic one. What results looks transient but is lasting, and is very quiet though it speaks to us most clearly of the joys and sorrows of being human. 'Where man is not, nature is barren' (Blake).

6 The Grid and the Town

Walter Sickert

Suppose it were possible to look at landscape impersonally, to look at it as fact; not to exercise judgement or choice in selecting it, but to square it up and transfer it to canvas precisely because of its ordinariness. This is no view. This is no ideal vantage-point from which to take in the English countryside or an English street. It is composed of random facts: the light catches the corner of a building exactly so, an awning exactly so, a tree because that is the way it happens to stand on one leg, and the accidents of the ground because they exist.

It is haphazard. Haphazard in the way that passions exist; days contain inconsequential events and grand events equally, and *with equal emphasis*. Suppose it were possible to see the landscape without it engendering any particular emotions, and without selection. A grid, like the lines of latitude and longitude on a map which enable you to locate places precisely, can be placed over the landscape and it can be transferred to a picture wholesale, appropriated.

Now suppose a painter were to say to himself: I cannot possibly take on these untreated chunks of landscape by sitting in front of them and painting them direct. They are too variable, too full of detail, too distracting (and probably too apt to work on my feelings). Instead I will draw them and work them up into paintings in the studio, well away from the motif. This will distance me from the subject so that I can make something else of it in the painting.

Imagine the artist doing this for many years and coming to realize that the accidents and incidents that are characteristic of his drawings made on the spot are providing him with almost as much information

to paint as the subject itself. So, finally, he begins to say to himself: I will distance myself from the subject even further by refusing even to draw it. I will use random photographs, snapshots, press-cuttings, in which the poor quality of reproduction begins to make alterations to the original image which interest me increasingly.

The result is that the artist has arrived at a more or less foolproof method of adopting rectangles of information about the arbitrary appearance of the world, which he sees as humdrum and intends to turn into paintings without comment. He hopes to do this by putting to use an almost mechanical method, in which flat shapes can be drawn on the canvas in low tones, allowed to dry, and then added to by scrubbing lighter passages across them until they are recognizable as form.

This artist is Walter Sickert. His method is intended to result in objectivity. He looks at places and people as bald actuality, as having a chief characteristic of extreme ordinariness. Almost any landscape would do, just as any person or any situation would do. He would square them up and paint them equally according to his method. They are all painting fodder. The part of the equation that has been left out so far is Sickert's own nature, and there is nothing at all ordinary about that.

What it comes down to is appetite, a gargantuan, insatiable, avid appetite for the appearance of things and for their transfer into paint.

If the world can be used up in this way, without any conscious attempt to differentiate the significance of its parts, a strange thing begins to happen to landscape. Sickert's subjects were not often without human interest but he was also a lifelong landscape painter of a very particular kind. He was in one way a realist. Virginia Woolf pointed out that he had much in common with nineteenth-century novelists, in particular with Dickens and Turgenev, because he would describe landscape where it was a psychological extension of his characters. He shows it, she said, over the shoulders of the publican.

But consider what happens when he *does* transfer landscape to paint. I am inclined to describe its effect as tangible, a physical sensation like warmth, or the smell of cooking, or an itch. In Sickert, the fact of the

landscape becoming paint is entirely hypnotic. The subject is taken raw, without meaning, the more obvious the better. But as soon as it begins its painstaking and well-prepared method of transfer, Sickert's enormous appetite comes over it. He called this 'a lech for the brush'. Odd corners of the view take on a strange fascination. That Sickert cannot see a shape within a shadow leads him to draw objects and their shadows as one. That he is more often than not working from a black-and-white photograph means that he can introduce more or less arbitrary colour. Most of all, his handling, which is methodical and rational, is immediately subservient to his personality which can barely contain its eagerness to make landscape into new conformations, to fabricate less obvious shapes out of obvious ones, to make sensations in the paint that are both rougher and more improvisatory than the scene could ever have appeared to him in the first place.

When you see a Sickert landscape you want to smell it, touch it, pick it up and carry it about, because often out of very little it has become the delectable and convincing sensation of a piece of the world made into a tangible event. You can see the process of its construction, the way one colour is rubbed across another with a hard brush leaving the ground to 'grin through', as he liked to say. It is as though you can see the strongly improvised drawing making itself felt as it goes, sometimes checked, sometimes banished, sometimes followed through with an effort of imagination. As a painter he could not help himself. Appearances were grist to his mill and he used them up, landscape included, because they presented themselves to him as facts to be transmuted into paint.

The rougher, the more approximate this process becomes as Sickert grows older, the more affecting it is. The photograph has to some extent damaged the image in the first place; then he adds to the quirkiness of the subject, sometimes by drawing it rather over scale on rough canvas as heavy as sacking and in colours which, far from understating its ordinariness or restraint, make it strangely new-found. Liver colour, chocolate, mauve, green. These colours do not so much put you in mind of the countryside or of streets and buildings as of themselves as pure paint, the intense feelings engendered by a brown object, a blue patch, some green dabs, which bear a strong resemblance

to a subject seen but are much more potent as a means of setting up emotions of their own. Paint does this. Sickert's sensibility, using the everyday landscape, has made it emerge as something else.

And now comes the real difference. By taking the random appearance of things and transmuting it into paint, Sickert's personality and touch have enacted in it a transformation. We see it through his temperament. The everyday, chosen and re-done by him, gains significance. The ordinary landscape, the ordinary street seen like any street as though from a bus stop at no particular time of day or time of year, is suddenly recognizable as being significant, as significant in its way as the chosen view, the particular place, the exceptional building. It is not a point of view that, in the normal course of life, is at all easy to grasp: the realization that the world bears down equally on everything and everyone, that the most everyday landscape and the most predictable tree or hill or patch of sky are in some mysterious way grand and tragic and amusing and entirely worthy of celebration.

Test this idea on two bouts of landscape painting by Sickert in and around Bath, twenty years apart. Townscape is a relatively new word, invented by *Architectural Review* in the 1940s, and I think it is justifiable to discuss Sickert's pictures of Bath as landscape. He went there first in 1917, and again right at the end of his life in 1938–42. He died in Bathampton. At once you will rightly say: but Bath is in no sense an ordinary place. There is nothing remotely predictable about it. It is the most beautiful and complete small cathedral city in England. It is true that Sickert admired it as a city very much. 'Bath is *it*,' he wrote. 'There never was such a place for rest and comfort and leisurely work. Such country and *such* town.' But he did not choose it particularly: he went there only because it was impossible any longer for him to work in France. As he told the disbelieving Jacques Blanche, for him one place was quite as good as another. He believed implicitly that no subject, no place, is pictorial in itself, and certainly that nothing is ugly. The painter makes use of any place for his own ends. The point is that Sickert treated Bath very much as if it had no particular distinction, much as he had treated Venice and Dieppe. Beauty, to him, was to be found in any and every aspect of landscape and townscape regardless of place. Nothing is more beautiful than the

commonplace. It is we who benefit from having feelings about Bath, not him.

Summer. In 1917 Sickert took a small house above Camden Crescent in Bath, found a large studio nearby, and began work with a good appetite, using up the surrounding streets. Walk down these streets and into the blackened curving edifice of the Victoria Art Gallery, across the road from the south end of Pulteney Bridge, and ask to look at his picture of the view down Belvedere towards Beechen Cliff [18]. It is a small upright canvas of an exact sentiment and observation. The delectable shade has been scrubbed against its buildings with vigour, and brightness punched into the tops of the trees in dots and blotches with a small blunt brush. The open foreground is brushed over thinly and only in the areas of complication, altercation, with the excitement of incident and fenestration, does the paint build up in successive touches and scrubbings to a bolt of deep drawing so satisfying in relation to the thinner parts that it is difficult to contain one's pleasure. Sickert had been etching a great deal at the beginning of the war, and the vertical mark that was his way of drawing on the plate is discernible everywhere in the picture. He rubs in the cliff and the sky with a characteristic palisade of verticals. That he relishes the bristle of the brush, the give of the canvas and the luxuriance of colour after so much sharp black and white is communicated by his way with it. He might easily be enjoying a good meal. Here is drawing which turns into painting, by accruing information about the positions of things, because of the splendid nature of the painter, his directness as a man.

He had much to go on. Pictures to him, good pictures, were an accumulation of drawing, the facts coming together well and clearly until they stood in relation to each other as a design in their own right, without padding. He liked this process and made no bones about it being one of vicarious experience, more to do with the stomach than the head: 'The nutriment from which this painting results is a form of cribbing. You take the last man's version and turn it from left to right, from dark to light, from male to female, and from comedy to tragedy.'

In Bath, in the summer of 1917, the last man's version was the

architecture. So much shadow and sunlight, moulding and pediment, the delicious black stain on yellow stone which itself is a bold version of light and shade. His impulse always to draw took the form of pushing a blunt brush all over the geometry of architecture, to plot it. The business of blocks and pediments, steps and rustications, crescents and railings, is the stuff of drawing in pictures. Bath consists of arcs and triangles, parallel lines and rectangles, clear wedges of light and shade. Mouldings and shop-front lettering *are* drawing, and the bow fronts of chemists' shops and drapers. The sense of drawing that pursued him was related to that grid I spoke of earlier, the pleasing sense of direction of all lines compared to the vertical or horizontal, the drawing related to the grid implicit in the architecture he saw all round him.

That was the drawing. Colour belonged to full summer and to those intrusions of landscape into the town of the kind that he had liked in Venice: the movement of water under Pulteney Bridge, a patch of blue sky above balustrades, high-summer trees making irregular shapes against regular façades in Camden Crescent, creeper on the bowed end of Mr Sheepshanks's house. Bath is small enough, and in enough of a hollow, that beyond the ends of streets you see the colours of the country; above roofs there are fields and hills and woods with their blue shadows. All this led Sickert to use light underpainting and patches of brighter colour. The yellow of the stone, especially when in deep shadow, and the rich mahogany of old shop-fronts still gave him that range of mud colours in which he had luxuriated in the fish-smelling alleys of Dieppe, but there were patches of pure colour now too, viridian and purple, pink and violet, cobalt and cerulean blue and scrubbed white. He was working from drawings with colour notes on them, words scribbled hastily in to list such things as rust and lilac. Lilac in all its colours, especially with the rich green of its foliage, is typical of Sickert's palette in 1917 when he looked for nature, brightly lit, against the yellow and ochre of the town as though he savoured it. Lilac is, in a secret way, the equivalent colour to sandstone, its opposite and exact complement. And in the freshness of the colour there is the irresistible variation between dry areas, thinly painted, and

the rich glitter of oil in passages where his *camaieu*, as he called it (or crust), is built up to celebrate some particular incident or tone.

True painting, this is, yet retaining a certain restraint, a small scale and smallness of touch that are part of its atmosphere. The qualities he admired in pictures were lavish and economical, restrained and ecstatic, a combination of erudition and instinctive impulse. Bath was ideal for strong intentions and loose handling.

Winter. Twenty years later, when he was old, Sickert's view of Bath was sapped of colour and became almost entirely drawing, almost monochrome. It would be possible to say that, returning to live at St George's Hill House, Bathampton, overlooking the city, he was just sufficiently removed from his old subject to be able to see it as something like an abstraction. To a great extent it had always been the abstraction of Bath that pleased him: the angles, he would say, that the streets and buildings had to the vertical. By the time he came back in 1938 he had been using photographs to paint from for many years and had always reserved the right to colour things as he saw fit. He was dependent now, for the exact topography of the city, on Thérèse Lessore's snapshots. He coloured it in palely in his imagination so as not to interfere with its geometry: pale pink, pale mauve, pale yellow. The colour, like the blood, had mostly drained out of things, leaving them pallid, but the excitement of the unequivocal design remained. The old streets were drawn in, mauvish, liverish, without misplaced sympathy, because the information he had on them, halfway up his hill, was that that was how they stacked their mouldings and stepped their shop-fronts, and for no worse reason. On shaggy canvas he painted them extremely dry, chalky-dry, as if they had dried from the back. A rough surface might do its best to botch the drawing but would only succeed in giving it nap and bite, the grossness that denies too fastidious a sentiment and keeps it on the track of life.

It looks peremptory, this last work. Many people have been distrustful of it. Art historians and dealers on the whole do not like it, and artists do, which is a good indication of its excellence. To enjoy it you must abandon yourself to the trustworthy but unpredictable character of Sickert, as you might to a favourite uncle, and be ready to take the

rough with the smooth, forfeiting all notions of taste. A great artist at the end of his career can take unexpected directions and push out successes and failures with about equal enthusiasm because there is something about each that satisfies him. There is no longer any safe ground. Too much is known for that.

From the small black-and-white snapshots, he redid Bladud Buildings, Belmont [19], the Vineyards, Abbey Yard, the Paragon. He would make his way down into the town and be brought back in a taxi, confused, but the shapes he plotted out from photographs, the lines of the streets, their stone geometry, were categorical. Anything may be pressed into the service of picture-making and the streets need not have been as beautiful as they are. He was not painting feelings but the position of one window, merely, in relation to others.

He also painted his own house and garden, and the view from his window to the hills. His landscape had a touching ally in his old enthusiasm for documenting his own life. He lived palely in an almost colourless house, pale stone outside, plaster and high ceilings inside. It is a cold house in winter, with snowdrops hanging their heads under shrubs in the garden, and the view lacks the warmth of honey-coloured stone lower down the hill and in the town. It is slightly remote, more plaster than stone, made up of big regular shapes, rectangles in the empty rooms, in the large sash windows, the porch, the pictures, in the garden terrace, in the path and rosebeds. The place provided plane geometry, with only the cross-hatching of trellises on the outside walls. Cecil Beaton must have come just in time, and climbed a step-ladder, to take the famous photograph of Sickert standing as an invalid bear in a rough suit on the path outside the kitchen window. I describe all this because the house is very like the pictures, and the pictures need to be seen.

Nature does not pose (Millet). Sickert's last landscape, perhaps unfinished, is the view from his windows at Bathampton, through the line of trees at the foot of his garden to the hills north of the city [VII]. By putting a line around the woods and linked escarpments he reduced the scene to a sequence of fret-shapes which he chose to colour pink, mauve and yellow, as though the deep vista were an architectural plan on a rough surface. It is. Like the last townscapes, like any good

picture, it is a form of abstract. As Sickert himself would say: 'The real subject of the picture is the plastic facts it succeeds in expressing. If the subject of a picture could be stated in words, *there had been no need to paint it.*'

The poetry comes afterwards. If Sickert's contribution ended here, as that of a painter whose work was cut out observing and recording, these would be no more than excellent pictures full of rough brushing and quirky shapes. But something happened towards the end of his process that was self-revelatory. Somehow limitations became the release of feeling. It is unmistakable in the pictures. It has to do with his nature, his temperament, which was robust and racy. For all that he intended netting the raw facts and sparing us the luxury of his feelings, we find awakened in ourselves an interest in his subjects which is deeply subjective. I suppose that this has to do with memory.

There is a sense in which places, accurately observed at the time, seem to have been remembered. You say to yourself: I see this place now as I shall remember it in future. But there is also the quite distinct feeling that we are permanently screened off from things by the limitations of our perceptions, and that we shall really only know them as memories. The complete aesthetic experience of a place comes later, often much later, as a realization. It is as though the experience is incomplete unless seen from a distance. Virginia Woolf expresses this exactly when she says: 'The past is beautiful because one never realizes an emotion at the time. It expands later; and thus we don't have complete emotions about the present, only about the past.'

The everydayness of Sickert's town subjects puts me strongly in the frame of mind of remembered places and remembered days. I value these streets. What I remember about them is not the particular distinction of the architecture but what it is like to walk under a dark shop-awning or cross a road from shadow into light, where light and shade fall across everything with equanimity, deriving from a time when I thought all streets were this broad, that all pavements were this wide, and that all shop-fronts/façades/stone steps were this generous, this colour on this particular afternoon. The sensations, which I hardly thought particular enough to be committed consciously to memory at

the time, turn out to be embodied with the most moving exactness in the pictures. Only much later do I realize their consequence. These streets, painted without licence or discretion, turn out, because of my kinship with Sickert's humanity, to be parts of me. How do the scrubbed lines and chocolate shadows encapsulate the exceptional place and the unforgettable day? How do those last pallid streets and yellowish hills belong to a time when you and some town, some hill, were younger and days did not so easily end? Stamp your foot and feel the hard stone, the hard sunlight on the pavement, of Sickert's place. No wonder your present puts you out of joint with such a solid past and makes you long for it as though at the time it was only half-realized. Are you not a little out of step with your essential self?

7 Seeing Becomes Feeling

William Townsend

To look steadily. In the early summer of 1950, William Townsend put a small sketchbook in his pocket and bicycled round the hop gardens in his part of Kent and Sussex, drawing them. The weather was hot, and the whole business of hops, with their shady avenues of romantic swags (the bines) and the late summer five-week bacchanal when Cockneys came down for hop-picking, was full of associations. Townsend did not want that. This was May and June; the scribble of growth was not yet far up, and the fields were still in their classical state of long colonnades of poles and a yellow cat's-cradle of new hemp stringing. The stringing was tight, making straight lines and geometrical figures. These gardens are all gone now.

Now Townsend had a reticent manner and his idea at the time was to scrutinize his surroundings with absolute care. All temperament was to be subdued by looking. He sat against the hedge and drew the stringing. It was the stringing that interested him. He saw that there were five distinct systems of stringing, each slightly different from the others, and he drew the patterns they made against the blue sky, methodically noting down each of the five types as they looked from the front of the aisles, from the side, and from an oblique view across the gardens at 45 degrees.

Not long before, he had completed a big, studiously observant picture of the interior of Canterbury Cathedral, his only major picture to date. By this time he was forty. He had sat, in comparative gloom, high up in the east transept of the cathedral and, with much measuring and study, worked out the downward view of the crossing at the

chancel. The picture was solemn and controlled, but because it involved such scrutiny of the columns and arches, squinches and spandrels, and their exact relationships to each other, it had given him many weeks of pleasure. Now that he was transferring his attention from stone architectural bulk to the linear string architecture of the hop gardens, their aisles in bright sunlight, he felt the same profound satisfaction. The cathedral had become a subject that he practised painting with as much objectivity as he could muster, though he had strong feelings about it. He had drawn it full of sandbags and other ARP clutter in 1939/40, but that had not stopped him painting it later as a clear and beautiful object, with no evidence of his own emotion in the way he treated it. His idea was to approach the hop gardens in the same way [20].

To look steadily is in itself a profound pleasure. He wanted to make his pictures out of firmly observed shapes, that did not wobble or fade out, and to do this he had to use his eyes in the landscape and not generalize. Looking can be a form of worship and also an exact science. The great thing is to be able to look correctly and with attention, with as much objectivity as possible. This is not only pleasurable as a contemplative process but it also provides the basis for feeling. This may seem obvious, but think how much landscape painting is done from exactly the opposite point of view; a cloud the colour of self-absorption goes over the sun, making it impossible to see anything at all clearly. A landscape coiled and racked by subjectivity has no meaning except as a shattered and imprecise expression of the storms of the psyche. It has no meaning of its own. It can be lit up by the lightning of a jagged insight, but only momentarily. Have you never leaned from an upstairs window and seen a storm at night among mountains? First thing next day you go to investigate objects only glimpsed in a white flicker, to look at them steadily as though you never saw them before or had forgotten them. Aristotle suggested that perfect happiness is 'some sort of energy of contemplation', and a considered scrutiny of the natural world produces exactly this. Knowing how to see, how to approach the whole business of seeing, without prejudice or theory or self-consciousness, can be the very basis on which to feel. To look at landscape is to exercise the same

perceptiveness as looking at pictures. Accurate observation arouses the imagination. To have these feelings, you do not observe the countryside in a generalized and imprecise way; you study it.

There come times with many painters when they suspect that what they are doing is unacceptably arbitrary, too much subject to chance, and too soon over. When you are dealing with feelings via something that depends on sight, subjectivity can sometimes threaten to get out of control. Sight in some way ought to equal insight. I can remember Townsend's friend William Coldstream saying that, when doing his best to produce entirely abstract pictures in 1934, he had thought an abstract painting was going well until he recognized in it a hen and three chicks. It is not surprising that painters, especially landscape painters, want sometimes to start again from what they see, as though to exert too much will on something as lovely and as intricate as the English landscape is inappropriate and insensitive, or at least not at all in accord with their senses. When Townsend and Coldstream, among others, decided to go back to the landscape and paint it as observantly as possible, they were determined that there should be no gestures, no un-thought-out responses, no excursions into reactions to paint alone, no whimsy, no liberties.

Claude Rogers also thought this, but with the difference that if something moved he liked to fix it. He saw the Euston Road landscape crackle into life with stubble burning, and painted a series of pictures of it, upwind, downwind, with the rim of flames on a hillcrest, as though trying to understand its logic. How does a screen of heat fold and collapse the landscape beyond it? Is it possible accurately to judge distance through smoke? Rogers was a notoriously forgetful man whose inclination, perhaps because of that, was to do his best to establish things exactly. But when there was a slow and steady movement to be observed, like the total eclipse of the moon which he saw in 1951, his efforts to record it resulted in pictures of pure poetry [21].

Townsend's landscapes were still. From boyhood, he had studied the Weald in detail, learning the derivations of its place-names, its architecture and archaeology, its birds and weather. He had made lists. When he came to paint it, he did not lavish his feelings on it but

continued to gather exact, almost scientific, information in his pictures. This may sound dull, but correct observation is in itself a sensuous pleasure. The realization that much in the landscape was beautifully composed naturally, far more beautifully ordered than he could ever re-order it in a picture, led him to make faithful statements about it from which he suspected the senses would derive as much pleasure, the imagination as much stimulus, as they did from the landscape itself.

I do not mean by this that he wanted merely to mimic what he saw. It was May and June and he had, as he bicycled about, the whole of a newly deep landscape at his disposal. The lanes were hidden in cow-parsley and the fields under buttercups; the may was out and the yellow flags in the ditches; the hedges were already lolling with dog roses. Although he enjoyed them, he went past them all and concentrated instead on the ascetic, almost colourless designs of the stringing.

Why? I think it was because the pleasure he derived from it was its structure, which was the same pleasure he derived from paintings, and from the process of painting.

It is worth trying to explain how this way of treating landscape with absolute truth could result in pictures that are, in their way, strongly abstract. It has to do with a process that is almost as systematic as scanning and plotting electronically on a screen. The position of one object in relation to all others in the view is repeatedly gauged and noted, as though the eye, tracking across first the landscape and then the canvas, measures off and deposits pieces of information about the relative positions of things, calibrating them until a complete and exact image is built up in a series of patient touches of paint. Especially in later life, this certainly became Coldstream's method, and although Townsend did not work in such a systematic way his principle of patient scrutiny was similar. He told me that painting a view in the Weald was like going for a walk in it, from one point to the next, often pausing to verify something or to make something out. You know a cube is a cube without ever being able to see its six faces at any one time: you study the ones you can see from several sides and collate the information to build up an exact idea of the whole shape. Often he would break off painting and go to do exactly this, moving

about in the view until he understood the distances between one thing and another, or the way in which, from his vantage-point, one thing was masked by another. Only when he had found this out could he set it down in paint.

The satisfactions of this analytic method were not only those of trying to approach the landscape with the objectivity of a scientist rather than the subjectivity of a poet, as Ruskin suggested you should look at a flower. The marks building up on the canvas gave a deep pleasure of their own. They derived from what he could see, they had an external logic to them, but as the painting progressed they began to set up a delicious web of marks of their own on the flat surface, something entirely satisfying in its own right as an abstract arrangement. I think this is why he chose subjects from a lush landscape that were essentially rather spare, and which would lend themselves to clear architectural systems.

Is that not one way in which the landscape pleases? We love it for its structures, whether man-made like hop stringing and ecclesiastical architecture, or dependent for their strength and survival on their structure like any plant, tree or hill. See this accurately and set it down patiently, as clearly as possible, and a strange thing happens. Far from showing only the surface of things, as you might think, such objective foraging seems to get some way to the warm centre of them. It stirs the imagination in the same way that the landscape does itself. Feeling flows naturally after observation. And, as well as that, in a good painter, it will produce pictures that are firm and evocative in their own right as abstract arrangements. This, too, produces its response. As he sat there making his hop stringing drawings in red lines and blue, like an electrical wiring diagram, the better to track down the exact route through the apparent chaos of a particular string, it must have occurred to Townsend that if he needed a pretext to paint entirely abstract pictures that happened to derive from a scrupulous transcription of the landscape, then this was it.

8 The Sea

Joan Eardley at Catterline

The sea, the sea. Baudelaire thought of it as landscape in perpetual movement. To paint the sea convincingly is a near impossibility. It has to be experienced. Like snow on the land, its essential nature simply may not be painted. With snow it is silence: with the sea it is movement. There is the calm, too. 'It is a mild, mild wind,' Ahab tells Starbuck, looking at the flat ocean, 'and a mild looking meadow' (*Moby Dick*). But the power of the sea over the imagination derives from its enormous bulk, weight, volume and depth being hugely in motion. There are certain rare kinds of mentality which recognize an innate emotional connection between sea and paint, between the changeableness of mass and the ambiguity of paint, between what it is like to confront the illimitable motion of the sea and to imply volume and movement in broad, running paint through the risked gesture to such an extent that the spray is in the pigment and the racket of the waves and wind have inexplicably entered its sentiment.

Glasgow, weatherless except for the drizzle of soot on stone. The smell of the brewery. A room, which had been a ramshackle photographer's studio, at 204 St James's Road. It was above a corner shop, in the Townhead slums, an older part of the city than the Gorbals, demolished now. It was a small room in which to paint, visited with never-ending curiosity by the six boys and six cross-eyed girls of the Samson family who lived across the passage. In this place during the early 1950s Joan Eardley worked under the difficulty that she preferred. Out of the apparent confusion of the surface of indoor life, a storm

of paper, paint, graffiti, newspapers, torn posters and bills, old clothes, tins and cartons, she could make pictures that had some meaning for her.

She was in her early thirties, large, reticent and with a forceful but ambiguous air of independence and depth. This did not in the least deter the slum children who became her natural subjects. She had been born in Sussex, in the comfortable south in a comfortable house, and yet the drawings she brought back to the Glasgow School of Art from her travelling scholarship in France and Italy in 1948 had shown a concern for the over-worked and socially deprived that had as much to do with feeling as with composition. She liked Townhead. She was a curiosity there but she was also a working woman like any other. From its squalor she could make something humane, and her paintings and drawings of it have its accumulated surface of life that has been sick on the corner and sick again on the stairs on the way up. It was, for all its intensity, a shut-in kind of painting, where the figures stood up close to her because of the smallness of the room, and even the non-weather of the streets is excluded, muffled.

But there was a place in the open that had begun to work on her imagination. In 1950, while convalescing at Stonehaven, in Aberdeenshire, she had been taken by a friend to visit the fishing village of Catterline 3 miles to the south. Increasingly, she began going there to paint out of doors. She would leave Glasgow for Catterline, especially when she heard on the wireless that the weather would be bad and the sea rough.

Through farmland the railway goes along the ragged east coast northwards from Dundee, sometimes only a few yards from the drop to the shore. She would get out at deserted Stonehaven and, using a bicycle or an old Lambretta scooter, double back south through the fields to Catterline. It is a tiny place, two rows of single-storey stone cottages built along the top of a grassy cliff. Below this, a long way below, the semi-circle of a diminutive natural harbour with a short stone jetty, wedge-shaped, pointing across the bay. On its north side the bay is guarded inadequately against the weather by a natural breakwater of black rocks, one larger and blacker than the others, like an upended loaf, which are constantly run over and around by

the white surf. It would be wrong to describe it as a picturesque place. In rough weather, when the huge seas are grey and the sky is black and the cottages lean in a narrow line of stone as though flattened along the cliff edge, the wind is suffocating, twitching the short grass quickly this way and that to show the purple-red earth in its parting, and cutting the tops off gigantic breakers to disperse them as spindrift indiscernible from the hail blown in the air and on to the sea.

Dread is a desire for what one fears (Kierkegaard). Perhaps Joan Eardley feared it, the enormous motion of the sea which was to become her true subject, because at first she did not approach it closely but watched it instead from above, skirting the cliffs as if to find the best way eventually to creep down to it. She lived and worked facing directly out to the centre of the bay, then on its north edge, then on its south. If you did not know this, you could easily discover it from the paintings. The Creel Inn, the only public place in the village, where she put up on her first prolonged visits, is tacked on to the row of cottages with its back to the fields, looking straight out to sea. Before long, when sure that Catterline suited her imagination exactly, she began to use the derelict coastguard cottage, called the Watch House, that stands by itself with a black tarred conservatory and a small patch of vegetable garden above the cliff to the north; but, painting outside it, she must have found that there was sometimes too much sea-brightness in her eyes when she looked down the coast southwards, past the distant lighthouse, so she moved round to the last of the upward-tilting row of cottages with its back to the light on the far side of the harbour, the cottage nearest to the sea.

From this constantly battered and buffeted vantage-point she produced her best pictures of Catterline Bay seen from above. Whenever possible, despite the wind, she worked outside on the narrow ledge of path between the cottage and the cliff, to the edge of which the little vertical shed of the cottage privy, like a displaced green bathing-machine, clung as if by a miracle. Despite the risks she took in the paint, and the way in which she was able to gather the whole view up into the eye of the weather, you can see that she depended on orderly drawing and exact observation of the rocks and quay as they were spread out below her.

Winter Sea IV, painted from outside the cottage in 1958, is a good example [22]. It is almost entirely grey. The grey swell in the harbour is interrupted by the smudged black and white patterns of spray and rocks before the big horizontal brushmarks of the open sea dribbled into by an equally grey sky. But in all the gesturing and driving of paint you can clearly make out the boat-shed with the pitch-black doors, the wedge-shaped quay, the gable of the fisherman's shed called the Bothy against the side of Brandy Hill, the little dashed-in form of the Watch House studio, the vertical marks where the reddish-purple earth of the cliff has collapsed downwards in funnels to the shore, the clean arc of a high tide and, towards the top, a patch of stifled cerulean above the cliff that might have been Mr Stevens's winter cabbages in the field beyond the village to the north.

On fine days when she was there in the summer, she seems rather to have lost interest in the sea. It hardly moved, so she turned her attention to the farmland behind the cottages. If there was a breeze, at least the corn moved. She would paint its undulations instead, standing or lying her boards in the long grass. Seeds and stems lodged themselves in the paint as she worked and were not always wiped off. Using broad side-swipes of yellow, red and burnt umber, she drew and re-drew the swaying of the summer landscape as though sunk in its motion, sometimes scrubbing or scratching vigorously with the butt of the brush to suggest the vertical emphasis of stems, sometimes staring like an insect directly into the red of a late sun at harvest. The results are not romantic pictures of ripe, high-summer landscapes; they are hard-fought, near-abstract paintings which depend on a struggle of sensibilities in the paint, and they are of fields in which she had to work as a farm labourer, usually hoeing or digging potatoes, to earn money so that she could go on painting. Neither at Catterline nor in Glasgow did her life ever approach the idyllic.

And gradually, as if tempted, she painted her way down the grass cliffs to the sea. Her favourite painting place, by the winter of 1959–60, was on the ledge that runs back from the boathouse, just above the beach, northwards towards the rocks. From here, her old studio and the row of other cottages was no more than a stone line against the horizon. Now, instead of only looking down, she could

look through things: between masts and hulls, and more especially through the black and brown swags of fishing nets strung up on poles to dry. She began to use a wider format in which long horizontals are cut boldly across by verticals, especially by masts and posts at intervals in the foreground. The painting kept in the Creel Inn in memory of her, of red-brown nets extending like a screen towards both sides of the painting, is like that. These pictures used sometimes to be left propped for days, anchored against the wind by stones, beside the Bothy, just out of reach of the sea. They were not there simply to dry but, as she explained, somehow to absorb the atmosphere of the place, to become physically part of it, and to get grit, grass and spray in the paint. It was as though, like her, they had somehow to take on the weather. Her handling became broader and more urgent.

In the end there was only the sea. At last she turned and looked straight out at it from the beach. The rougher the day the better. In pictures like *The Wave* [23] and *High Tide: A Winter Afternoon*, which is 8 feet long, there is big, grey, horizontal brush-drawing of the most muscular kind. No horizon. A swell seems to be coming over the long brushmark that is the jetty wall. The dark lower half of the picture is full of re-drawing and covered in spatters and bits. Paint has hit and run down the jetty like spume. Plugged into the pigment are the wide marks that are beached boats drawn quickly and accurately, on impulse, with the delicious black and glutinous green/blue of what seems to be boat paint; boat numbers are scribbled on to the hulls with the same frisson of excitement she produced with graffiti in her pictures of the Samson children. The Glasgow paintings, apparently, had been a static, weatherless storm. Their paint, especially the white passages smoothed out, cancelled and written over, were recognizably the same: but now the paint itself had become almost entirely weather. Pigment and spray, depth and mass, stirred together, lashed and spun away, had become inseparable through an effort of imagination.

To paint these big wave pictures repeatedly, she tied her boards to rocks and posts on the beach. A large woman, in high excitement, wearing army-surplus clothes against the weather, it was as if she

would paint her way right into the sea. It is in the nature of man to want to stand in the middle of things.

When Joan Eardley was forty-two, cancer spread suddenly up into her head, making her blind. What she most dreaded was to be moved away from Catterline for treatment. When she died, her ashes were scattered on Catterline beach, into the wind. I doubt if you will find better sea pictures than hers.

9 Inlets and Estuaries

Graham Sutherland

Here are two aspects of the work of Graham Sutherland embodied by two different stretches of Pembrokeshire countryside. They are close, in each case, but quite distinct. What separates them chiefly is not distance but time. In his work they are more than twenty years apart. I hope when I discuss the pictures that you may be able to visualize the landscape too, and vice versa, because tangled up in the nerves and brambles of the landscape, and twisted into the shape of thoughts, is the crab's claw of his idea.

He could not see it at first. Artists do not think in concepts and he was stuck almost as soon as he had begun. He came first to Wales in 1934. He was over thirty by then but had done very little painting. He returned the next summer and the next; instead of drawing he seems mostly to have walked, and looked. He stayed at Solva and near St David's, to the north of St Bride's Bay. Until 1931 he had etched a great deal. His state of mind had been different from other pastoral etchers. Etching deeper into the plate, finding more blackness, was like walking into a wood. Trees, fungoid, were no longer picturesque but malevolent. He had started by etching whole landscapes but came increasingly to focus on individual objects: shapes had begun to detach themselves from the surrounding country and set themselves apart as if to draw attention to their oddness. Anything isolated just a little accrues force. The etchings had become a darkened path on the way to a state of mind. Does an artist bring his idea to an unfamiliar landscape, or does the place itself generate the idea?

When the Welsh drawings eventually began to materialize, they

looked chancy. They are tangled, nervous, experimental, on small slips of paper. Black ink and gouache have been scratched about in them on pauses during his walks, in the hope of getting at the truth. A picture is between a thought and a thing. He knew from the beginning that the Welsh landscape concealed something crucial to his imagination, or he would not have kept returning to it, but as he walked about he must have begun to despair of ever seeing what it was. So have I loitered my life away (Hazlitt).

Graham Sutherland had been converted to Catholicism in 1926 and was alert to new encounters. Those first drawings are rough and improvisatory, as if he was having to push through an obscuring blindness. I think it is reasonable to suggest that he had a religious instinct in the landscape. To begin with, he accepted doubt and gambled with his feelings. His encounters among natural objects were passionate and ambiguous. Fortunately, as reality does not depend on the quantity of anything, these small jottings convey more than the very large pictures he painted later. He began in a country of curious scale and of little inlets.

It is the lanes he must have noticed first. The lanes that lead up to Clegyr-Boia and down to Porthclais can have altered hardly at all since 1934. All vegetation turns over them. From the top of the buried stone walls on either side, the plants launch themselves: gorse, brambles, thrift, periwinkles, moss, grasses, ragged robin, thorn. Thorn and gorse crouch, miming their postures in high winds even on the stillest summer day. Often the gorse dies and blackens into snake-shapes or crucifix-shapes left standing on the tops of the walls. An arc of dead bramble can enclose a view. As you walk, the effect of sunken lanes is to hold up individual plants or branches at eye level, exhibiting them in an emblematic or heraldic way in front of the view. Thorniness thrusts itself at your eyes from the overgrown walls; it is at the forks of small white lanes and on paths that run parallel to hidden streams down to the sea.

He noted the thorniness in rapid penmarks and carried it away in his head. Much later, thorns would become a quotable metaphor for the damaged Christ: crucifixions, too, stand slightly apart in open ground, like the stranded gorse. The fragments of vegetation he

stopped to draw now on Welsh paths would be superseded in ten or twelve years, after the war, by pieces of yellow palm blown down by the mistral, and by jagged flotsam at Menton. The tangle that arched over Welsh lanes would become vine pergolas; as yet Sutherland had not lost his innocence.

The Pembrokeshire coast was full of hidden and half-hidden images. The inlets were invisible at first. The undulating land conceals them in its labyrinths of undergrowth. You come upon them suddenly. There is no clue to them from above. Most extend only a few yards in from the coast, broad enough at their seaward end for half a dozen small boats to moor there, sometimes with the additional protection of a diminutive sea wall. The blue inlets lead quickly up to mud and the dark thickets of overhanging banks, secret places where the saints could land. So abrupt are these declivities that you can stand near the bed of a stream and see the heads of cattle poking through the tops of trees on the little cliff above. It is then that you begin to realize how the small scale of the inlets is a clue to the scale of the land as a whole.

Scale is a mysterious element in all this. The drawings themselves are very small and yet they seem often to suggest an extensive landscape. One effect of drawing isolated roots and stones is greatly to increase their apparent size. It is one of the first indications that they ape much larger forms. The stone becomes the rock becomes the mountain. And yet there are other ways in which the countryside in the vicinity of St Bride's Bay adds to the ambiguity. Much of the land is rough ground, bog and sedges, rich in wild flowers and birds, with wet patches where the gorse has died back to leave miniature forests of black bones. Sometimes, at the centres of fields there are standing stones. Mostly they are slivers of rock, more like sharp, planted spearheads than columns or cairns, but they are the archetypes of Sutherland's parts of landscape separated off, objects made to seem oddly significant by their isolation.

Looking across this ground you see that it is dominated by knots of rocky muscle, strong rocky outcrops. The eye tends to move in their direction, and so do the white lanes which have always wound up to them because often they were the sites of ancient settlements.

The outcrops are visible from a long way off and have the profiles of mountains: but if you begin to walk towards them they come suddenly, abruptly, closer. They are only a few feet high. With the light behind them, or the setting sun squeezed between them [25], they can lower and loom as impressively as alps, but like the monster cattle in the tops of the trees they are working a trick of scale. In this strange place, a figure running on a distant lane is gigantic among the miniature mountains and diminutive roads. The skull of an animal set on the ground can dominate hills. The sun itself is swollen to enormous size by comparison with the little hills.

Save for that running figure in the near but apparent distance of an oil painting showing the entrance to Porthclaith [11], the landscape is left to loom on the tiny pages of the sketchbooks without being cut down to size by reference to humans. The hills, in reality very small, by the inlet at Solva are allowed to flex their muscles in the imagination. But even writing of them in that way admits the possibility that the landscape is at least partly anthropomorphic. Words are the thought, but the drawings are the image of the thought. When Sutherland drew a root or a fallen branch he began to turn it round and draw it almost from end on, as though foreshortening somehow both increased its drama and the sense of its analogy with the human body. The root was not only like the tree, it was like the figure. (In Moore, the bone became the figure became the cliff or range of hills.) Scale, already peculiar in the Pembrokeshire landscape, added to Sutherland's sensation that he was discovering himself. He wrote at the time that he felt the earth was as much a part of himself as his own features. Much later, when he began to paint portraits, he deliberately made no distinction between the bony outcrops of Somerset Maugham's arrogant snapping-turtle face and the landscape drawings he made of the individual features.

I do not think, though, that this aspect of landscape should be just a question of appearances. Despite his preoccupation with bits and pieces of Pembrokeshire countryside, the prickled sea-urchin and the stick of gorse on the wall, he was living off all his senses, risking the chance to paraphrase, not to transcribe, which is one difference between poetry and prose. It must have been why he found it so

difficult to begin, and why he continued with thorny, experimental drawings in Pembrokeshire every summer until the war. The real analogy the country suggested was not with the body but with the spirit. He explored the lanes on paper and in his head. Dylan Thomas, who was living no distance away at Laugharne by 1938, in his torrent of words knew the same thing: that the landscape was a labyrinth of nerves, that the mandrake is somehow warmed to blood temperature by the sun, and that time is told better by the surge and fester of vegetable decay than by the clock: 'the slug's a living calendar of days'.

Where Dylan Thomas's imagery was spray-based and tide-threaded, Sutherland did a most unobvious thing by turning his back on the sea. The coast is the most conspicuous aspect of this landscape, but he drew looking inland from inlets and estuaries. Blood and sun which light up Thomas's country also came bursting into Sutherland's. The legacy of black from his etchings, which became ink in the drawings, is superseded at intervals by flares of colour. It is far from being natural colour. Shadows that lie across undulating land near Rhosson are drawn as crab claws of sharp cerulean. The interiors of woods ignite in an incendiary green, a green not of the wood but of the aquarium mind. A pulsing red belongs not so much to the sun as to the whole landscape: mountains dipped in dye.

In war, explosions, street fires and furnaces would shortly present him with the same colours uninvited. The drama he had seen in broken trees was awaiting him in crumpled girders and shattered buildings. White figures would be rootlets in the inferno. The imagery he had eventually unearthed in Pembrokeshire was sufficiently part of himself by 1940 that, wherever he went, it would have its further applications. In the process, it grew bigger, more dogmatic. The ambiguities of scale, the paradoxes of the little inlets, must have begun to seem far away and long ago as he continued his work after the war in the international brilliance of the Midi, with Picasso along the coast, both literally and metaphorically. And just when those tentative beginnings might have been forgotten, he went back to Wales: not to the inlets this time, but to the Cleddau and its estuaries, further south and

twenty-five years later. This was to be the second of his Pembrokeshire landscapes, and I think it represents an entirely different state of mind.

What he saw in Pembrokeshire when he came back was a lexicon of writhing forms, rank with mythology and pre-history, which were so closely related in his imagination that they physically interlocked. The landscape had begun in his head, sprouted from it, but see what happened when he became almost all head later. The land became his skull, the dome or engine on the beach; an unidentifiable mechanical and natural history exhibit left by the tide on a shelf.

Consider the whole business of estuaries. Two of them provided almost all the imagery for his pictures in the 1970s. Those inlets he had drawn earlier were small segments of sea spliced into the land and forgotten. Estuaries are not the same thing at all. They are neither one thing nor the other. They are full of the call of seabirds and of woodbirds. Their smells are of seaweed, beached crabs and mud, but also of wild flowers, woods, cornfields and manure. Above all they differ from inlets in the way they spread themselves. With their extensive mudflats through which the last of the river snakes at low tide, leisurely making and un-making ox-bows, they are bigger, more conspicuous, not secret.

Scale again. By the time he returned to Pembrokeshire in 1967 he was used to thinking and working on a large scale. He was no longer feeling his way. He had invented a method and arrived at an iconography. Welsh landscape in the past had made him uneasy. It was a place of disquiet. Suns which had bitten, spiked, into the edges of sacred dark in his earliest Kentish woods and hop gardens had come to stand over strange Welsh hills and divided lanes. There was no call, any longer, to divine that with his previous fierce delicacy on a small scale. For one thing he would run the risk of repeating himself. The uneasy pricking of Welsh thorns and Welsh ambiguities of scale had first prompted his language, but since then his imagination had thrown up a battery of hard, bony forms. He returned to look at Wales in the knowledge that this time the landscape was a potent source of images that could be animal, vegetable and mineral simultaneously. He knew from experience that it must be possible to make these images parts

of each other, even within the same shape, and long ago he had learned how to set the shape apart, like the standing stones, to give it force.

As he wandered the estuaries, he began to think of ways of engineering together the diverse parts of what he saw. The expression 'think of' is difficult in this context. Thought exists first independently of words, unarticulated. The kind of thought that goes into, and out of, paintings and music is unarticulated. The effect of words is to delay it long enough to form it into concepts, inevitably altering it in the process. That is one reason why pictures are impossible to write about correctly. The difference between Sutherland's thought in Wales in 1938 and 1968 is that in the first case he was sensing a mystery and in the second he was digging up its bones for conclusive proof. The church does this with the tombs of saints. He located the bones and began to find ways in which he could engineer topographical, botanical and even architectural forms into an anthropomorphic clinch.

They are strange things, the engines of nature he invented as a result of this process [26]. It is possible to see exactly where and what they derived from. Like Thoreau, he would walk miles to keep an appointment with a particular tree.

His first estuary is predominantly red. Where the tide has undermined the shore, the red sandstone makes a low-browed, overhanging cliff, like a breaking wave. The sandstone is dark when wet, almost pink when dry. Nearer the river, the rocks are stockinged with a thin deposit of closely-fitting green weed, like cloth, which looks unnaturally acid against the stone. The broad mud banks through which the river coils are so masked with this weed that, seen from estuary level, boats at low tide seem to be lolling on mown lawns. The narrow lanes that lead down to this place, called Sandy Haven, are banked with wild flowers and accompanied by clear streams in which you can see the red stones and shingle at the bottom of pools. Above the shore was a pair of cottages and a small pub, called The Sloop. *Entrance to a Lane* derived from here. The woods through which the lanes run stand along the edge of the low cliff. They harbour such a quantity of deep green shade, such webbed darkness that, while one bank of the estuary lies in the sun, the other seems almost black.

The drawings for *Entrance to a Lane*, in 1939, still showed a thorny,

knit-up world, the world of Dylan Thomas's sparrows wrangling in hedges, and the rocking alphabet. In this later imagery, the torrent seems to stop. The poet's place of pebbles in holy streams, the full-tilt river, the minnows wreathing round their prayer, lock up. Earth, rock, bone, hill, for all their linked shapes, are static. That men, animals and the vegetable kingdom are inseparable, interdependent and subject to the same laws is self-evident. What is original, in the way that he treats this idea, is the extent to which all things are shown to be subject to the despairing principle of birth and decay common to the natural world. Each goes down to its death with its arms about the others. Sutherland bolts them together, trusses them with shared rhythms. It is not so much a poetic response to landscape as a cast of mind born out by it.

The second estuary, this time that of the eastern Cleddau, near Picton, is wider, more expansive still. Its colours are yellow and grey. The desert of wet mud is patterned by the tide and then pricked out with tiny vortexes and asterisks in the form of wormcasts and the footprints of birds. There is a broad shore on which rocks lie bound by bladderwrack. A ferrous stream comes up in the grass and flows away. The place is open, idle, empty, as if nothing was ever here.

The cliff stands 10 or 12 feet high, with oblique yellow-ochre strata, sometimes cracked in such a way that it resembles building stone in courses, but this time it is undercut dramatically. Its overhang is cantilevered 5 or 6 feet in places, prevented from collapsing by the mesh of rootlets from the trees above, which reinforce its flat ceiling. They are oak trees, scrub oaks some of them, which struggle for a foothold on the edge of the cliff like the front row of a crowd on the brink of a chasm.

Some send their writhing roots across the cliff in an attempt to grip air. Others try to rest the elbows of their enormous branches on the eroding shore, the bark of their sleeves rolled up by the tide to reveal weather-bleached flesh. The absence of anything to grasp, or the loss of old grips, has left them as no more than frantic gestures, some corkscrewed, some zigzag. Their trunks, stovepiping out from the cliff with its unnaturally bright, almost iridescent, green fringe of ivies and ferns, make monstrous movements. At intervals, the wreckage of a

tree, unable long ago to support itself further, lies at the foot of the cliff, scattered like the ribs and tusks of a mastadon. Of some, all that remains is a constriction of roots in packaged form, compact, awaiting final demolition.

He drew these still identifiable trees and roots repeatedly, as individuals, welding them to other images. One was the curious walled wood at St Ishmael's, where trees have been combed by the wind into a matted roof and a doorway gives on to a black shore. Others are more grotesque. The reptiles and birds of this ancient land are fierce spirits locked up in their constraining shapes. They are dangerous, unreasoning, prehistoric. The heron does not stand silent in the estuary, like Dylan Thomas's 'ankling the scaly lowlands of the waves', but clatters upwards like a pterodactyl, adding its spikes and bones to the sharpness of the place.

When I test my feelings against these late pictures, I come repeatedly to a dead end. They do not persuade me of the ambiguous spirit that pervades and transcends matter in the way that the early drawings do. Instead they speak terribly of physical limitations. A body does this: a root does this. The pictures map out their limitations as objects, fiercely chained, raging even, but the terror of them is that they are unable in the end to pump from the earth and rock 'the secret oils that drive the grass indefinitely. A timeless insect says the world wears away.'

This vision of landscape was no longer guessed at, puzzled over, turned over tentatively with the foot on the path. It was appropriated, fitted on to grids, transcribed under a meat-eating sun or caught in green webs. Grids do not hold water. The imagery was set down, often on a large scale, from the front and in a shallow space. The turning of objects end-on was no longer essential, and, this time, pigment and handling were not inseparable from the idea. A blackness, perhaps a darkness from the excess of light, finds its way into them, and they often contain a strange black-green gloom which is his own invention. They are thinly painted, stained in memory of the eloquent watercolour. The tangle of nature which once seemed so entirely arbitrary and confusing, so like belief, has resolved itself into strata of logic, into monuments rather than life. I always dread this. It is the

dark. 'The closer I move to death . . . the louder the sun blooms and the tusked, ramshackling sea exults' (Dylan Thomas).

PART II
Intangible Places

PART II

Intangible Places

10 God

David Jones and the Unseen

There are many ways in which things may almost be said. There is a sense in which the expression of any experience contains other kinds of experience caught up in suspension within it: summer implies winter snow, and the glittering calm sea betrays the storm. How the materiality of the world interposes itself between us and its essential nature! It is so assertive. The enormous matter of landscape is the measure of all bulk, the floor on which we crawl; but there are some artists and writers whose nature it is to paint or write every sort of overtone and undertone rather than the thing itself. It is an impossible task. They are in the wrong game. The poems they write and the pictures they paint are not necessarily those they intend. Dealing with images of what they see, they try always to show us what is just out of sight.

Poetry is a much better medium for the almost-said and the just-out-of-sight. Painting, especially oil painting, is a physical medium that embroils itself naturally in the substance of things; it is fatty and fleshy and has a way of rolling about in the pit of matter, emerging sometimes triumphant to show us physical mass in some kind of architectural order. Its always surprising capacity for doing this is its glory and its essential form. But suppose the thing seen is to be recognized not *in* the object painted but *through* it. What then? It is like a religion based on water, or on light, or glass: a view of the world in which the infinite beauty of the natural order is transparently marking the place of something else.

How to paint the invisible in terms of the visible? David Jones, who had been on the Western Front in the Great War and converted to

Catholicism in 1921, tried to achieve this between about 1927 and his first serious nervous breakdown in the late summer of 1932. He had no doubt that he did not succeed, the pictures hardly even approached what he had in mind, and when he was well enough to work again he resorted chiefly to poetry as much the better medium for the almost-said. His later drawings, those he could manage, were often a dense thicket of symbolism. They use signs for what he meant and, I suppose because of that, are more understandable. Far better to examine the earlier, flawed, pictures for their difficult involvement with particular hills and a particular sea, not as signs for something else, but as the high windows on their essential nature.

Water, the transparent, refracting, angled clarity of water in a Welsh valley running with it, may have given him his first clue. He went to Capel-y-ffin, in the Black Mountains, in late 1924 to rejoin Eric Gill who had moved there from Sussex. For someone who, in a nervous and hesitating way, knew that his preoccupation was transcendentally a spiritual one, this area of the Welsh borders must have been revelatory.

There is something odd here. Long before the Romantic movement confused the perception of God with the experience of nature, the clear thinking of Thomas Traherne and Henry Vaughan had found in this neighbourhood an absolute proof of grace. The visible landscape, which Traherne wanted to revel in until he perceived himself 'sole heir of the whole world', is here. Vaughan's deep but dazzling darkness is here, in the next valley from Capel-y-ffin, within earshot of the River Usk. The place runs with water. Vaughan thought it fresh as air and clear as glass:

> And though poor stones have neither speech nor tongue,
> While active winds and streams both run and speak,
> Yet stones are deep in admiration.

A litany of water begins; Welsh water. Hopkins, who learned Welsh and wrote while in Wales in an anguish caught between love of God and love of nature, could see, at St Winefride's Well in the 1870s, 'the spring in place leading back the thoughts by its spring in time to its

spring in eternity'. His inscapes in the natural world were precisely the means by which he identified the beauty of God in the essence of nature. At Clyro, at the head of David Jones's valley, Kilvert in his simpler way had known the same thing.

But how to communicate this idea in painting? How to get past the fact of a boulder or a foxglove or a solid roundheaded hill to their true nature? One answer was flowing in water. He did not see it at first. The earliest drawings David Jones made at Capel-y-ffin are carpentered together; though their lines are carried up on the contours of the hills, there are still the constraints of Gill's stone carving, and engraving, and the joinery with which David Jones had tried unsuccessfully to dovetail his shattered nerves into something useful after the war. Then, gradually, as though in the first weeks of a slow thaw, his style began to loosen. The rhythms of flowing water caught horizons, trees and ferns in their current until the whole landscape gently coiled and uncoiled like weeds under a stream [27].

The whale-back undulations of Downs painted at Ditchling were at once drawn up into new heights, the difference between a calm sea and a rough one. The regular pencilled curve of a Sussex cornfield became the flexing of fruit trees, tousled grass and brassicas in the monastery orchard. The curving backs of wild ponies echoed the switchback of horizon above them. There were curves in the laid hedges, in the interweavings of wattle fencing, and most of all in the turning stream.

If you walk up this valley now you will understand how it happened. The Vale of Ewyas, approached from the south, is graceful, broad, cultivated and almost deserted. Four miles up are the ruins of Llanthony Priory, abandoned by Augustinian canons in the thirteenth century because even they could not endure the weather. Through the arches you can see the high hills. It is after this, as the valley steepens and narrows, that the Honddu, deep in a cwm of dripping elders and scrub oaks, makes itself felt. Above the farmland, where the trees cease and the high round rust-coloured backs of the Black Mountains are bald, there are ribbons and mare's-tails of water hurrying down to meet the stream and the path, which in turn flow quickly back the way you have come on their route to the Usk. By the time Capel-y-

ffin is reached, with the head of the valley dominated by a curious rainbow-shaped tump, Y Twmpa, the place at most times of year is chuckling with hidden water and caught up in the bright rhythms of the nants.

From the windows of the white Victorian 'monastery' where David Jones lived with Gill and his community intermittently until 1929, praying and working, he must have watched this shifting and water-smudged place and felt its unworldliness. Mutability, the way in which the streaming water made everything in it move and seem insubstantial, was to him the sign of its divinity. The same thing had occurred to Vaughan in the 1650s.

> Beauty consists in colours; and that's blest
> Which is not fixed, but flies and flows;
> The settled red is dull, and whites that rest
> Something of sickness would disclose.
> Vicissitude plays all the game.
> Nothing that stirs,
> Or hath a name,
> But waits upon this wheel . . .

From tenderly hatching the valley's patterns, its streams and freshets, David Jones moved towards a way of drawing that was far more tentative, allusive and confused, as though the whole of nature was in a watery flux. Its solidity was washed away, or seen through. The landscape was no longer the thing itself but a revelation, all travelling and never arriving, like water.

And then there was the sea. Sea change. If this shy and confused man now felt the need of a subject about which it was impossible to be dogmatic, a subject entirely *governed* by change and of which the meaning was infinite, he need only stare at the sea. Already behind the topics for his engravings at this time were limitless stretches of water, in his illustrations for *The Chester Play of the Deluge* and *The Rime of the Ancient Mariner*. He began, too, to experiment with paintings of the rocky coast when he worked for a time at the monastery on Caldey Island; but then, in 1927, his parents took a seaside

villa at Portslade, near Brighton, for the summer. After the enormous white liners of big hotels as you go out of Brighton in a westerly direction the architecture settles down. The house Jones lived in was one of a short row of two-storeyed Edwardian white-painted villas that stands isolated and exposed on a spur of land beyond the canal in front of Portslade, facing out to sea. It is a length of seaside architecture cut off neatly and stranded by itself on a strip of beach between sea and sea, parallel to the coast. Running the length of the row at first-floor level was a balcony, now partly glassed-in. The house David Jones worked in retained painted uprights that supported this balcony, which was like the front of a cricket pavilion except that the uprights on it had scrolled wooden capitals like the wings of seagulls. Below the terrace there was a drop to the beach, with some steps down on to it; a short, steep, shingled beach at high tide, short enough that to anyone sitting on the balcony the beach was out of sight. It was like being at sea.

On fine days he could draw on the balcony, looking past the other villas towards the distant west pier and the cliffs beyond, with a calm sea to his right coming in steadily at equal intervals, and a deck-chair and a vase of flowers for company. On bad days he closed the glass door of the upstairs room and sat looking across the empty balcony, directly out to sea.

If the nature of things is to stand heavily and assert their identity, they must be shown to change. The Welsh valley, flowing and moving, had taught him that. The most formidable matter can drift in veils of watercolour. In watercolour an object is not only itself but the object in front of it and the object behind it and an object half-guessed-at. On days when he looked out to sea, with the glitter of light in his face, and the sea-wind so strong that it stirred the curtains out into the room although the glass door was shut, the watery process begun at Capel-y-ffin was taken a nervous stage further.

They are strange, these half-sea pictures [28]. Water is their medium, and water mostly their subject. They are written with water on water, and water refracts and fragments them, always moving, always catching the light. And in all this bright shiftingness there are touched fragments, allusions in pencil or crayon, bright scribbles of colour.

The eye does not insist on them long. They have no need to be stable or to assert themselves too strongly as physical fact. A ship snouts its way through heavy weather, trailing smoke: a sailing boat glides close enough for its sails to be in the room. They are references to the world, signals to be read, but hardly objects to be grasped. The marks for them shoot about in pools of limpid watercolour like little arrows of drawing, shoals of small signs that hover a moment and dart away. Oh, never be too sure of what you see. Think what you can almost see.

How often the process of painting or writing is like this, the perilous business of making statements, revising them, overlaying them, referring back on the spur of the moment to what remains of them, trying them again in various relations to what survives of other altered parts, all the time reacting intuitively and in suspense as the work evolves towards some half-imagined accident-prone whole which may well be quite other than the one you had originally part-envisaged. How infinitely much harder this is if the purpose of the picture is the ill-defined and elusive *idea* of the subject rather than the subject itself, an idea which seems to dodge the marks on the page and move always backwards, in parenthesis.

At all times of his life David Jones looked from windows as though contemplating the world in search of this end. At Capel-y-ffin, though he often worked out of doors, he was happiest when sitting, trench-coated, at a high window in the monastery, looking out. He had a cell, or cubicle. At Caldey he watched from his window, and now again at Portslade. The best he could hope, as he said, was to evoke an image that might be recognizable via his 'lines, smudges, colours, opacities, translucencies, tightnesses, hardnesses, pencil marks, paint marks, chalk marks, spit marks, thumb marks'. When trying to draw the constantly ambiguous flux of the sea he was awash with this problem. On Caldey Island he had started by making studies of the Celtic shapes of rocks, the solid shore, but as he turned his attention to the sea he had felt for the first time what he could unreasonably expect a painting to be: not some dead convention, not impressionistic or realistic, but a kind of sign which was both form and content simultaneously, matter and form stirred up together. I cannot help

thinking of how St Cuthbert prayed, at Holy Island, standing up to his neck in the sea. Ideas, as Locke saw them, not only were intellectual but included the information, uninterpreted, provided by the senses. Waiting in Tenby for the weather to change so that he could take the boat for Caldey Island, David Jones wrote: 'Here am I a prisoner not being able to say to the sea be still'; and at Portslade he was exhilarated that the house he worked in was on the tide-line: spray burst over it and its rooms were full of the roar of the sea, the impossible pretext for the paintings, the most completely fluid equivalent for a sense of sanctity.

How could his work be made to bear its meaning? He wanted to be understood. He knew that lost causes are almost always just causes, but he was increasingly convinced of the idea that painting should be able to show forth, under another form, existing realities. He used the word 'transubstantiate'. He wanted to proceed from the known to the unknown. His work-table, as he had often been reminded by Gill at the outset, was the altar on which he offered his work to God, and certainly his intention was to make something that had meaning beyond the appearance of its subject. As he said, the subject is everything in one sense and yet nothing in another, the difficulty being that most people have to be content, rightly and properly, with knowing God through created things. It meant, this imprecise view of painting as a sacrament, that he felt himself involved in his tentative but determined way with a mystery. 'Do you, sir,' Blake once asked, 'paint in fear and trembling?'

For five years David Jones worked in this way, watching always for movement, change, transmogrification, as spiritual clues, trying always to press ambiguous seascape and landscape subjects into holding sacramental meaning without ever being so specific as to convert them into fact. When Gill abandoned Wales for a farmhouse in Buckinghamshire in 1929, David Jones began to work there too. His watercolour style by now was so flowing, so scattered with light and with drifting, breezy scribbles of coloured drawing, that it looks lighthearted. The views were not drawn and then coloured so much as drawn in pencil and watercolour as one process and all at the same time. You can

mistake it easily enough for that holiday air of his fellow members of the Seven and Five Society. How often, especially in scientific research, do people arrive at the same conclusions by totally dissimilar routes and for opposing reasons? David Jones wanted to use a style that seemed fresh and new, but behind the twitching colours and flowing marks was an increasingly anxious and baffled mind. No one delighted more than he did in flowers on a sunlit window-sill, the fat rows of vegetables in the kitchen garden and the beech woods behind the farm roofs, but apart from hinting repeatedly at their insubstantiality, try as he might, he could find no convincing way of making them carry a sufficient burden of meaning beyond themselves.

It was partly, he felt, a limitation imposed by his particular era, a period poorly adapted to interpretation because society had no consistent philosophical point of view, least of all a religious one. Despite the help of his friends, he began to suspect that he was in a spiritual wilderness. How could he coax his landscapes and water pictures into conveying even a fraction of what he meant? 'Everyone means different things by the same words,' he wrote, 'and everyone interprets ideas and actions so diversely that one is more scrupulous I suppose than one might normally be if there were a real civilization builded upon some understood philosophy.' By 1931 these light-filled pictures were being produced often only with the greatest difficulty; sometimes, rather rarely, when their juxtapositions seemed to accord with his feelings they were joyous, but increasingly their veils of colour were revised and drawn across with frustration and then with irritation, even anger. The layers of meaning they were meant to expose were, he felt, often no more than an incoherent muddle, a contradiction of the beautiful fluid clarity which the watery landscape had first revealed to him.

He produced a sustained burst of watercolours in 1932, about sixty in one summer, and then fell silent. In exasperation.

I have avoided mentioning symbolism so far because I wanted to try to show how David Jones worked before it seemed indispensable to him. The heights and depths of these early pictures, which in many ways fail movingly, come from their attempt to make the visible world

both itself and simultaneously something else without recourse to any sacramental sign language or code. It is much more than a religious respect for created nature that they show, or the power of being deeply moved by beauty, but a balance between God and the world, the visible and invisible. You need to be on David Jones's side when you look at them, more eager to see their point than to miss it. Even where they fail, absences make themselves felt. I admire this because I think, despite its difficulty, that is how the world is.

When, after a long period of depression and total inactivity, he tried to work again it was chiefly as a poet, using words which would bear particular interpretation and with which he could signal particular allusions. Instead of the fluid watercolours he began slowly to draw subject pictures rather than landscapes. His process became much more elaborate. The business of revision by which most works of art are made, the overlapping of one allusion with another and then another which had begun in the hesitant smudgings of the water-colours, led him on to make allusions of every kind – mythological, historical, metaphysical, religious – so that it would now be true to say that the drawings can be 'read' in the same sense that one reads poetry. Much was gained, but something extremely subtle and difficult, not to say impossible, that is peculiar to the medium of painting, was lost. Was it freedom? A kind of abstraction?

At sea, on a sea voyage to Cairo, he partly recovered his nerve. For some years afterwards he lived by himself in a hotel at Sidmouth. 'I don't much like the red cliffs about here,' he wrote. 'On some days it's like living under a vast baulk of chocolate – they turn the bitter sea also into a kind of cocoa lake, however.'

In his paintings only intermittently did anything comparable to the early freedom return. I think it came chiefly when he painted, in his old way, directly from what he could see. Then he was assailed by all that he most admired in his favourite poet, Hopkins: the dappled, pied, altering nature of things that at the same time seems to imply some great comprehensiveness. Among the lurking depressions and fearfulness to which David Jones was subject, there were shafts of watery yellow light. High views seemed to give him temporary freedom

of spirit: the view from a high window at Gatwick House, in Essex, through light-filled trees; a lofty stretch of open sun-littered fells seen from a ridge above Matterdale, in Cumberland [30]. Both are pale, spiritual, almost insubstantial.

The best high-window views, those that most convey the heightened sense of moments of being, were drawn when, as the result of another deeply disturbing period in 1947, he lived at a nursing home in Harrow and was required by his doctors to paint as therapy. There were trees outside his window. Both here and later at Northwick House (now pulled down) on Harrow Hill, he could look from his habitual high vantage-point into the tops of trees. He drew them as fellow creatures, with the most touching and hesitant delicacy [29]. They have no solidity but an odd ethereal brightness, one chalk-scribbled branch seen past or through another in fractured lines and indefinite focus. How different from the orchard trees at Capel-y-ffin! Before, the landscape waved: now, the drawings themselves wave most insubstantially towards the sun.

Rhythms somehow go beyond what is seen, slipping uncertainly towards one meaning. The tree drawings are strange and, as Bacon says, there is 'no excellent beauty that hath not some strangeness in proportion'. They did not exactly fit any longer, though, David Jones's liturgical cast of mind. The poet and artist had a priestlike vocation and must make himself clear. The land, the trees, had become to him not a country but the past. Those trees below the window were not part of gratuitous creation in the way that pictures are so easily part of gratuitous creation; they were signs and symbols in the same way that Maritain insisted the artefact itself must be a sign or symbol.

It is not difficult to think of David Jones as a monk in his cell, watching the world out of his window; a small man who worked slowly and with almost paralyzing misgivings to make visible something other than what he could see via what he could see. When he was ill, psychoanalysis could have got in his way had he not guarded against it. The subtle connections he made might have been spoilt had he learned too well how his mind worked. In the event, when dealing with such elusive matter, psychotherapy seemed to him a blunt and clumsy tool, like trying to extract a very small and deep splinter with

a large penknife. Nothing could dislodge the fact that for him those trees were not just trees but perfect signs. They stood for all that confluence of meanings which is everywhere in the landscape, especially when it is remembered rather than seen.

He drew them again, this time teasing out their secret analogies and correspondences: they were the clump of trees called Mametz Wood that was his terrifying military objective in 1916; they were the sacred groves of antiquity, the place in which men saw God in the landscape long before Christianity; they were the cross of Christ round which the world dances. The load of meaning that landscape bears must, it seemed to him, now at least partly be revealed in his work, no longer hidden away and obscured by dumb marks. Landscape is a palimpsest, and an anathemata: a store of memories and associations laid up for the gods.

So, layer upon layer, stratum upon stratum, his meanings had their way with the landscape and it was no longer as free as it had been, or as half-seen.

Will those first, free watercolours remain motionless long enough to submit to symbolic interpretations in retrospect? No. There is no thicket of references there; the ground shifts too much. No labels, either, on the irreconcilable sea. I cannot help remembering that Capel-y-ffin, which means chapel on the border, is in border country, a margin land that is neither one thing nor another, ambiguous. The Honddu and the Usk are not hand's-breadths of dull water but leaping light. The imperfections of old glass, like water, ripple and fragment the landscape seen through them, distorting the rows of drying hay and bending the trees. Thomas Vaughan, Henry Vaughan's twin brother, wrote of this place: 'There is in nature a certain chain of subordinate propinquity of complexions between visibles and invisibles.' Forty years after he first tried to draw there, David Jones wrote of the Black Mountains as the body of the sleeping Lord, the hills as 'the hunch of his shoulders', as though they were something solid. His great difficulty in the watercolours had been to draw that without referring to it, just as in the sea pictures he had wanted to draw sea voyages as the journey of the soul without referring to that either.

Perhaps it was an impossible proposition. In all probability there

was no choice. Who is to say that a man's sense of God in the land should not be felt and hinted at rather than communicated more exactly?

Winifred Nicholson and the Just-out-of-Sight

In the sacred landscape, form is in the way. Sometimes it is possible to see past it or through it. If the spirit is not to be found in the husk or skin of landscape, but beyond, above, under, it may be possible in paintings to subtract form. Subtract form and what have you left? Colour.

As she watched her enormous chalice of light in the Irthing valley, and tried to paint it, Winifred Nicholson realized the extraordinary effect that colour, independent of form, can have on feelings. It seems not to act on the intellect at all. Colour, moving about without form, affects the nervous system like gas. It swirls through the senses in a bright mist. Mondrian and Ben Nicholson would say that when colour has no shape there is nothing to articulate it, nothing to make sense of it: formless music and formless pictures forfeit that characteristic of making a microcosm of the world which great works always have. You cannot imagine Mondrian permitting his red to relax or his yellow to diffuse as they approach a line or an edge. Pure colour may have no implicit meaning, but Winifred Nicholson knew that it could let light stream in on to the imprisoned psyche, so used to the constraints of reason, and become a revelation, visionary. She equated light with spirit, the spirit that teems into everything.

To understand this as a landscape painter she had to have a strongly developed sense of the unseen, the belief that the essence of landscape was just out of sight beyond appearances; that, were her own faculties and beliefs more developed, she would see more, feel more. The senses of sight and hearing, she thought, have for most of us become very dull; smell and taste as well. The smell of a wild flower or of a pebble which seem so faint as to be barely perceptible, should be clear and self-evident. A bud makes a sound when opening. From when she had first begun to paint she was aware of colours only partly seen, the iridescence of a shell, the colours, which, like fugitives, detach them-

selves quickly from one edge to disappear behind another, a St Elmo's fire dashing abruptly from one object to another. What chiefly came to interest her was this aspect of colour as part of the great life-giving element of white light.

She was well aware of the fact that her feelings were being acted upon by colours she could only partly see at either end of the spectrum, on either side of the rainbow. There is apricot on one side (which I think she felt she could see more clearly than most people) and violet tending to ultraviolet on the other. Seen through a prism, the flaring of bright light, especially of orange and violet from the edges of objects, is unmistakable. But there was another aspect of colour that preoccupied her, the fact that colour is not visible until lit. Colour does not lie hidden in the landscape, waiting to be animated by light. Colour is contained in light. Objects have the capacity to select and isolate, from the stream of white light falling on them, colours they appear to emit. These two properties, once realized, transfigured her view of landscape and occupied her constantly in the kind of painting which seemed not to depend on one canvas, as a statement, but on a long sequence of pictures, painted sometimes more than one a day, which lasted over many years and looked all the time for insights into endlessly varying moments of light and colour as though into a spiritual condition.

I doubt whether this philosophical preoccupation with colour would have been possible without the enormous forum of the view from her windows, which gave her freedom and largeness of gesture. One of the ways in which we wrongly learn to recognize ourselves is by our constraints. We are accustomed to being boxed up, trussed up, nailed down by the limits of our limbs, by rooms, houses, cities; a people of forms, enclosed by shapes. Even in aeroplanes we sit reading, more comfortably aware of the short tunnel of the fuselage than of the limitless silver space through which we turn. The reach seldom exceeds the grasp.

In painting, the sensation of wide horizons changes all this. The petty restrictions of everyday are irrelevant. Laboured thought and clumsy actions are forgotten; nothing is a limitation, and nothing is any longer cramped. It is as if the spirit, renewed, feels itself part of

everything else. It takes longer breaths of purer air. The brilliant white light makes for inspiration, for bigger gestures, for broader horizons of feeling. When Winifred Nicholson looked at an expansive view, her own instinctive largeness of spirit found itself naturally in paintings which were always risky, urgent, exuberant and improvisatory. How the painting impulse longs for this new air of abandon, of release, as though the endless energy of light should itself communicate directly with the picture!

In Cumberland her view was immense, like a receptacle for hoarding the sky. Southwards from Hadrian's Wall, fields fall into a river valley so generous that it acts as an enormous reservoir for light. This was her subject. Light pours into it. On days when even the shade heats up and shadows are short and blue, sun drives the colour from the fields with their moisture, and stone walls give back a silvery light. This also was her subject. Very often the great space is entirely full of altering mist which traps light and turns it slowly as though examining it. There is lemon light and violet, principal ingredients in her pictures. When the mist clears there are acres of blue air and radiance as far as the distant fells. From the bedroom where she worked, from which she watched all this, she could see through the tops of wild cherry and apple trees to Tindale Fell, close or distant depending on the weather, and, far off, on the rhythmic horizon, Helvellyn, Skiddaw and Saddleback. Sometimes snow shapes the landscape, quietly disallowing night.

Now, if you asked her about her ideas for paintings she would reply at once not by speaking of subjects but of colours. She would not start with a shape and colour it in. She would start with a colour and find what form would best express it. A rainbow starts with colour but is more beautifully expressed as an arc than as a straight ribbon. She would feel the need of a particular combination of colours, a relationship between a particular peach colour and a particular saffron yellow, and then she would look about her in the real world to see how best she could embody it. This was how she expressed it. It was the colour that was the idea.

Once, in 1938, she was in a train from Paris to the Channel coast with her friend Piet Mondrian. Both of them had worked for a long

time in Paris without venturing into the country. Out of the train window, across the racing fields, she could see the late afternoon light playing havoc with the colours of the landscape on a scale which she had almost forgotten was possible. Mondrian, too, stared out of the window absorbed. When she spoke to him about the bursts of light and colour they were watching, he seemed surprised. What interested him, he explained in his monk-like way, was the speed at which telegraph poles flicked past the carriage window, dividing the landscape at vertical intervals.

Only music, which has time as its large canvas, seemed to Winifred Nicholson to have a lack of constraint comparable to that of colour. The similarity between the ways in which colour and music work on the emotions was often in her mind, and she invariably discussed one in terms of the other. The names of colours, though often evocative – crimson lake, burnt Siena, French ultramarine – can hardly amount to definitions, and often we use the name of objects to denote them instead. Without form, and without even the correct terms for sensations, colour exists in an area beyond language in total abstraction. I hear the piano-tuner in the empty room, patiently trying first one note, then several, then scales, sometimes audibly tightening a string during the vibration of a note to make it sharper. These are the colours which, when gathered into a perfect construction by Schubert or Beethoven, have the mystical capacity of making me feel the whole scope of experience.

Music, when it moves me, seems more often to be about sorrow than about joy, perhaps because there are more gradations to sadness than to happiness and it is a larger subject. Or the reason may be partly technical: the sense of loss that music so often provokes, and the equally poignant senses of longing and resolution, may be to do with the search for, and return to, a particular key. Is not colour more optimistic than music, more likely to communicate feelings of serenity, elation, excitement or profound peace of mind than despair? Chords are like induced colour. Any changed note within a chord alters the emotional effect of all the rest, just as the hue of one colour may be altered almost out of recognition by the vibration of a veil of light

from the colour resting next to it. The eye cannot separate them. Even very subdued colour, very little light, can deeply affect the feelings. Have you noticed how pictures containing almost no colour can seem colourful? Neither music nor colour is much given to understatement. The deepest feeling can show itself in silence, in musical intervals, or in the white light from which all these vibrations come.

Her valley is a long way north. It is not always flooded with light. Short winter days hardly get beyond dawn, with daylight so low and so diffuse that it has no direction. Still her paintings contained much colour. No light lands on the bracken to turn it from dull brown to fox-red, or else the valley is erased altogether by drizzle. The shortest day of the year repeats itself. The view has no answers then, with paint earth-coloured. At these times she still painted, but looked more closely for the smallest sparks of colour made to seem brighter by the surrounding gloom. I like her almost best for this. Out of the mud, which is no colour and entirely sunk in winter darkness, come up the intensest colours of all, in the green beaks of bulbs [31].

Flowers trap colour as a rainbow is trapped in a spray of water. Winifred Nicholson admired them for their form but painted them as pure colour unexplained. The deep space of her landscape was often best seen by her past a snowdrop in a jar, a bowl of Roman hyacinth bulbs in black fibre, a lily, the foreground flowers under the hand. What more optimistic sign is there of spirit in landscape than the inexhaustible coloured light that comes from nowhere into flowers and goes nowhere?

This is to treat colour entirely literally as a source of light, as seen by the eye. Pictures can bring light into a room. So can flowers. She would collect wild flowers and put them in a jug on her table to act as a lamp on a dull day: yellow Iceland poppies, yellow iris, sunflowers, buttercups, dandelions. Not until she added a magenta sweet pea to the bunch did she find that it began to generate light. This was exactly the opposition of violet and yellow that she knew from experience to be an essential means of producing vibrancy in her paintings. How can a buttercup persist in radiating such yellowness without exhausting its reserves of yellow, and how can a painting?

How close is all this to trying to paint the unseen in landscape by using the mysterious properties of colour? Close, I think, though in the end it is inexplicable. She could research into colour, and try its effect in painting, but chiefly it engendered in her a lasting sense of wonder. I believe that, like many artists, she had a strong feeling that both painting and looking were essentially religious activities and that art is the natural ally of religion. Christian Science occupied her greatly. She found the spirit of landscape almost blinding, like Hopkins's shook foil.

Writers have used colour, almost as a condition of mind, to convey the same sensation. When Richard Jefferies described his ecstatic sense of at last being totally absorbed into the scheme of the universe, his powerful longing for an irradiance of mind finally satisfied, he did so by sublimating himself not into an idea but into a colour. He described himself turning over on his back, on the top of his Wiltshire down in the 1860s with its enormous view, and staring up at the sky: 'The rich blue of the unattainable flower of the sky drew my soul towards it, and there it rested, for pure colour is rest of heart.'

Such visions have to be caught quickly, and Winifred Nicholson certainly painted with urgency, regardless of time and place. It was characteristic of her that she used no easel but worked with her canvas or board propped against the back of a chair or flat on a table. She was in a hurry to catch the uplift of light when she could in sunlit shadows and insubstantial distances. And this is another thing that light in landscape does, though it is hard to convey: it has an immediacy that contains in it the knowledge that this is exactly how it was before and how it will always be, the sun on the hill; the realization of the continuous instant. It was called by de Coussard the sacrament of the present moment. Paintings, though they may take some time to produce, are, once finished, continuous moments. That is their condition. In pictures, by their very nature, everything happens at once. Outside, time exists to prevent everything happening simultaneously.

Say you were to open a window, or, better, say you were in a gloomy room and threw back the shutters on a bright morning. At once you are buffeted by sensations: warm air on the face, light, the smell of flowers, birdsong, the sound of insects and of water. This is

what the immediacy of Winifred Nicholson's paintings is like. The open window, the world simultaneously inside the room and outside, is an old Seven and Five subject, but she somehow superseded the open window in her work with the lit-up distance itself, not by painting the view but by painting its colour.

By the time I knew her, she made frequent use of a prism which she carried with her everywhere in order to see colours beyond the limits of normal vision. In its way, this gave her physical access to the unseen. She was passionately fond of rainbows, especially double rainbows, and never ceased wondering at them, trying to analyse their colours. Her painting journeys to the Hebrides were partly undertaken because the islands were a rainbow hunting ground. But with the help of a prism she could see rainbows in quite ordinary conditions. She called it a rainbow machine. It enabled her to see rainbows between one plant and another, between one tree and another, and vibrations of colour drawn up out of the earth by sunlight. In her late paintings, rainbows flicker at the edges of plants, in water, on the shoulders of forms and on the walls of her white stone-flagged rooms. The freedom with which she drew in paint meant that into her hands played the swing of the sea and nautiluses, and the rising flight of birds, but the use of a prism gave her the ultimate pretext to avoid painting objects as objects any longer, as anything more than occasions for light and colour. There was nothing now to impede the rainbow of paint wherever there was light.

Into her pools of colour she could divert the pearl light of midday and the bruise at the centre of a poppy. She altered feelings with lapis lazuli, celadon, cerulean and the colour of oyster shells. She evoked the suspect odours of some plants, views from one disregarded island to another, and how hay scents the air impartially. She liked eye-shaped brown pips and luxurious corollas. Did you ever see more colour than in a table full of apples or in the 'cello shapes of pears? Using colour she made a hymn to the sun and to what Philip Larkin called unfenced existence.

But value her, too, for her way with the near-darkness in landscape, that singular way of using dark to suggest, not the absence of light, but depth. It is a means of looking at the world. St John of the Cross

wrote of 'the cloud so tenebrous and grand that illuminated the night'. A painter whose view of landscape depended so optimistically on colour could not look at the dark and find it spiritually without light. Dark has its own lightness. She knew that lilies which are white and hold their breath in the daytime are blue and pungent at night. She did her best to paint the snow of stars, far thunder, dusk when moths fall in flight, the Dog Star and moonlight, dawnlight between curtains and the hellebore beneath the snow.

As a landscape painter, she looked at even the dullest days aware of throbbing light just out of her vision, on the borders of her perception. Colour could not adequately describe it; but it could somehow, in its abandoned and intuitive way, make her pictures part of that light – enough part of it to produce their pervasive sense of its comprehension. In its way, this was simple, like all insights.

> From a place I came
> That was never in time,
> From the beat of a heart
> That was never in pain.
> The sun and the moon,
> The wind and the world,
> The song and the bird
> Travelled my thought
> Time out of mind.
> Shall I know at last
> My lost delight?

> Kathleen Raine

11 Psychology

L. S. Lowry and Loneliness

Painting is a lonely activity. The degree of introspection it requires came make you gloomy. Most good artists are dogged by a sense of the pointlessness of what they are doing. They feel themselves often on very thin ice. It is *other people's* approach to what they do that gives their pictures meaning. 'I don't understand it,' Lowry would say. 'I don't see the point of it really. Painting to me is a habit, like everything else. I just go on until the picture balances.'

The landscape, too, is lonely, and the vacant sea. The loneliest days are those on which even the weather is absent, white days with no shadows and no wind, when all natural events seem suspended by a ceiling of no particular colour and there is no movement. Half past three in the afternoon and no resources at no particular time of year. A time to go to the cinema, but there is no cinema. I think it is this time and these days that Lowry's emptiest landscapes show so well, the days on which loneliness is so much a condition that it matters little whether you are still alive or your grandfather is still alive, or the town clock goes on without you, or it may just as well stop and remain stopped for an indefinite period because there is no way of measuring its days spent stopped without its going, except that a train sometimes goes over the viaduct with no one on it who knows you or knows even of your existence, and cares less.

Lowry was well versed in loneliness, having lived with his mother until she died when he was fifty-two and then by himself for thirty years, painting at night 'for company', as he liked to say, by electric light because it gave him something to do. I doubt if he realized the

extent to which loneliness was his subject. He had plenty to paint because he worked at a time in his head when factory whistles went and the streets were jostling with people and the trams running, and when Salford and Manchester were full of dirty buildings looking splendid before they were hauled down or shot-blasted clean as cheese, and when there were enough soot-black sham-Gothic churches on corners to keep his awkward brush moving round elephantine buttresses and ogee arches half the night because he so liked their bulk. But long before he realized, or invented, the beauty of these urban scenes he was studying to paint the empty landscape and the empty sea which he had seen on adolescent holidays at Lytham St Anne's. He painted them with some difficulty, despite the fifteen or twenty years he spent part-time at art school in Manchester and Salford, and he painted their vacancy with what he came to see in his imagination as an unsettled greyish-white, the colour of nothing at all.

It was his poetic insight, this white, the half-conscious poetic realization that the industrial landscape was not black but white. Smoke-white, tile-white, the white of paint discoloured, the white of washing polluted, the window-sills under soot. It was partly these and yet none of them. I asked him about it once and he told me what I think he often said, that the white in his pictures would improve as it got dirtier. It was flake-white and he liked it best when it discoloured with age, sometimes to a dirty cream colour and sometimes to a bluish milk-grey. This colour, or non-colour, enabled him to draw figures against it in his streets, the figures which may as well have been him. The loneliness of the town sometimes seems greater than that of the country, but I do not think this is so in Lowry's case. When he took a bus or a branch-line into the country, and found it empty, the discoloured moors and lakes and the occasional isolated house became his loneliness exactly and he painted them with an artless pitilessness that is distressing, a kind of daily suicide [32].

Did they really exist, these places? They exist in the mind. Every artist creates a world of his own, unlike any other. Who has not looked from a train window, on a branch-line near Manchester, and seen listlessly what Lowry saw? A red-brick church among a few grave-stones and a railing in a landscape pallid with colour drained

from the grass and sky, a little knot of figures round a grave. I have seen this on a day when I was lost, when no book or picture would have held my interest any more than a strange gasometer going past the train window, when there were no thoughts, no conversation and nothing to be done. What is the point to it? Does there have to be a point? The white road winds over the moors and goes straight up the flat valley [34]. The lakes and pools that should be such picturesque events among the mountains pass almost without comment, so much spilt milk among contours. A yellowish house shows the gaps in its face beyond a hill. The milk-green and milk-blue of his imagination laps round each of these things like a thin tide of amnesia, as though the correct use of words has gone missing because for several days there has been no one to talk to.

It is as this unexplained painter of waste places that Lowry should be remembered, not for the teeming of towns which his mind kept running back to. He could sit on a slope overlooking Windermere and still draw Salford. Stockport Viaduct, the beauty of its curving arches, had lodged in his imagination to the extent that he would introduce it almost at random into any landscape because he liked it; but behind all these lay his own isolation, best expressed by empty places and by the sea. As he said at the beginning, Lowry liked to balance a painting up, but this could be done with extremely few elements as well as very many. Some painters feel that all they do is to go on taking away until the picture looks right. Have you seen the complete simplicity with which Lowry painted, for example, a neolithic stone circle as a distant ring of small grey accents on the horizon of an expanse of blanched grass? He would paint the expanse of sea in the same way, looking directly out across it.

More often than not, this sea was empty. Sometimes a few shallow waves with their backs to the light would set up a slight rhythm at the bottom of the picture which would be echoed along the top edge by parallel lines of smoke-coloured cloud, not many. Lowry explained that, had he not been lonely, he would not have seen what he did. Once, a long way out, a single ship undergoing sea-trials erased itself from his sight with a scribble of smoke [33]. Another time a trawler crossing a patch of glitter seemed squeezed by the light almost to

extinction. More often than not, as he got older, there was nothing to look at except the slake-lime waves.

He saw all these things, I suppose, but there is a much more important sense in which he also imagined them. That vacant landscape and vacant sea were composite inventions that lived in his head. He had only to describe them to make them exist. It is a curious thing, the force and simplicity of an imagination that by its persistence can make a landscape appear where it did not exist before; as though Lowry dreamt a white place with nobody in it because he was lonely, and the rest of us woke up to find it the truth.

Melancholy and the Limestone Landscape

Depression, as only depressives know, can lay bare the truth of life. They see what nobody else who is, as one is supposed to say, balanced, can see. 'La grandeur de l'homme est grande en ce qu'il se connaît misérable' (Pascal). Take, for example, the changed appearance of landscape in Graham Sutherland's etchings in 1929, the year his baby son died. It is the same landscape before and after, but how his view of it alters! The land over which Palmer's stars came out, and which hid in twilight the gentle Catholic medievalism of Griggs, the sound of his chapel bell, is abruptly transformed. In the artist's sorrow he sees it quite differently, as a place no longer safe. It harbours darkness. Its woods threaten and constrict [35]. The old style and the old order, once so reassuring, is broken down, cracked up, walled in.

Have you never experienced this in your own life, the transfiguring of what you see by what you feel? Serious depression prevents work altogether. It results in darkness and a terrible inertia. Like Dürer's figure of Melancholy, the artist sits surrounded by his tools, all he might need, and all the mysteries and beauties of the world, but their secrets will not yield themselves up to him. He is powerless to react to them and, hollow-eyed, powerless also to express them. But if, after a period of inactivity and despair, a little work does become possible, the first attitude to be jettisoned is the Picturesque. Before, Sutherland's barns had let slip their thatch to allow the birds in or a shaft of dust-filled sunlight: after 1929 the thatch rotted. No idylls any more.

Nothing for effect, or to please. Just loss and winter, and the worrying rose.

This is a state of mind transfiguring landscape. Like any mood or humour, like elation or a sense of sanctity, it can be expressed with real places as its subject. The feeling does not derive from the landscape; it finds its way into it. As Bacon suggested, a mood can be made use of.

I think there are two senses in which landscape can be altered like this. One is private. The artists who followed Sutherland found that they could make an anxious garden for their individual psyches. The edginess they felt made for edgy pictures, full of sharp pieces. But there is a public version, too, of which the best example is the effect of war.

There is nothing to compare with war for changing perceptions of the land. The individual artist can rack the fields with his own preoccupations, but war changes them for everybody. They are the same fields as before the war, but they look different. As Cyril Connolly said, there is nothing that heightens perceptions more than the drone of the bomber above the drone of the bee.

When feeling finds its way into landscape in either of these ways, public or private, there is a risk to the pictures. I suppose it is one of the risks always run by Romanticism, that it trumps up feelings and overruns its audience with emotions they do not have. Sentimentality does this, but so does passion. There is a character in an Iris Murdoch novel who profoundly distrusts music because he suspects it of giving him feelings he does not have. Chopin saw his music as being in the classical tradition of Mozart and not being open to Romantic manipulation in performance. But can even music make us feel what we do not feel already? Classicism at least may be seen by everyone equally, and our response to it derives from what we know and what we are.

Romanticism, and especially what, thanks to Robin Ironside and Raymond Mortimer, has come to be referred to as neo-Romanticism, can over-heat. The sentiments it tried to express could be foisted on to landscape, like gratuitous temper or hypermania. Always suspect -isms. They have nothing to do with life. You can trap an -ism and

put it in a cage. It may look fine in the critical best parlour but let it out and it will fall to the ground and die of cold.

If you test a picture against your own sensibilities, you can always tell when a painter is in the business of artifice, of setting scenes instead of showing you what he truly feels. In neo-Romanticism, beware of the hot-house sets, the painters of scenes rather than the painters of plays. They are everywhere.

Take an archetypal Romantic subject like Gordale Scar, near Malham, in Yorkshire. It is approached by walking across innocent short-cropped fields. A shallow stream flows next to the path, its placid current, idly trailing weeds, holding no clue to the trauma it has just endured. Thomas Gray, Girtin, Turner, Wordsworth came this way in single file spaced out by time, and James Ward, and a great many Victorian parsons, amateur geologists and antiquarians. Then, in 1942, Geoffrey Grigson and John Piper arrived together.

How to react, in 1942, after so many Romantic reflexes, to this great, scarred, roofless cavern of carboniferous limestone, with its stream dropping slowly as a white cloud to split on impact with the cauliflower cushion of tufa on its floor? A bulky, whale-grey freak of nature, its shelves of near-vertical strata snapped off in a form reminiscent of the choir-stalls at York, it had already been written about and painted so much that it resounded with echoes. What had it to do with a modern version of Romanticism? Very little; until you realize that it is like a bombed building, stained by fires, fissured, with, very high up against the sky, small trees growing on ledges.

In his painting of it, and in the sequence of drawings and paintings he made of equally dramatic geological subjects in Snowdonia during the next ten years, Piper derived his mood from what he saw. What moved him was the high theatre of the sublime. He exulted in sensation. Heights and dizzy depths, chasms and darkness he drew, in a storm of ink and feeling, well realizing that what he saw accurately expressed human nature, especially in time of war, and sensing that to scratch it quickly on to very small notebook pages was somehow to intensify it. Less is more.

A danger of Romanticism is the gap that can so easily open up

between cause and effect. Hopkins pointed out once in a letter that great poetry is inspiration but that much of what passes for poetry is simply in a poetic mode, well expressed but too typical of its maker to mean much. To draw dramatic scenery as though it carries some meaning of its own is one thing: to sense its connection with your own terror or loneliness or melancholy is another.

The index of John Piper's art seems to me to be not so much subjectivity as subject. No one has known better than he how to look at countryside and buildings, especially buildings in pleasing decay. He sees them as if slowly, by bicycle, and nothing escapes him. Nothing is ever dull. Many of the buildings and landscapes he has painted are already works of art, but pictures of works of art have always presented problems. However much an artist understands the history, botany and archaeology of his subject, he will not necessarily transmute them into a separate object that does more than refer back to them. Piper knows that Romanticism derives quintessentially from reality. There is a contradiction between his passionate insistence on the individuality of each place and the generalizing *son-et-lumière* of his Romantic manner. Good observation does not necessarily make for good art. Is every building a folly? Is every park a magic glade? Perhaps you would say so.

What changes? The air-raid siren and the blackout come, and the crump of bombing. Ruins had always been a staple ingredient of the Picturesque, and now there was to be no shortage of them. 'Ruin-bibbers, randy for antique', Larkin called Piper and Betjeman, thinking of their peacetime explorations. But ruins are an intractable architectural style. The buildings Piper had drawn with a patina of age he drew again when they were smouldering. Footlights went up on the theatre of war. Instead of hinting at a Romantic past, English countryside and architecture took on a catastrophic present. No one sees a church more clearly than when it is burning. Landscape, country houses, parish churches, hills forts and ancient sites, which until then may have been taken for granted, appear in a new light, perhaps on the point of vanishing for ever, re-seen in the frame of death. Either they could be painted as they were, complete with the feelings they

engendered, or they had to be in some way re-imagined. There is an artist missing here. No one of any consequence painted England as it was in war time. If you want to know what it was like you look at films by Humphrey Jennings and photographs by Humphrey Spender. No one will show you better than Jennings the sunny cumulus piled over the Weald, the wartime harvest under the fighters, the schoolchildren in gas masks, the docks burning. This was a public view; everyone could see it all around them. But the blackout could be a subjective event as well, a blackout of the mind.

At least this subjectivity made for better pictures. Craxton, Vaughan, Minton and Colquhoun were town artists whose view of the country was a poetic one, and intense. Probably they had never seen a shepherd except done by Calvert but, like shepherds and dreamers, they imagined themselves alone in an ideal land, a place where you might as easily expect to see goats picking their way among Arcadian ruins as among bomb damage. A bomber's moon was Palmer's moon to them. Their landscape was a place of self-absorption, worked out mostly on a small scale, which intensified it, and in hasty media like ink or crayon.

The landscapes they drew and painted were most certainly a state of mind.

It may have started as a Romantic conceit, a dressing-up in the rags of melancholy, but a style so preoccupied with treating the countryside as a poetic place turned out to mean something as well. The holy valley of Palmer had an unnerving connection with the unholy tension of the present. What started as abundance, in John Minton's drawings of Kentish gardens, threatened to become a malignant tangle [37]. Calvert's and Palmer's profusion of peaceful Shoreham vegetables became, instead of a garden, a dangerous thicket and a trap.

This is the essence of what is now taken for neo-Romanticism: a benign landscape corrupted by the present and by bitter feeling. See how Keats's embalmed darkness becomes blackout. Nettles grow. Trees die. The nib of Minton's pen begins to rip the paper. The full moon becomes a sharp-horned one instead of a graceful O, and the landscape, taking its cue from the razor-sharp segment of moon, shar-

pens itself into hooks, sickles, blades and slivers. The penmark that made smooth stems before, now makes undergrowth like barbed wire, and Craxton's is a blitzed harvest.

This sounds like a description of that public view of countryside conditioned by war, a Romantic way of expressing a landscape which, if seen from the air, is found to be dug up for aerodromes, dug for victory, dotted with nissen huts and essential factories. It is not. The validity of this kind of painting is that it is almost violently subjective. The best examples of it, which are rare, are to do with specific predicaments and the individual psyche. It is at its best when it stands for an existential loneliness.

Why else use such a style? There is nothing to be gained from re-doing landscape in such an old-fashioned, hot-house style, deliberately at odds with all the clearest thought in modern European painting, if it does not somehow express a present predicament. The loneliness has been mistaken for that of artists cut off from Europe by war and forced to live off the over-ripe fruit of their own tradition. It is not that. It is the loneliness of hardly being able to work, of being uncertain of a style, of being cut off from the grand, exemplary utterances of peacetime masterpieces, contemplated with plenty of time and plenty of materials, and instead left to thrash out some twitch of feeling in isolation, in danger, in a small space and without much time.

Only very rigorous artists can transfigure landscape with this degree of feeling and avoid looking vacuous or sentimental. Neo-Romanticism was like a tantrum, or adolescence, or an illness: people were not themselves while going through it. Those who survived (Minton did not) distanced themselves from it as soon as possible as if from a show of feelings that was ill-judged and ill-expressed. The painters who handled it most convincingly all had a serious underlying need for order that sustained them during their disturbed dream.

Keith Vaughan found ways of making the Yorkshire landscape into a tight-packed place, made up of blocks of colour, within which the arcs and gestures of his male figures could form humane incidents, like moments of fellow-feeling in a barrack-room. Having to work in the north as a conscientious objector freed him from the pretty tendrils

of the south. He liked rock, houses 'clamped', as he said, 'into hard landscape', and village streets as vertebrae. To him, war tore up the upholstery of landscape. He packed it back in dense, small – sometimes diminutive – rectangles. His first sinuousness, the war-time flicker in mixed media which he learned so eagerly from Sutherland, turned out to be against his depressive nature. He needed greater precision, greater grandeur.

Alan Reynolds knew how to make a dark wood stand for the unknown or unrecognizable, without forfeiting the formal implications that would lead him ultimately to constructivism [40]. His landscape was altered away from its familiar logic more by the concealed influence of Klee than by Romanticism, by something sharp rather than something round.

Prunella Clough looked steadily at objects on a closed beach, or propped on a break-water, and contrived to suggest their absolute mystery by carefully considering their structure [41]. Her version of the tangled garden was the tank-trapped beach, its wintry spikes and weathered concrete edges at odds with the line of the tide. It was an austere insight: it led her afterwards to prefer the scrapyard to the garden, the gasometer to the green river valley, but how much better to use waste subjects and make poetry from them than to re-paint the English pastoral in the hope of some remaining resonance, some residual inflection of green shade. Colquhoun experimented with unfamiliar English landscape [38], putting its undulations into an order that held good, like the chevrons on a backgammon board, emphasizing edges and pictorial logic.

None of these artists was given to making flailing gestures that could not be understood. Neo-Romanticism is not hysteria. Nor is it only a question of intelligence, or Michael Ayrton would have been a better artist. All these painters used landscape as an exact expression of their own condition. They had in common an edginess, and a tendency to subdue things to formal ends. It was better for them to make an idea small and compressed than to try for a larger statement and leave its peripheries billowing and flapping loose in a storm of feeling. It was as if they went through a version of Romanticism and found some way of making it more lasting. No amount of roughed-up texture to

suggest masonry, and no amount of floodlighting, in Piper's paintings could bring him into the same area of urgent expression. Nor could the inferno or furnace pictures of war-time Sutherland.

There is no doubt that the homosexuality of Minton, Colquhoun and Vaughan added to their sense of isolation, especially in the prejudiced atmosphere of the 1940s, and their life-style in war-time Fitzrovia was dangerously self-destructive. Is it to do with self-regardingness, the mirror image, that so many excellent artists of both sexes have often been homosexual? Is it that the female part of a male artist's nature leads him to make things rather than into the area of abstract thought? Is it to do with appetite? Because of their homosexuality, some of these painters felt themselves separate from the rest of society in the way that the artist invariably already feels himself to be. The aggressive nationalists, Colquhoun and MacBryde, certainly felt isolated in London. To this was added, at least in Minton's case, the dangers of facility. Talent in an artist is a dangerous quality. It allows him to slip neatly past thought. Both Minton and Craxton were extremely precocious. When, after the war, Minton found his ability running to waste because he was able to improvise almost any style, he came in his manic-depressive way both to revel in the ease of his manner and to hate himself for his facility. The waif that looks up from the bombed dockland has Minton's white features.

So the isolation of the shepherd boy and the goatherd, dreamers in their pleasant places, became the loneliness of the night-watchman in his improvised shelter with the world falling down about his ears. The landscape changed, but what changed it most of all in the pictures was the state of mind of the artist. The pathetic fallacy, as coined by Ruskin, suggests a *false* impression of external things induced by seeing them through violent emotion. That is not the same thing as ascribing human feelings to nature, which happens often in poetry. Emotion in landscape will not be faked. To see the countryside transfigured by the individual psyche is a crucial function of the landscape painter. It defines what he does. The weight of feeling placed on the landscape by the so-called neo-Romantics makes it an unsafe place in which to be. Like the ground in limestone scenery, it is liable to give way.

Should the artist fall through he is, like the melancholic, in the dark and entirely alone.

Edward Burra and Hysteria

Burra paints the hill as a looming pneumatic slope. Often it is things we dread that most attract us.

The big house and the sickly boy. It was a big house, with a large porch and dwarfing mantelpieces. It was threatened from the front by voluminous trees. For the past ninety years the drive had grown narrower and more tortuous as the trees grew larger. At the back there was a lawn and a terrace and a circular formal pond. All this was at Playden, in Sussex, on the last rise before Rye. The house, called Springfield, had belonged to Burra's family since 1864. He had been sent away to prep school but, being constantly ill, had received the rest of his education at home. He was a sickly child who worked at watercolours in this bedroom. He lived at home and would continue to work in his bedroom, going up the enormous staircase to draw after breakfast each day until he was nearly fifty.

The trees that stood close to the windows were almost his first subject, especially a gigantic cedar, the level upon level of whose blue branches seemed to be hiding something. A Miss Bradley, in Rye, gave him drawing lessons. He was small and weak. It was his imagination that grew.

Jazz records, 78s in brown cardboard covers, had energy. He painted to jazz. The allegro negro cocktail shaker. Negroes seemed to have the vitality he could not have. Films and novels about low life in the Mediterranean gave him a taste for the louche world he had never seen, the blue curaçao with which to subvert the straitlaced barrister's household in Sussex.

Standing next to a small youth at the entrance scholarship examination at the Royal College of Art, in London, Eric Ravilious could not help noticing that he had made no attempt to draw the life model

on the unaccustomedly large page. Burra spent the day drawing just one eye, in the middle of the paper, in meticulous detail.

When he drew landscapes they were imaginary settings for bizarre figures, the sailors and divorced contraltos of his imagination, in water-colours of which the characteristic colour was a glowing aubergine.

When he went to Marseilles, he was observed by Anthony Powell to keep always out of the sun, so that he had the complexion of a prisoner or an invalid, which he was. He spoke hardly at all, but always with withering aptness.

What he liked to draw best were: waiters, seedy decor, nightclubs, cheap suits. He enjoyed the brash and racy. A lifelong exhaustion made him prey on other people's fun, especially (what he really sav-oured) bad behaviour, unkind laughter, mendacity, waspishness, all-out malicious enjoyment and any kind of excess. Bad feeling motivated him. It gave his work the energy he did not have.

It was an obscure knack. Through the people he struck out in a leisurely way for the landscape as though in search of absent thoughts, absent causes. When he was younger (though he looked old) he would sit at a corner table, either in reality or in imagination, at some dive like Issy Ort's and commit the bird-women and negroes to memory so that he could draw them afterwards, hearing the same side of a favourite 78 repeatedly, feeling its elation and vitality in the saxophone solo each time. As he got older he began to see through people. The carnival skeletons and waitresses danced off into the distance. That tinny noise of a Mediterranean festival band, conscripted from boys in the local town, faded. When the people had dragged their smiles away, he was left with the landscape, a big empty distant dreamlike landscape with electric air and the threat of thunder promising relief and a wash of rain.

For the last fifteen years of his life he concentrated chiefly on paint-ing landscapes which are odder and more potent than anything else he did. He denied ever having loved anybody, and now the people were gone. Conrad Aiken, Paul Nash and Malcolm Lowry had added to his ideas as if to a postcard collection or a surreal montage. He

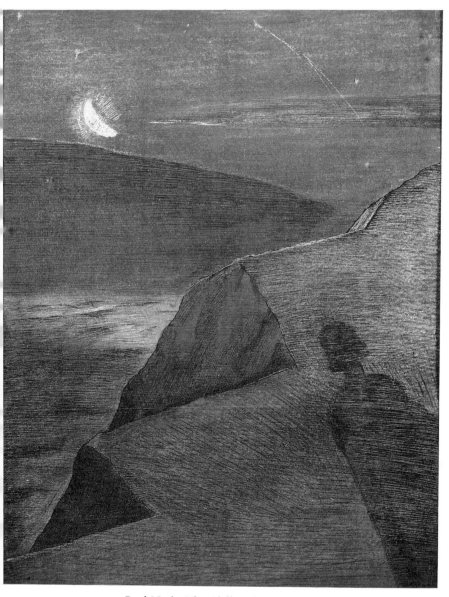

1 Paul Nash, *The Cliff to the North*, 1912

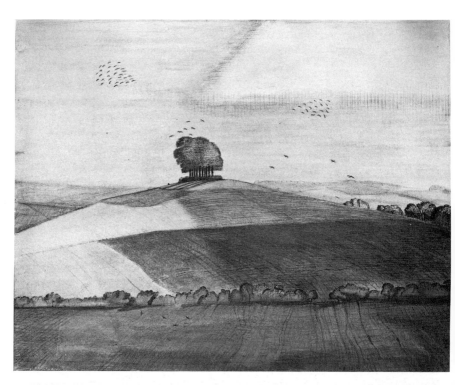

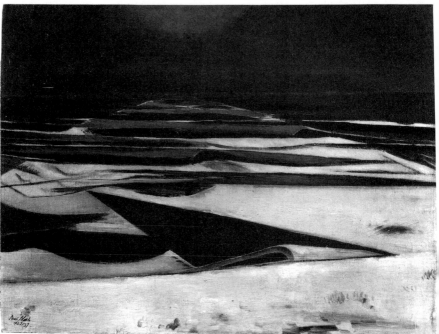

2 Paul Nash, *Wittenham Clumps*, 1913

3 Paul Nash, *Winter Sea*, 1925/37

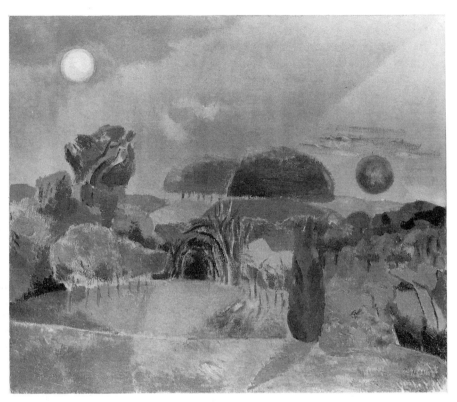

4 Paul Nash, *Landscape of the Vernal Equinox*, 1944

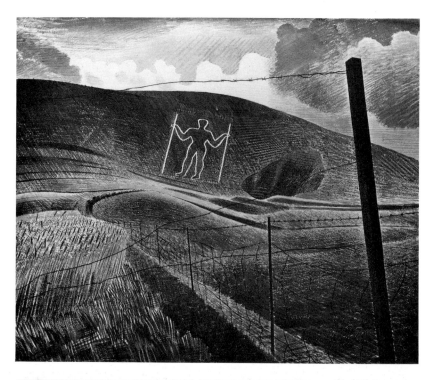

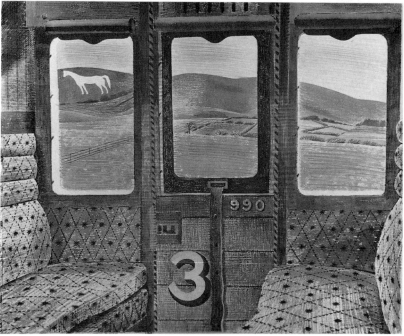

5 Eric Ravilious, *The Wilmington Giant*, 1939

6 Eric Ravilious, *Train Landscape*, c. 1939

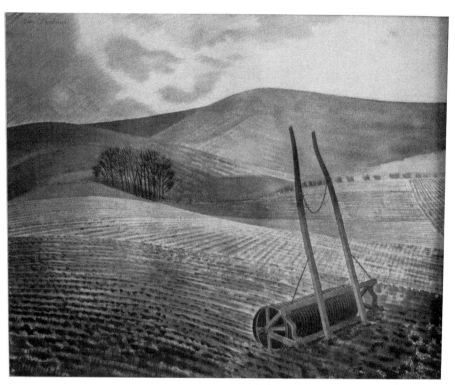

7 Eric Ravilious, *Downs in Winter*, c. 1934

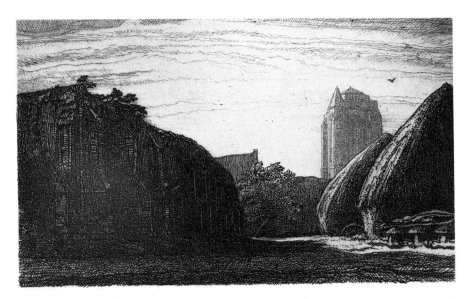

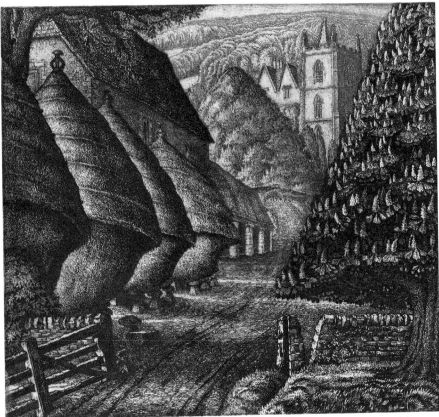

8 F. L. Griggs, *Maur's Farm*, 1913

9 Robin Tanner, *Wiltshire Rickyard*, 1939

10 Stanley Spencer, *Rowborough, Cookham*, 1934

11 Stanley Spencer, *Cookham Moor*, 1937

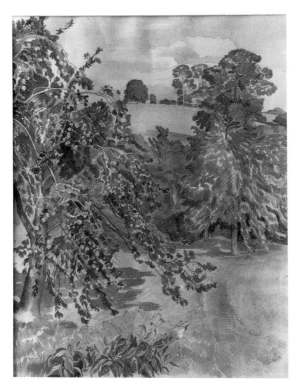

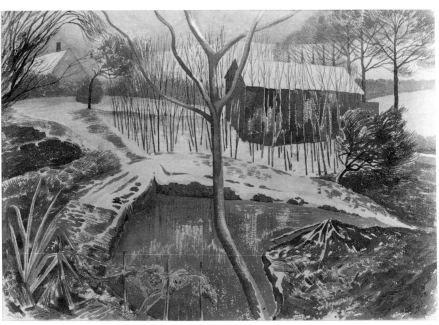

12 John Nash, *The Blenheim*, 1947

13 John Nash, *Wild Garden, Winter*, 1959

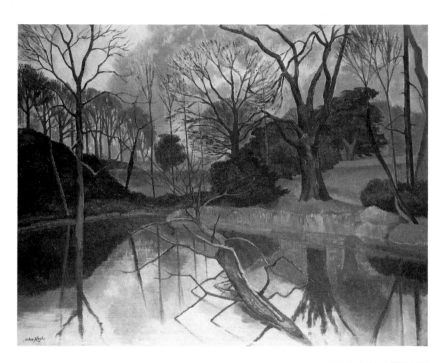

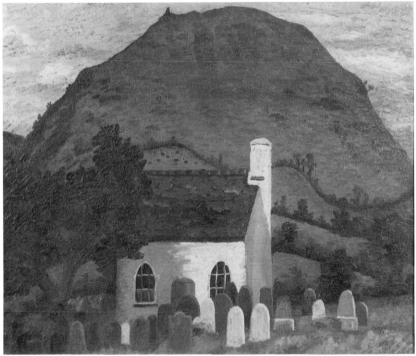

14 John Nash, *The Lake, Little Horkesley Hall*, 1958

15 Cedric Morris, *Lord Hereford's Knob*, 1939

16 Cedric Morris, *Landscape of Shame*, c. 1960

17 Cedric Morris, *Several Inventions*, 1964

18 Walter Sickert, *Beechen Cliff from Belvedere, Bath,* 1917

19 Walter Sickert, *Belmont, Bath,* 1941

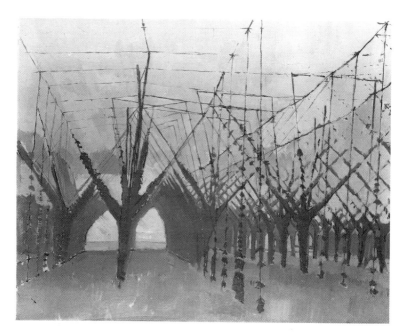

20 William Townsend, *The Hop Garden*, 1950

21 Claude Rogers, *Eclipse at Blandford*, 1951

22 Joan Eardley, *Winter Sea IV*, 1958

23 Joan Eardley, *The Wave*, 1961

24 Graham Sutherland, *Corn Stook in Landscape*, c. 1945

25 Graham Sutherland, *Study for Folded Hills*, 1943

26 Graham Sutherland, *Boulder with Hawthorn Tree*, 1974

27 David Jones, *The Waterfall*, 1926

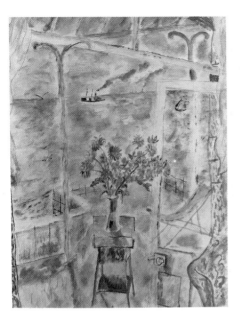

28 David Jones, *The Terrace*, 1929

29 David Jones, *Major Hall's Bothy*, 1949

30 David Jones, *Helen's Gate, Dockray*, 1946

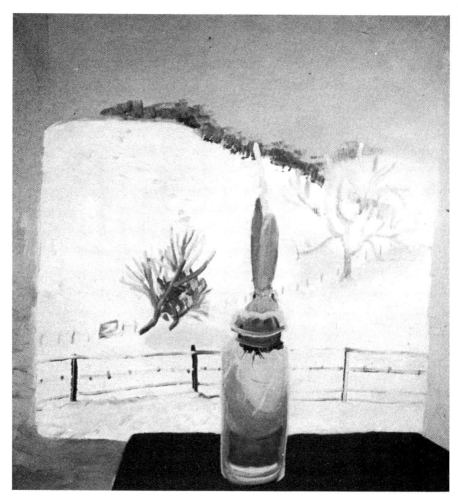

31 Winifred Nicholson, *Winter Hyacinth*, c. 1955

32 L. S. Lowry, *The Landmark*, 1936

33 L. S. Lowry, *Sea Trials at South Shields*, 1963

34 L. S. Lowry, *Fylde*, 1953

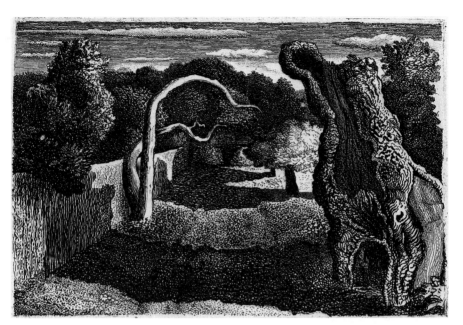

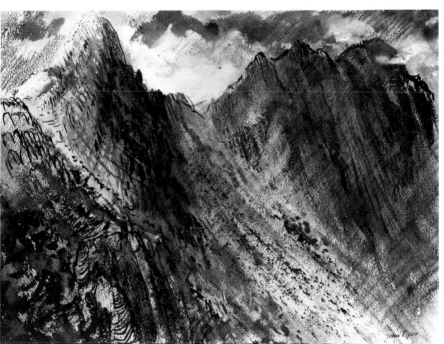

35 Graham Sutherland, *Pastoral*, 1930

36 John Piper, *Crib Goch*, 1947

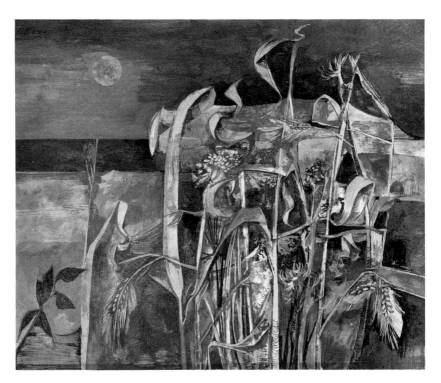

37 John Minton, *Harvest Moon*, 1944

38 Robert Colquhoun, *Marrowfield, Worcestershire*, 1941

39 Keith Vaughan, *The Lighthouse*, 1944

40 Alan Reynolds, *The Copse at Dusk II*, 1952

41 Prunella Clough, *Seascape and Bone*, 1945

42 Edward Burra, *The Allotments*, 1962–63

43 Edward Burra, *English Country Scene I*, c. 1970

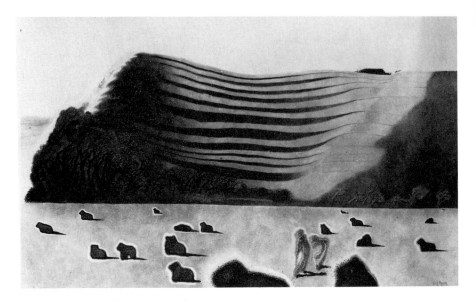

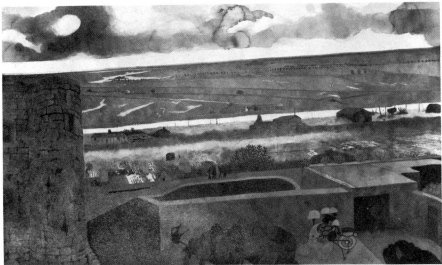

44 Edward Burra, *Under the Hill*, 1964–65

45 Edward Burra, *The Ramparts*, 1959–61

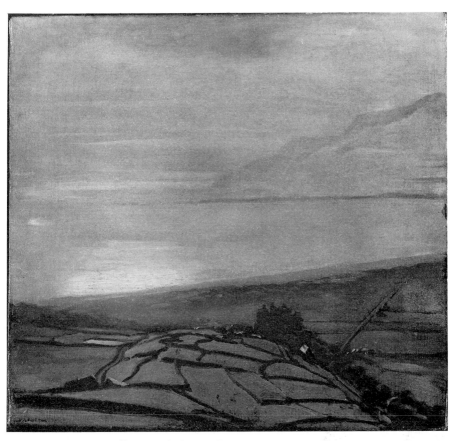

46 William Nicholson, *The Hill above Harlech*, c. 1917

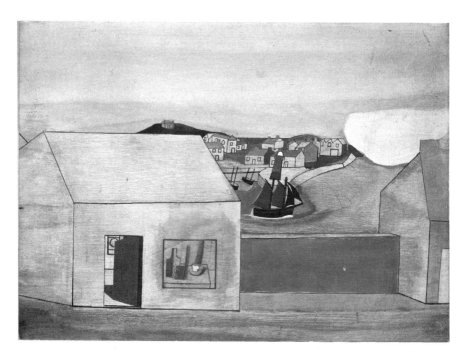

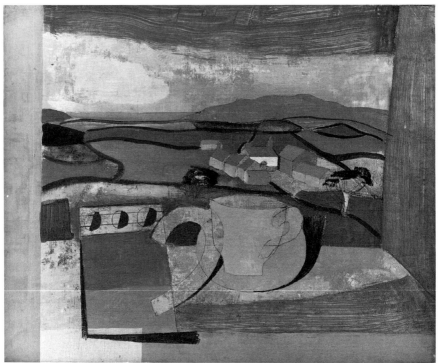

47 Ben Nicholson, *1940 (St Ives, version 3)*

48 Ben Nicholson, *1946 (Towednack, Cornwall)*

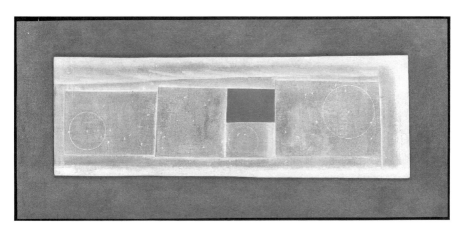

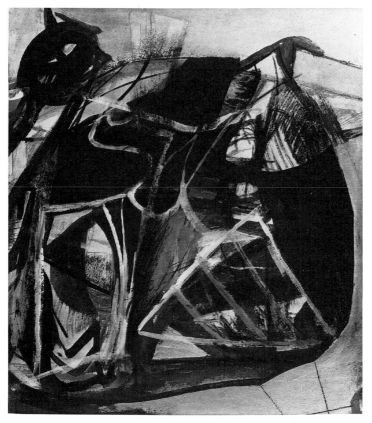

49 Ben Nicholson, *December 1962 (galaxy)*

50 Peter Lanyon, *Landscape with Greenhouses*, 1952

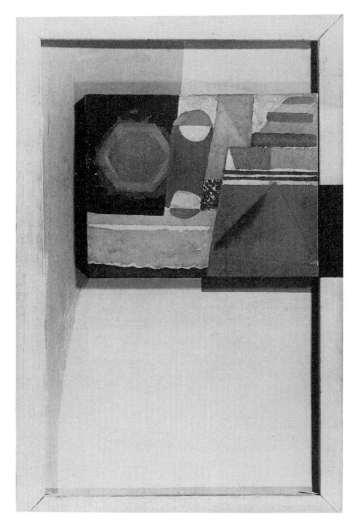

51 Ivon Hitchens, *Triangle to Beyond*, 1936

52 Ivon Hitchens, *A Distant Lake*, 1970

53 Mary Potter, *Fishing Nets, Aldeburgh*, 1953

54 Mary Potter, *Sun and Stones*, 1980

55 David Bomberg, *Sunset, Bideford Bay*, 1946

56 David Bomberg, *Evening in the City*, 1944

had blocked his window with hardboard in order to avoid seeing the view across Rye. A picturesque town of old rippling roofs and cobbled streets, a tea-shop place was the last thing he needed. While he was at the cinema matinee in his head, his idea was to avoid coming out, blinking, into the sunlight.

Never liking it, it was typical that he should live in Rye all his life. He preferred the gravel pits and sheds on the road to the harbour. He liked the high view down on to the recreation ground, the fisty trees, the debris generated by the workshops and fishing boats on the winding estuary. He liked the way the slug of Stone Hill crept across the far side of the Marsh [44]. In 1953 he left Springfield at last and moved into the disliked town, to a house built on the site of a Methodist chapel bombed during the war. From here, high up, he could look across the Marsh with its snaking river, razor-sharp dikes and flashes of lying water [45]. From side to side his eye shot, but mainly into the far distance unclouded by mist and atmosphere. Like a cockroach creeping up on an outsize ham, he had approached landscape via people. Now he began to paint an extraordinary sequence of panoramic views, quite bereft of figures, which seem as though the feverish child shut in his old bedroom at Springfield, tiring finally of waspishness and gossip, had put his eye down to the level of his eiderdown and looked along it.

A great deal of what he knew of painting figures he brought to landscape. Views that might normally have provided consolation seem in Burra to convey profound unease. Pictures which on the face of it suggest those cheerful expanses unrolling in posters before the Bank-Holiday tandem cyclist or traveller by Greenline bus become suddenly distasteful. The metamorphoses which, in paintings of people, had turned a nose into a Venetian beak, now made the most inoffensive landscape feature dilate uncomfortably and strain at its constraining skin. All the senses, not just his visual sense, were heightened, taut. As to an adolescent, or someone aping insanity for fun, the physical world seemed unnaturally bright, unnaturally actual. The smallest event could become an intense and terrifying adventure. Like Denton Welch, whose novels and notebooks convey the same unnerving pent-

ness because he was an invalid, Burra exactly described the physical appearance of what he did not like. The two of them are very similar, I think, in the fastidious and hypnotic way in which they suggest aversion. Denton Welch could convey precisely what it was like to have his head held in the warm air over a radiator or to cut the top off a finger: and Burra was sharp about landscape as though what it, too, needed was some eyeshadow and a few cruel jokes. The physical world, whether boulders lying like brains in a landscape, or a collection of scented objects on the top of a dressing table, groomed by careful description, has a horrid way of adding to the frailty of human nature.

The extreme oddness of these pictures is very difficult to come to terms with. When they confront you they are quite different from their effect in reproduction. For watercolours, they are abnormally large, very big indeed, often built up by joining several sheets together as the design, like the landscape, took on a life of its own and seemed to expand. They have a dreamlike clarity of surface because they were painted flat on a table with all contrasts of tone deliberately exaggerated and a very careful attention to edges, or rims, so that forms approach each other and stop short in a worrying way that is not at all the way of forms in the real world. This produces a look of glassy clarity and clean air which makes vision boundless as if to the magnetic mountain. 'For rhyming trains are meeting at a foxtrot / For string is floating on the water.' (Roger Roughton)

I once saw a yellow hotel on a hill. It was so vivid that I am uncertain whether I saw it in reality, in a dream, or in a painting by Burra, in one of those annual one-man shows in Bruton Street that used to leave the world looking booby-trapped for months.

The working method which contributed to this strangeness was developed in his bedroom as a child and never varied. He could work anywhere, on rickety tabletops in hotels if necessary. He explained this as being the least taxing method possible, because he was almost permanently tired and would have worked lying down if that had been practical. Beginning on one page at the bottom right-hand corner, he progressed upwards and to the left in an arc, adding subsequent sheets when necessary until the drawn design was complete, and then

filling it in. The process of selection he used was mainly the effect of memory. He did not paint on the spot but sometimes used drawings made after seeing a view. Because the drawings were done after seeing the landscape, and the painting from them was often not begun until many months later when the scene had come to the boil in his mind, there were two clear intervals between seeing the subject and making the picture during which his imagination had the chance to act on it. There was yeast in his imagination, as there is in nightmares. The effect was often that two or more swollen or stretched views were combined while giving the impression that the picture was one land-scape painted from direct observation.

He would sit in a car, watching. All over England, people park cars at strategic high points and sit looking at extensive views as though the act of looking is somehow self-justifying. The separateness of a view emphasizes your own impotence. There is little you can do with a view except to stare at it. Beginning in 1965, Burra was driven on regular car journeys around England by his sister Anne. It was she who chose where to stop. They went to empty places where he could see a long way, in East Anglia, on the Yorkshire moors and in the Welsh borders. He sat wherever she chose and watched impassively from lay-bys, just as he had watched human antics through the fumes of nightclubs, memorizing the faces of waiters so that a long time later he could make accurate and compelling pictures from what he had seen.

Was it disenchantment with people that led him repeatedly to paint these empty places, or a fascinated disenchantment with the places themselves? He seemed to dread them. They swell, stretch, curve, crease. Bruised clouds stack over them and break open. Floods and fields make their puddles of watercolour. Trees are abruptly lit up in negative as if by a nuclear blast. Rock outcrops are swollen with disease. Chasms dwarf. Bile-yellow and a punishing green can hardly contain themselves. It is as though Cotman were reborn specifically to see England in its worst light. Imagine a purple cabbage cut crisply through in section: the curving, vivid edges and faultless intricate

divisions are the vegetable shapes in Burra's landscapes, perfectly adapted to watercolour. But what gives the pictures their emotional potency is their raking depth to the horizon, their roller-coaster perspective [III].

I suppose it was always a long way down one of his bars, but by 1960 he could do almost anything with perspective. Perspective became his longest suit. Romney Marsh may have given him the idea but he found countless ways of extending it. Railway tracks, motorways, dikes and lines of pylons cut directly up his designs from bottom to top. They sink into dead ground and reappear climbing distant slopes. They go over ridge after ridge and still the atmosphere is clear enough to see them plainly. Lines go up his pictures like thermometers rising. Roads bolt upwards to the horizon as though making for a very distant burrow.

The landscape is empty because the traffic never stops. The pitiless, remorseless, nose-to-tail traffic; the mobile junkyard of half-human lorries which, snorting their own fumes and grimacing with effort, breast the hills to transport graffiti across intersections and over viaducts until the world is deaf and dumb and all the countryside shaken to bits [43]. These machines can turn on each other, earth-movers bite bits out of one another with metal jaws, dog eat dog, and only the half-crazed Bank-Holiday pillion-rider, hair flying, cutting through the traffic, can be seen to be almost entirely human. 'You who go out alone, on tandem or on pillion / Down arterial roads riding in April / . . . Refugees from cursed towns and devastated areas' (C. Day-Lewis).

No one would venture willingly off the road into the unholy places where he sometimes shows an isolated figure. A faceless figure, darkened by a trick of the light under leafless trees, is digging a grave or working an allotment [42]. 'I cannot see their faces / . . . the knobs of their ankles / catch the moonlight as they pass the stile / and cross the moor among skeletons of bog oak / following the track from the gallows back to the town' (Louis MacNeice). The only traffic on a forlorn path through a graveyard of boulders (in Connemara) is a figure, the same figure like Death, hooded by an army blanket, repeated three times as though at different stages on its journey. None of the

three will ever catch its other selves up, separated by the landscape and by time, its furthest self already distant, moving as surely towards the horizon as the reddleman on the heath. How effortlessly the landscape outlives the traveller! The heart has rotted out of the trees, out of the figures and out of the views themselves.

Views across chalk Downs to factory chimneys in Sussex; the Weald seen from above, bulging like the bottom of a boy scout on a bicycle; the cloisonné pattern of Cornish fields broken off by the sea; Dartmoor ready to murder lost hikers; the Lake District with its knees up under the wet viridian blanket; an industrial town itching the lap of a valley; the scarred high places of Yorkshire and Northumberland; hills in Snowdonia like the stockinged heads of criminals; the Wye Valley in a vast gesture parodying Wordsworth and the Sublime. Everywhere there are the giant teeth of broken viaducts, dizzy quarries, white cauliflowers of smoke. Who will give you sixpence for a cup of tea, a cup of comfort, in such a landscape, where the insane traffic throws grit in the face of the receding hitch-hiker and all the meadow plants are poisonous?

No one has made a more convincing case than Burra against finer feelings in landscape. Even the traffic must have seemed to him to have an energy which he lacked. He watched the countryside as though craving extremes, and painted it as though something terrible were about to happen. Depicting people or depicting landscape, he was a kind of voyeur. About mountains and valleys he made sharp, exaggerated comment. He put round malicious rumours about places so that we see them in a new way. But an imaginative truth always stands for a real truth, and if he played up the awesome, the flawed and threatening, we can see the accuracy of it sticking up through the pelt of fields and moors whenever we look.

Asked about the meaning of his landscape paintings, he gave a version of the reply which I suspect he often used. He simply said: 'Call in a psychiatrist.' With his air of subversion he made isolation a virtue. In some ways we are over-civilized. We are surrounded by, and constantly react to, art that insulates us against real feeling. That includes an easy view of landscape. In its place, Burra shows us a distraught countryside, never limited by its usual benign appearance,

in the hope that we may be unsettled enough to have some feelings of our own.

When he was young he was sent by his mother to London to have his spleen attended to. Instead of going to the doctor he thought of a slightly different kind of operation – more spirited, less useful – and had himself tattooed. His attitude to landscape was very like that. He saw and painted the related but utterly unobvious; and only artists and children have the imagination and courage to do that.

12 Abstraction

Ben Nicholson

Let us look at the *idea* of abstraction in relation to the landscape without being too dogmatic about it, and remaining as alert as possible to sensations.

Landscape by itself is meaningless, but it works on our feelings in profound ways, arousing in us a sense of ourselves in relation to the outside world. What does it feel like to stare up at the night sky or to confront a mountain? A picture which mimics the appearance of natural phenomena will miss the point, not just of *their* essential nature but of ours too. Instead, some equivalent has to be found: an equivalent of the way in which they act on our sensibilities.

Music, being wholly abstract, is able to suggest equivalents because unencumbered by the appearance of the world: it exists in the form of cyphers for thought and feeling which bypass words and images in the same way that mathematics does. This is why, at their most affecting, other arts often tend towards the condition of music. A religious sense, and the wonderment engendered by contemplating landscape and natural phenomena, inhabit this same area of abstraction, not because they give rise to a state of elation in which sensation has become arbitrary and imprecise but because they are exact, accurate and truthful.

In *The Cloud of Unknowing*, the anonymous fourteenth-century writer warns against the dangers of interpreting physically what is meant spiritually. Painting has to find a valid way of operating in this area, of providing objects which in some mysterious way can stand

for thought and at the same time equate with the real world – in this case with landscape.

I think that it is at once possible to state a number of principles which might do. The first has to do with reality. Because it is fruitless to try to imitate a place in paint, and because its appearance and sensations may not adequately be caught in this way, it has to be re-made in terms of the painting. As Proust said, reality lies not in the appearance of the subject but in the extent to which it leaves an impression on the artist. In other words, realism has to be jettisoned in the search for reality. The sensation of being in a particular land-scape can best be conveyed, not by imitating in paint the appearance of its parts, but by summoning up its essential nature, things like its light, space, stoniness or blueness. To do this, it is necessary first of all to relinquish the idea of a single viewpoint. Long after Cubism, that should not require too great an intellectual effort: as Ben Nichol-son would say, there is really no reason why we should be limited to a fixed viewpoint once we have realized that in life there are an unlimited number of points of view.

This first principle may not be easy to accept, and it is possible to put up against it all kinds of well-reasoned objections, but if you allow it to stand while letting the pictures begin to work on your sensibility, you will see that it has immense implications. There is one way in which it is highly idealistic. If it does turn out to be a valid way of communicating what it is like to be in the world, to be the human psyche in the maze of landscape, then it is far from being a limited means of expression understood by only a few, and becomes a potent universal language – like music.

The next principle, which derives from the first, has to do with experience. In the landscape, under the stars or in front of a mountain, it is the experience of them at first hand that has its effect on us; the sense that they occupy a place which is somehow related to us if we could but understand how. To stand correctly and to exercise its effect, a painting must be an experience in the same way. It is not an inert object which apes the appearance of something else, but it must have a life of its own as intense and as readily communicable as the life we recognize in natural phenomena, and it should be as surprising and

as difficult to pin down as they are. This is to say, in effect, that it must take its place in the natural world on equal terms and that it should be enjoyed, understood, experienced, according to the same criteria. Nicholson's way of expressing this was to say that blue can exist in a painting in its own right, and that no sea, no sky, is required as a key to the experience of such blueness. Blue becomes an idea, not simply something painted on to the surface of a picture, and the colour blue as an experience can no more be touched physically than you can touch the blue of a summer sky.

Now I think there is a sense in which this makes the picture into its own country. The sensations that went into the making of Nicholson's abstracts had very much to do with his places, in particular with Cumberland and Cornwall, especially in respect of their colour and bright light; but, though they derive from specific landscapes, the response they evoke is one of universal shared experience, not necessarily that of a particular place. It often feels as though this kind of painting originates in a state of mind, a condition, which takes on the shape and colour of the painting (its locality) and then expands again in the mind of the viewer into a condition resulting from its implications: so the idea is this shape

compressed into the form of an object only at the point at which it passes through the picture. This must be true of any work of art but it has particular implications for landscape. Some great artists, like Nicholson's friend Mondrian, have been at pains to make abstract art so pure that it is untouched by any reference to the natural world, as though that might be misleading. It made Nicholson smile to think how Mondrian, on noticing the leaves of a chestnut tree just visible through the skylight of Nicholson's Hampstead studio, shook his head in disapproval and said: 'Too much nature.' A painting by Mondrian is self-contained to the extent that it somehow puts you in mind of

nothing so much as itself, whereas a picture by Ben Nicholson invariably puts you in mind of the distant and near of mountains or sea or of light pouring over buildings far away.

I hope that, so far, this does not sound too abstruse. Nicholson himself disliked attempts at intellectual discussion about painting and said little. What he did say was almost always analogous and kept well away from pictures themselves so as not to impinge on their freedom. He knew not to try to explain them. In his studio, I found that long silences were what he expected and hoped for, because to talk in front of pictures is only to interrupt them. An amused and allusive conversation about tennis or Italy, preferably in the kitchen with a drawing or two propped on the table among the plates, suited him much better and enabled him to say as much as he was prepared to say about his own work. He would discuss it in terms of modern architecture, Cubism or music; he would talk about Miro and Braque and Piero in ways that made it plain that he was talking about his own painting too; he was witty and undoctrinaire and certain to ensure that words never came near enough to the work to pin it down, as though it had to be accepted that everything in it of importance was beyond the range of language. As soon as, instead of experiencing something, you express it, it ceases to belong to reality. However, it *is* possible to go a little further without offending this principle, because the argument for abstraction seems to have thrown up a contradiction.

Contradictions are at least a sign of life. Nicholson looked at experience and worked on that: it was what he had to go on. Experience asks fundamental questions of what exists, first by trying out what statements can be made about that experience which are incontrovertible: in saying that blue is blue you at once exclude the possibility that it is un-blue. The *idea* of blue remains the same while other changes take place. In all cases, the essential elements, the identity of an object, remain the same while change takes place, and yet that essential identity resides in our experience of it, our idea of it, rather than in the object itself. So the apparent contradiction is between the particular and the universal, the form (which is specific) and the spirit (which is not). Because Nicholson always felt himself to be concerned with

visual territory, it is reasonable to suggest a literary equivalent. When Hopkins stared into the face of a daisy or at the poplars at Binsey, his intense feeling for their individuality was absolutely specific but what he wrote about them was, precisely because of that, universal.

Here are two other contradictions. Nicholson wanted to convey some idea of the infinite, of the spirit of landscape, by using what he called free form and free colour so that his pictures should themselves become part of light and space and life, but he did so by making us extremely alert to them as objects with a physical presence of their own. In other words, it was the *spirit* of landscape that he looked at, not its stones, and yet he seems to be dealing in rough substances and physical facts.

It follows from this that, from rather early on, he saw that he could make pictures into physical events by treating them physically: by scratching them, scraping them, and incising them to make us aware of their surfaces, and by wiping or rubbing paint on to them so that we are aware all the time that it *is* paint as a deposit and do not mistake it for an imitation of colour in something else. Seeing his mother, the artist Mabel Pryde, taking pleasure in scrubbing the bare wood of the kitchen table rather than discussing aesthetic theory, made him realize, he said, that he wanted his work and all the physical sensations of daily life to be parts of the same thing. That is very convincing, but how does this awareness of paint as a physical substance (one of the great pleasures of a picture by him) square with his idea that colour and form are inseparable and that colour, like the blue of the sky, exists as the inner core of an idea? It always seems shocking to me that if you rub a brown hen's egg the colour comes off. Nicholson, in his pictures, wanted it to be as impossible to separate wood from wood-colour as it is to separate stone-colour from stone. When you look at the White Reliefs you must think of the quality of whiteness as going right through them, as if they were carved in chalk. In fact they are carved, usually, in mahogany table tops picked up in the Portobello Road and afterwards painted white.

Before trying to find some kind of useful equivalent in words for the way in which Nicholson could abstract landscape, I want to suggest one other rather awkward principle. I am afraid it is another contradic-

tion, and an old one. How much of the world's pain can be expressed by a straight white edge or by a rubbed circle? The physical world is a threatening one and sometimes it only seems possible to convey its nature accurately by the use of instruments as risky, violent and demonstrative as forms of expressionism. Several of the artists in this book have felt impotent in the face of landscape unless they submerged themselves in the paint of it and swamped themselves in its sensations. Does Nicholson's clarity, elegance almost, mean that he was immune to experience at this level, or that he transcended it? What has the radiance and comparative peacefulness of his abstractions to do with the turbulence of real landscape?

I think there is always a little distance, an implied distance, between us and the world. It is being barely perceptibly at one remove that sometimes enables us to perceive it more clearly, like holding a page a focal-distance away so that it becomes possible to read. This slight distance makes us more aware of ourselves as the recipients of sensations, as though we can best be receptive to the place and the state of mind evoked by the picture if we first have a sense of our own separate identity. This delicate sensation of being tuned up and alert to clear nuances of design is difficult to convey. I have often had it in Italy, especially when looking at Italian primitive art, of which the abstract qualities seem to occupy much the same ground as Nicholson, and to have a similar mood.

Distance and lucidity: they give rise to a metaphysical frame of mind while stressing their physical presence. Would not cloisters, too, be a suitable analogy? The beauty of cloisters is in the colour of the stone, in the lively and solemn bounding of the line, the graceful carrying and disposition of weight, and, most of all, in the fall of bright light on to the gloom and the slow but passionate movement of that light in regular divisions across stone surfaces. This might equally be a description of a Nicholson relief. It makes the spirit breathe in. It can refer accurately to the sensations engendered by landscape, and its implications can be extremely far-reaching within its own refinement without recourse to violent gesture. You know this quality equally in front of a Piero. The picture is its own country. A state of mind becomes a place.

*

So, what *had* Nicholson to go on? If we return briefly to the analogy with music, it would be true to say that the extraordinary range of sensations it can induce is the result of three main elements: harmony, melody and rhythm. It is correct to say that the profound and limitless reflection of the world produced by the abstract system of music is largely the result of these three resources working on our sensibilities. In Nicholson's case I think that their equivalents, with which he conveyed the sensations of being in landscape, were line, form and light.

Line always seemed to him to be a mystery. It has a life of its own. It is a record of the journey of a point on a paper or board, the trajectory of a ball, the contour of a hill. It can start by being one thing and, without leaving the page, change to being another. It can go over, under or behind, break off without warning or wind itself into a spring. It is playful and deceptive. It hardly exists in the real world. No line goes round a cathedral, a cloud or a plant except in the mind's eye as a means of marking off one thing from another or implying the volume of each: the boundary, or margin, of a form, an edge. Even the frontier between two colours becomes a line, like a dado. It can make a feint at being a horizon and turn out to be an edge. It is athletic. It can spring, sag, tangle or make a straight bid for freedom to the edge of the picture and disappear. It can describe a perfect circle. If you spread your hand on a page and draw round the fingers, the result does not look like a hand-print made at one instant but retains the sense that the line was traced out as a sequence. I think Nicholson felt it was important when you looked at a line to have a sense of the speed at which it was drawn in order to experience it fully. The quite stiff resistance put up by whatever he was drawing on, to the progress of a pencil, a knife or an etching needle, to him was a valid part of its effect. There is no harm in a line wobbling because it adds to the knowledge that it is handmade. Very often, after turning its somersaults, it returns to its starting point, which is discernible, as though to imply a continuous movement: the movement of light round a neon tube in an advertising sign. Is not the crucial nature of it that it is predetermined by something else, something it has to go round or something that drives it?

One of the lines that Nicholson most liked in landscape was the railway line that he could see from Winifred Nicholson's house in Cumberland. Below the garden was the deep view across the valley of the Irthing with the fells beyond. On the far slope from the house it was possible to see a train making its way around the contours of the landscape, drawing its line determined by the valley and the shape of the hill where the track ran. Sometimes, to his delight, the lines of two trains would converge from opposite sides of the view, meet, cross, and draw away from one another again. Those lines described very well the bulge of the landscape. Its steepness determined their speed.

Compared to this, form is infinitely profound. It is mass, the grave substance of the world. He always felt at home with the massive standing stones at Carnac and with the quoits of West Penwith, saying that they had a peculiarly intense feeling of life because they were not considered to be works of art. He carved into the form of his pictures to emphasize their solidity. The bulk of things stands up to him. The irregular edges of his forms have an identity independent of the edges of conventionally rectilinear pictures. They cannot be boxed in, caged up, by frames which do their best to mark them off as separate from the world when their whole function is to be part of it. Their forms go free whether they seem to have the bulk of an alp or the wound-up angular unpredictability of a grasshopper in hot grass. Because of their form, small works by him often have the inexplicable faculty of conveying a grand scale. Henry Moore told me once that his idea of drawing the lower half of seated figures as gigantic cliffs, and diminishing the chest and head, was the result of sitting on the floor in a cramped flat to draw his wife on a chair. The shallow space of Nicholson's abstract reliefs gives the same impression of being close up to physical bulk, as though within its ambit.

One of the qualities of mass in the landscape is that it is still. Line unravelling across surfaces can move, can dance; heavy rain on the surface of the lake will inscribe rings; but what remains the same while other things change is the solemn form, its splendid architecture.

When he first arrived in Cornwall in war-time, Nicholson worked in a small room, lent to him by Adrian Stokes, and went on with the white reliefs that he had been making in London. He worked on a

small table, with sharp tools, with jazz on the radio. He also played ping-pong because timing and vigour and improvisation in ball games always delighted him and seemed to him to have much in common with painting. The shapes and surfaces he made in the reliefs did not refer directly to landscape: they were pure, contemplative, architectural. Painting is an instinctive process, thriving on the unexpected, making use of accidents. You can measure and calculate: that will enable you to design a beautiful object or a perfect building. But you must be imaginative, intuitive, alert and risky, to adjust that design until it has a poetic meaning that is no longer quantifiable. The great beauty of the white reliefs is not that they are fleeting ideas caught on the wing, but enduring and harmonious objects. They were felt and experienced rather than arrived at intellectually. They were made in the spirit of quietness and composure that Nicholson liked so much in Mondrian's studio: the light in the room, and the pauses and silences between speaking.

Outside his own Cornish studio the world must have seemed exceedingly disorderly: most days the sky going by at a tremendous pace; the sluicing of waves and exploding of breakers, that endless pitiless tugging at the headlands by the sea; prevailing winds, quoits and stone hedges; the underworld of tin lodes; the old hardship of it all, generation after generation; harbours, like churchyards, bobbing with coffins. Only very slowly did this have any effect on what he was doing. There was too much movement in it. Barbara Hepworth could stand on the cliffs and feel herself to be physically part of the arms of the land, the shape of her body seeming to her to become coves and headlands, her spirit identifying with the waves strung tight between them, as though she was so much part of what she saw that she became both land and her own sculpture. Later, Peter Lanyon, who was no visitor but genuinely part of Cornwall, would lie on clifftops and concentrate on the sensations of pressing himself to the ground, seeing the clouds move, feeling the world turn, knowing that it was this that he wanted to brush widely into his paintings with such conviction that they would be recognizable as their elements to a mackerel or to a gull as to a man.

I think that for the land and weather to impinge so violently on him

would have made Nicholson feel that the internal harmony of his work was somehow put at risk, that the composure and unity of the pictures might be damaged by the arbitrary: that the country of the pictures was threatened by too much external activity. Painters in whose experience the storm rampages all day do not necessarily know that the subject inside a picture is no longer the same as the subject outside it. It is true that what he had to go on of the natural world was the poetry of it, and that to use the intellect to reason it out when the world acts so turbulently on the senses is inadequate. Reason, when dealing with weather or light, is a poor substitute for feeling. But is it not an essential beauty of a work of art that it has its own unity, that it is a kind of microcosm, and that an attempt to convey the muddle of the world by making a muddle of sensation is to lose its point and limit its reason?

By beginning with the unity of his formal arrangements and then letting the landscape gradually act on them, Nicholson made his work appear to have grown from within, like everything else in nature. The form suggests reticence, composure: outside, the Atlantic breakers slug away at the headlands.

But gradually the world beyond the studio found its way into the work as surely as the tide comes in. Nicholson began scraping and scouring the surfaces of his forms, rubbing colour on to them with rags or brushing them with successive layers of thin pigment and then scouring and scratching it away again with razor blades to uncover the ground beneath, as though the erosion of rock by weather was something he could experience himself. He drew across the forms, and began to fill their interstices with firm, flat areas of clear colour. Sometimes the coloured areas were regular geometric shapes, rectangles, squares and circles [IV]. At others the line twitched because he had been out on the cliffs, drawing, at Pendeen and Lelant, where the engine-houses with their chimneys make their forlorn, abandoned geometry against the sea, or above the patterned farmland spread among its battered nervous system of walls around Trendine. He looked for the taut lines of telegraph wires, the verticals of poles and chimneys and church-towers which accorded with his precise geometry; but on bicycle rides to Carbis Bay and Zennor, and on

walks up Trencrom Hill, he was lassooed by a much less ruly line, in the curve of the road, the swell of the hills, the crescents of harbours and hulls, a line of which the loose end would snake in the wind if he let it.

Into the gaps between these shapes he painted colours that seemed to have been made from the landscape, in the same way that it is possible to boil up lichen to dye wool. Red-brown sails, mauve fox-gloves, sage and seaweed, sand, pebble, rust, rock, the finger-nail pink of shells, the absolute blue of sky. The point of these colours is not that they are used to describe forms but that they become them. They are substances, not surfaces. They can be cut into or carved off. They are facts, as much as the fact of a brown rectangle of chocolate bar or the green rectangle of the billiard table in the Gower Hotel, which seems to have caught his imagination more than anything he was taught as a student at the Slade. I deliberately did not distinguish between colour and form when suggesting the ingredients of his abstracts because he refused to make the distinction himself. The form and colour of the pictures are perfectly capable of digesting the raw materials of landscape outside the studio. Bits of reality, like the grit in a bird's gizzard, are an aid to digestion. The pictures depend on our recognizing the sensation of height or the colour of sea in the way that they refer to them. For the pictures to try to *describe* them would be as futile as trying to describe the smell of seaweed or of engine oil to someone without a sense of smell. Poetry suggests the essence of things in terms of something else.

There is one other point about colour that never failed to delight him, and that is its capacity to suggest depth. He had it demonstrated to him as a child by his mother and played with it like a toy he never grew out of for the rest of his life. It is no more complicated than that a block of one flat colour placed so that it touches another conveys a sharp sense of their existing on different planes. A tiny wedge of cerulean blue seen against a patch of black or red will suggest a distance far greater than a sea horizon. The eye focuses back and forth in it as it does when searching at different heights through the summer sky for a lark that can be heard singing.

I think these aspects of free form and free colour, improvised while

thinking of landscape and sea, gave him a high-spirited feeling that he was on the right track precisely because the pictures were a joy to make. Some artists work only with the greatest difficulty. Others speak of the way in which, when they are in luck, work comes out from under their hands easily and well as though they are no more than the conductors of some kind of divine current. Are not you suspicious of this? Science diminishes the fabric of the world by explaining it, takes something away; art adds to it. But at what cost? Nicholson lived by his senses, alert like a cat and light on his feet. He had confidence in the outside world and his place in it. If a picture was pleasurable to draw on, or scrape off, or brush colour into, if the line arc-ed easily like the flight of a bird and the colour sang, then all those things were somehow proofs of its validity. Often he spoke of the artist's freedom to base decisions on nothing more complicated than the pleasure he derived from the result. One of the effects of this is that the picture, which bears all the marks of having been an experience to the painter, seems not to be an end in itself but the beginning of an exhilarating experience for the viewer, as though he *becomes* something by it rather than just regarding it. It is in this way that, via the pictures, you go outwards again in imagination into the landscape.

And finally, light. Nicholson once said that he judged the liveliness of a painting by the quality of light it gave off. Often his clear surfaces and the concise freshness of his designs seem intended to trap brightness, the same radiance that he admired in Giotto and Duccio.

It is worth remembering that his first serious landscapes were painted outside in the snow during his two winters in Switzerland in 1921 and 1922. His father, William Nicholson, as an artist whose passion was the chalk-white landscape, and who knew how to convey the crystal-clear air of a cold morning with pockets of snow in the hollows of the Downs, was a stylish painter of white; but he used glints of impasto, a flick of the wrist as likely to put the gleam on a silver teapot or the highlight on a silk hat as to reflect light brightly off the sea at Rottingdean. Ben Nicholson's way, from the outset, was less fatty, less Edwardian. His biggest urge when beginning, had been to bust up the sophistication of Edwardian painting all around him. He painted his surfaces thinly or rubbed them down to reveal the

whiter ground beneath. A pencil line emphasized the pale presence of the board. A small white house in the first (Lugano) landscape makes a brilliant rectangle, a red one in front of it partly masking it as though to emphasize its dazzle. The picture does not just put you in mind of a bright landscape; it has a pleasant coolness and vitality that makes it a bright, cool object in itself. It is a radiantly light thing in a room.

This lightness becomes synonymous with lucidity. Life has a volition of its own and will carry you away from yourself if you allow it, but Nicholson took care to live and work in places which reflected his state of mind and which acted directly on the pictures. White, in abstract paintings by him, could be coaxed to an intense pitch, and in his reliefs there is the silvery brightness that seems to be light from the horizon or light off the sea. He had much to go on: the clear air of Cumberland, with the white geometric shapes of farmhouses and cottages on the rain-viridian fells; the Atlantic dazzle of Cornwall, with white-washed buildings so bright that even their walls in shadow reflected light. The first summer after the war, in St Ives, was cloudless month after month and unnaturally bright. Then there was the brittle air of the Ticino, with glare striking off the lake, and later the brightness of Greece and Tuscany. The white reliefs, made in white studios in the 1930s, seem to give off light as a natural adjunct of their clarity and order. It is part of their poetry.

Is painting, being static, better adapted to static images? Is permanence moving? Why is a flapping curtain so affecting, when, on a bright afternoon, it lets in light? Is it because the movement is not explicit, like someone waving, or because the curtain is normally still and when it lazily stirs it shows itself suddenly to be a part of the natural order, to do with the breeze? Many of Nicholson's abstracts seem to me to have a life of their own because of the light. A cloud goes across them like smoke or a stain and they brighten unexpectedly, like Hardy's sunlight 'hardening' on the wall. Is it the *moment* which produces the poem or painting, when the exceptional is suddenly within the everyday, the light striking something to transfigure it? Drawing is a way of remembering on paper, but the swelling and brightening of light has to do with harmony and resolution and the passing of time, Proust's profound intimacy of passing time. In front

of Nicholson's best abstracts I know the old longing which is almost always audible in great music: the sense of something lost and irredeemable that was much loved. It is as though the abstractions are specific about knowledge we already have but can never realize.

And then you see the lucidity, the clarity of the light, the lively bounding line and the beautiful seriousness of the form, which is of the world, and of you in it, and you sense the same resolution that you can hear in the music: the wholeness, or harmony, which is a type of infinity.

Ivon Hitchens: Music

Stand in front of a painting by Ivon Hitchens. It is wide and fresh. You scan it from side to side as you would look from side to side at the view itself. You must let its sentiment wash over you: its colour and spaces, its broad gestures which the eye follows as though the pigment is being brushed on as you watch. It is clear that this is a kind of writing, but there is no need (yet) to read it or to make out exactly what it means. Instead you feel its resonance and breathe its air. It seems to shift in front of you as light shifts on water or leaves turn over in the wind. It has the first requirement of a work of art: it is alive.

If you are alert to this, it stirs in you sudden recollections, not exactly of how things look but of how it *feels* to see them. It is a subtle thing for landscape painting to find some harmonious equivalent, not for the appearance but for the exact sensation of seeing landscape. There is only a narrow space for it to occupy between you and reality, and Hitchens's painting seems to stretch along a kind of ledge.

He knew how to convey the sensation of looking. I suspect that he painted watching the landscape more than the canvas, miming its movements with his brushes as his eye followed them. Probably he thought of himself as representing what he saw rather closely and certainly not as inventing abstract systems of loosely brushed colour.

Here is how he worked. He took one of his typically elongated canvases, sometimes a double square and sometimes over three times as long as its height, and propped it very low down in front of the

subject in the open air. Stooping down or seated practically on the ground, he found the low viewpoint he wanted. This enabled him to look through or between the stems of plants, clumps of reeds or past the trunks of trees so that his field of view was divided up vertically. In a more conventional painter, this would have led him to choose a single vista, with a single vanishing-point, down the sides of which the verticals would align themselves, ranged in perspective. Hitchens's discovery was the possibility of conveying two or even three distinct tunnels or paths leading into a single painting [52].

With an increasingly loaded brush, and drawing broadly and rhythmically, he constructed these avenues with sweeps of lush vegetable colour. He used to say that nature seemed to him to consist more of spaces than of objects, and it often appears that he instinctively drew the air and light that vibrates in the interstices of the view rather than the view itself. He worked quickly, his concentration directed at the mysterious business of summing up colour and shade, light and dark, simultaneously in the same brushstroke.

There is something uncomfortably man-made about a painting propped outside. Its corners are too regular, its surface too clean, and patches of sunlight and shadow through leaves disturb it. The hum of nature all around it emphasizes the impossibility of catching anything of such scale and complexity within the limits of even a very large canvas. It has to be re-imagined. Hitchens would often take the painting inside to complete it and to test the accuracy with which its drawing conveyed the spaces of the view from which he had worked.

Now comes a paradox. His calligraphic, full-brushed method suggests writing on the flat surface of the picture. He liked the surface, the marks on it linked from one side to the other with vertical breaks as a form of punctuation. He liked the analogy with music, especially with songs, suggesting that passages across the picture should be heard in sequence. He liked the white ground of the canvas too, which he often left untouched in places as though to let in brightness and air and to emphasize the spontaneity of his fresh marks on it. He liked to keep the finished pictures behind glass to retain their pristine surface, like bottling fresh air.

But the whole point of these paintings is that they are not on the

surface: they evoke, at every stroke, orderly and articulate depth. As landscape they are convincingly real precisely because the eye keeps recognizing their sensations – the glint of bright sky reflected in a single horizontal brushmark; the weed-filled standing water of a pool caught in a vertical; a patch of clear blue sky seen as a bold side-to-side gesture beyond the dark vertical swatches of clumped trees; the carmine and magenta patches roundly marking out clearings, avenues, vistas and boundaries, the near and the far plotted in depth simultaneously in their rhythms.

Such free, inventive and passionate painting looks like an escape from something tighter, and it is. Hitchens did not begin to paint landscapes like this until about 1937 when he was in his mid-forties. Showing with the Seven and Five, he had developed the Society's characteristic silvery, high-keyed palette: he had worked with Ben and Winifred Nicholson at Bankshead in 1925.

At the beginning, the easy, athletic brushstroke seemed to be waiting, held up by thought [51]. With hindsight you can see that it was there, but constrained by heavier paint and rougher edges: a fast animal in captivity. There are early oil paintings, almost square, in which muffled ochre and grey and his insistence on searching out interlocking segments in landscape dam up and obstruct the flow with pictorial architecture. They are imposing pictures, and can be very beautiful, but as yet it will be unthinkable for a row of trees to be blocked loosely in in profile or for a pink barn to elide with a pink field in one embracing gesture, because that would depend chiefly on spirit and intuition, on a deep breath and a wide movement of the arm; there was still much brainwork to be done first. He dug the footings for his foundations in still lifes, often using close-to objects seen from above. Although there had been pre-war excursions into the countryside to paint landscape, especially to Suffolk, it was not until he was bombed out of his studio in 1940 in one of the first air-raids of the war that he realized what he must do. By then he had laboured a long time in Adelaide Road, Primrose Hill, where Ginner and Gore had painted mauve roof-tops and grey pavements from their front windows; but some time earlier he had bought a patch of rough

ground near Petworth in Sussex and to this he now moved, to live in a caravan with his wife and baby son, to try to continue work.

At once his method began to evolve quickly. It was as if he had to hurry to get his sensations down. He lived in a blanket of woodland, a thicket of silver birch and rhododendrons among fir trees, with a few oaks and Spanish chestnuts and a great deal of bracken and undergrowth, all of which changed constantly with the weather and seasons. The site was very much enclosed. He made a small pond for his own use and to catch reflections, saw almost nobody, hardly ever went to London, and in Walden-like seclusion developed a philosophical nature which found its outlet only in the refined simplicity of the paintings.

Until I saw this place, which has always been so much overgrown that it is almost impossible to find, I had not understood that what Hitchens painted was mostly only a few feet in front of him. His field of vision was wide because his subject was almost at arm's length. The vistas down which he looked were not broad avenues but small paths through rhododendrons. The first pond, and the others linked to it which he made later, are pools, not the great sheets of water they seem in the pictures. The landscapes, like the still lifes, occupy a relatively shallow space. The fir woods had been cut down in the war and scrub grew up in their place, on the poor sandy soil, hemming the artist in, producing short-range views.

This overgrown setting is even deeper now. The caravan, a long gypsy van the shape of a railway carriage, painted lavender, pink and black, remains among the trees. Near it are the ponds, planted with lilies and now partially blind with duckweed through the vivid green of which the red of goldfish shows as in the pictures. There is the wooden lattice bridge and the boat that Hitchens so often painted, with the scrolled ironwork of its armrests like a pencil line. The patches of sun and shade in the wood garden are starred with his colours, sunflower-yellow, white daisies, foxgloves and magenta cranesbill. Half-buried in the undergrowth is the random low house that, over the years, he built room by room; a long, low house for long, low pictures. Its vistas inside from room to room are like the woodland perspectives of the landscapes, with the same slabs of colour: apricot

doors, black and pink materials, bright gladioli in a window or on the piano. Hanging up everywhere, like washing, there used to be the countless drawings he would make before beginning to paint. No place could look more like the work made from it.

Year after year, when it was fine enough to paint outside, Hitchens took his equipment into the undergrowth in a wheelbarrow and remained there all day with sandwiches and chocolate. Sometimes, as the vegetation grew higher, he worked from the flat roof of the house, surrounded by its curious chimneys with their H-shaped flues, but even from here there was no way in which he could see the distant view. He preferred this, and never tired of it. By immersing himself in the undergrowth and the seasons at close range, he developed distinctive palettes: it is almost as though the paintings are palettes themselves – the brown/red, the blue/black, the magenta/orange, the sedge-green/-cerulean, the brown/cobalt. Every painter knows instinctively how happily or unhappily his work is going to turn out from the state of his palette. But Hitchens had the added complication of his format, which could affect his palette too. From quite early on there is the periodic appearance of a cunningly placed small patch of red or orange intended to balance much larger passages of painting far away on the other side of the picture, a patch of risked colour, something out on a limb.

The long shape certainly generates risks. The avoidance of the golden section puts both painter and viewer slightly off-balance. Hitchens, like Ben Nicholson, was interested in investigating the shape of our field of vision, the configuration of what we actually see, and tried to adapt the geometry of pictures to conform to it. The bulging eyes of rabbits are adapted to seeing backwards; cows and horses look out sideways and have two separate views; but is our own arc of vision more like the two overlapping discs produced by looking through binoculars, or a single circle blurred at the edges, or a blurred rectangle? Its depth of focus seems not to make it a regular shape at all. We are aware of recessions and intrusions that we are not able to take in more than one or two at a time. Hitchens's long canvases produce something of the same sensation, just as Turner's unnaturally elongated canvases do, those of the park at Petworth nearby, or painted on

a boat as he went up the Thames from Walton to Windsor in 1805–10. The long horizontal surfaces of water lend themselves particularly well to a wide shape. When Hitchens did sometimes venture out of his wood, it was invariably to paint water, for example in the innovative pre-war series of Terwick Mill.

Terwick Mill, which he could reach by footpath across the fields from the old bridge at Trotton, south of Midhurst, provided him with a long sequence of ideal water subjects on a more expansive scale than his ponds at home. The fluid brushmark, the broad stain of colour that he liked to spread out on clear canvas, always lent itself to paintings of water and reflections on water. But it also epitomized his other preoccupation, that of making a space that pushed back into the picture with a single mark. An expanse of water does this. It lies down as a flat shape, a receding surface, while at the same time catching light and dark and reflected colour, all in the same brushstroke.

The pool below the weir at Terwick Mill was a place in which to think the problem out. The bank on which he sat in the 1930s has grown up with trees now but otherwise his view is the same, showing that even the most apparently abstract pictures were scrupulously related to what he could see in front of him. The place is like a stage, with the brown pool occupying the centre and, at the back, the constantly falling sheet of white water from the sluice-gate [v]. These two brushmarks of water are at right angles to one another in the paintings. On all sides, except the centre, the pool is enclosed by willows and sycamores, sedge and reeds, and the magenta and mauve wild flowers that he liked best – balsam, cranesbill, fireweed and foxgloves. The black weatherboarded gables of the mill itself he indicated at most with a few cursory marks, but beyond it, between the trees, bracketed by willows, was a slice of sky, sometimes yellow, sometimes steel-grey, sometimes black, that made its mark and then wedged its clear reflection in the pool.

Often, despite his vivid palette and the decor in which he lived, Hitchens painted outside on grey days. He liked them, and thought of them as ideal for work because in their dullness he had to seek out colour and tone simultaneously, making bold masses out of dark

shapes and reflected light. This is more like painting from memory in front of the landscape than reporting on it or imitating it. It is why big harmonies go across his pictures, clearly organized and spread out as a sequence of gestures summoned up. If this has the look of Eastern calligraphy and brush drawing, it would please him. He read of the Japanese theory of Notan, the harmony of dark and light, as a student, and it was an aspect of his work to which he liked to refer until the end of his life – one of the few clues to his method that he would give.

Having said that Hitchens made his way from still-life painting to a kind of landscape painting that was essentially close-to, I have to confess that I always look forward to moments when, in all his screen of shrubbery, there is a gap. Plenty of good artists have shut themselves deliberately into a confined space for what becomes a prolonged scrutiny of their immediate surroundings. But Hitchens confined himself to his wood when he had it in his power to suggest deep space almost at a single stroke. He had meant only to stay in the undergrowth until the war was over. As it was, it suited him so well that he remained almost forty years and watched it grow ever higher and more shadowy around him. In a way it was analogous to his position in contemporary painting, the tides of which seemed to advance towards him and then recede: Soulages and Tapiès constructed their spaces with a comparable, broad-brushed calligraphy; American painting in the Fifties looked as if it shared his resonance in colourfield painting; Lanyon and Heron, most imaginatively, benefited from him. But he remained essentially solitary, and almost never emerged. He only once went abroad, to Paris in 1957 for an exhibition of his work. The small changes in his immediate surroundings never failed to absorb him. Places that to most people would seem hardly to alter were to him totally transformed by a change of atmosphere or weather. One summer to him was not remotely like another and if a tree fell across the pond and formed a V with its reflection his world was transfigured.

But what if there *was* a gap, an aperture in the dark wood through which he could suddenly see not just yards but miles of sun-drenched countryside? Outside Hitchens's wood is an enormous stretch of rolling landscape. The farmland to the south of Petworth and Midhurst

extends lavishly towards the heavily wooded Downs. The Downs are quite different here from the bare slopes near Firle: horizons are crowned with deep, tall trees. Reaching towards them are acres of corn and grazing land punctuated by massive oaks and beeches, each one looking like a single perfect specimen from the *Observer's Book of Trees*. And, on bright days, across the top of them, constantly manipulating their patches of light, go pile upon pile of cumulus, turning, processing slowly with their backs to the sun so that their borders are lit dazzlingly with, behind them, lagoons and estuaries of clear blue sky, sometimes with a grey thunderhead against the white. Hitchens painted the very near, but when there was a gap through which he saw the distance, you can hardly conceive of the astounded depth with which he painted it, the way in which three or four brush-strokes enable the spirit to fly outwards and upwards into the airy space.

He had a free spirit, intuitive, which paradoxically the wood released. The undergrowth certainly never penned him in or con-strained him. Far from it. Perhaps it was an equivalent of the broad, near surface on which he was working. Sometimes it does look as if he painted too much and risked making pictures that were typical of himself, of singing a song that had somehow become, through frequent use, a kind of parody of his first invention. That happens to some artists who have the luxury of time, especially poets.

But see Hitchens at full pitch and his vision is like the weather, like all the damp vegetable colours of the English countryside and its sedgy places brushed mysteriously together and then released. It is abstract painting of unmistakable accuracy. When his autumns break out on canvas they carry with them such drifts and arcs of copper and orange that you run in imagination down endless avenues of beechmast with the swaying of prodigious quantities of foliage overhead. But it is in the inexhaustibly evocative overlappings of high-summer greens and blues and glinting whites that he drowns us finally.

Mary Potter: Reflections

I do not think that the difference between things is as great as it would seem. Shapes can become one another without the savour of

distinction. The sea becomes the shore and, especially in mist or in too much light, water becomes the sky. Reflections blur their differences and make all they receive into one element, held on one surface. If it were possible to see the world as all of a piece, it would offer a consolation.

To reach this state of mind it is necessary to make less of the edges of objects, and instead to elide them, one into another, as we do when listening to a melody or to a musical phrase which would be meaningless in isolation.

Imagine a palette in which closeness of key, a rather high key, is most characteristic. Each colour has a similar pitch or timbre. One will smudge easily against another, or rub into it, with a tonal distinction so slight that it would be next to invisible in a black-and-white photograph. Colours do this in a range of pale lemon-yellows that is not at odds with the colours of sand, pollen or milk. They will do it on white porcelain and in the just perceptibly green centre of a white azalea. They will do it in moonlight that saps daytime colour from bright objects, leaving them pale as moths, and in sunlight so bright that it sucks the landscape and vegetation to a paleness interspersed by shadows.

Now consider the firm surface on which these colours may be set down. The colours do not work against this surface; they accept it quite simply, as simply as they did the palette. The relationships of such kindred colours on any firm surface, whether on the pleasant white drum of stretched canvas or on the unyielding flatness of board, is inviting. Some artists (a few) have a way of putting themselves in a strong position by no more than the virtue of their particular sensibilities, like having an ability to memorize poetry or to extract a particular sound from a 'cello. To produce such a distinctive sound is at once to evoke harmonies.

Mary Potter was able to do this. A clean canvas is a steady thing and well adapted to the slightest inflections of feeling, and to interpolations that are not obvious. In her late pictures especially, she worked in a kind of hush, like the hush in a conch shell. I have tried to put you in mind of a palette that reduces differences. In her landscapes the pointedness of the world is not so much absent as *subdued*,

subdued by her own nature, rather as snow subdues the country, making it quiet. Having no hearing, we see it as if for the first time. Hedges, sticks, footmarks are softened. In her pictures, trees and flowers bloom softly, a short distance between their fragrance and complete abstraction. Even the sea is somehow rounded. Paint rubs softly, like smoke, and everything lies down on equal terms.

How best to convey the way in which signs for landscape are laid as simply on the surface of her pictures as anchovies laid on toast? The only place in which the landscape is normally so gently reduced to one level is in reflections, reflections in a pond or in a river [54]. To forget the focal distances of objects in the world – one of the conspicuous ways in which they separate – think of them as resting all together on one surface, as though the picture itself is the surface of the water. Reflections may wobble or lie perfectly still. Water can support weeds on its blotted skin as effortlessly as it accepts dazzle. It can be cut across by the wakes of boats that leave a herring-bone of silver and white or, when seen against the light, leave only a dark scar. The moon becomes an oval and is eclipsed by a lily-pad. See how the surface of the picture will become signs for things that are both very close and very far away. Chalky water can be so cloudy that the picture refuses reflections as absolutely as pastry. There is no dazzle on custard. Or it can be transparent and reflect much. But reflection is not possible until it is brought within the ambit of a mood. Invariably it is a quiet mood with little or no movement. River water, moving slowly, will keep its received images; on the sea-shore, even inch-high waves, up-ending themselves repeatedly on the sand, provoke meditation.

This is what her pictures became, but they were not always as still. Once there was a stiff breeze. On the promenade, walkers held on to one another for support and hurried to dodge the next wave; the hollow hairnet of an empty hanging basket was swung violently on a seaside verandah and breakers surged green round the post topped by a triangle. When she was a girl they tried to make her paint in dark colours like everybody else and to look for contrasts. Far better to search for harmonies, to watch how brown freckles plot their way up a yellow pear. Have you never noticed how the sun-faded colours of

a tree against a roof, or a pinkish railway truck against a cardboard-coloured wall, have a way of suggesting designs that are already almost flat and which repeat in the brain like a pulse or a mantra?

Only very good painting can catch this thistledown, this biscuit-coloured dust hanging in a shaft of sun, and make it visible as an abstract pattern which retains a logic of its own. Why does it move us? I think because we sense such moments all around us but seldom remain still enough to see them. Contemplation can make an event of an afternoon on which nothing happens: it needs no more than the sunlight on a corner of the garden. Seasons change so slowly that they can easily be mistaken for permanence in these moth patches of pigment and barely discernible islands of thought. I worry that, unless they are looked at with sufficient attention, such pictures could slip the mind like a name and no longer be physical fact.

In front of them, think: oil paint is quiet enough to stop a falling leaf, hold a bird in the air or a dog in the park or a moon in a pond, to plot the scroll of a balustrade, and to make of all these things a small event of consequence. It is an event in which there are no distinctions between things, so that, in the landscape, everything is part of everything else. But it is also an event which light touched once and colour made into abstract marks in permanent relation to the four sides of a dreaming rectangle, and then forgot.

13 Appetite

David Bomberg and the Spirit in the Mass

Look at Bomberg's landscape paintings. What do you find in them that tells of your own nature? It seems to me that they convey a grave sense of what it is like to work, not just from inclination, but out of despair. Soutine's Céret landscapes are marked by the same thing. It is a profound seriousness and also a great, perhaps the greatest, release. It is written all over them.

This chapter is intended to be about appetite. What is appetite but a form of desire? The more one desires, the more one desires. As Baudelaire knew, the painter who cannot begin to paint, and the writer who puts off writing, endure a living death of the spirit. As the seasons change, they are tormented by the combined eagerness of the senses and the passage of time. Frequently they are aware that everything around them gives urgent signs that *this* is the very moment at which to begin work, that *this* is the minute of all minutes that they owe it to themselves to preserve. No task is impossibly long or impossibly hard except the one that the painter or poet does not dare to begin. Bomberg, through no fault of his own, frequently put off starting. There were long periods when he was too despondent, too discouraged, to paint at all. But by delaying what has to be done one runs the risk of never being able to do it. Prolonged unhappiness, as Chateaubriand says, has the same effect on the soul as old age on the body: one can no longer be active; one goes to bed.

It is one of the chief characteristics of landscape that it can open up huge new perspectives of spirit. I think that it is essentially this that landscape painting has some chance of conveying, and in Bomberg

149

we have a supreme example. There are rare times when an artist whose greatness of spirit, chained down in the normal course of events by poverty, illness and depression, is mysteriously and spontaneously set free by something he sees. It happens to the artist and can happen to anyone. That is why it is recognizable in a picture. After a long period of enforced idleness and misery, the hand and mind begin to move in unison and all forces are at once miraculously in equilibrium. Vigorous inspiration, like a gift of grace, is abruptly and inexplicably at full pitch as though to compensate for all the time and thought that has been lost (and will be lost in the future). One can never forget time except by putting it to use. And behind the work, behind every brushstroke in Bomberg's case, is the urgency of desire that has accumulated as appetite accrues over a long period of starvation.

He had painted no landscapes for almost ten years up to 1946. The pictures I want to discuss were produced in two short bursts in the summers of 1946 and 1947. In each case, after he left the landscape and returned to London, Bomberg stopped painting. After 1947 there are no paintings of any kind for four years. The passionate attempt to recapture all this time is evinced by the frenetic energy of the pictures. The pressure of inactivity comes from afterwards as well as before, as though he knew at the time that he could not sustain his impetus by will; he could not learn from experience how to reach it again by a conscious effort or by discipline, even though it must have given him a day-to-day excitement and release, a passionate joy, compared to which existence when not working was a waking nightmare. He saw himself, briefly but clearly, in the landscape as though in a mirror: but afterwards had not the means to find himself again.

I am not sure that, while trying to discuss landscape painting, I have made a proper case for the fact that it can still be a means of expressing crucial truths about the human condition. It is not just the setting for man which provokes him to various reactions; in painting it *is* man. David Bomberg did not only respond to landscape: there is a fervent sense in which he became it.

How can this happen? Sometimes an artist has an innate tendency, from early on, towards a particular arrangement in pictures. That is

not to say that he paints the same picture over and over again, as some people write the same book: it is that, were he left to invent an arrangement independent of what he could see in the real world, he would arrive at a design that represented *him*. At its simplest, this happens because the process of painting is made up of making one mark in relation to the edges of the canvas or board and relating the next mark to it, and the next and the next, until the whole system of relationships and revisions, constantly acted upon by the temperament and intuition of the painter, is brought to some kind of conclusion, the resolution he can best stomach.

Probably the same tendency could be traced in human relationships, or in a proclivity for particular situations. The point is that it represents in some way the artist's essential nature.

Now, on the face of it, Bomberg's early and later styles could hardly be more different. The first pictures are all mechanical angles and all people; the last, broadly brushed landscapes. But if you look at their underlying designs you will see that they are not just remarkably similar, they express precisely the same preoccupations. Bomberg's need in a picture was to find the ways in which shapes interlock in a deep space. It was what excited him. It means that there is often a rush of perspective from the foreground, articulated at each stage, calibrated, towards a knot or some other complexity at the centre. And because he wanted to animate the whole surface of the canvas, he often used a high vantage point so that there was either no horizon or one that ran right along the top edge. He was as likely to make this sort of picture whether he was looking down at a crowd of figures in a public bath in his twenties or studying dizzy views of streets and the rooftops of towns when he was much older. He began by exploring the arrangement in an idiom that was related to Vorticism and almost abstract, and went on to one that in its way was scrupulous about appearances; but the pictures were fundamentally the same because whatever their pretext or style, each of them was a map of his own painter's psyche, the way the world seemed to him most recognizable, most potent and crucial, and in the process it became a chart of his own sensations.

That is the similarity between the first and last pictures but there is

also one essential difference. When he was young, Bomberg imposed this system on what he saw. It was what he needed, so he rearranged life to suit his vision. It was a theoretical process, to do with will. Making pictures in this vein is like designing buildings or designing machinery. But as he became older, his view changed. The First World War aroused in him, as in many other people, a horror of the dehumanizing effects of technology, and a terrible apprehension about the loss of individuality. From the mid-1920s, instead of imposing his will on his surroundings, he began to watch for the humane spirit in landscape and tried to let it impose on him. I suppose that really he was looking for his own nature, his own individuality and his own requirements of a picture, mirrored in some way by the countryside. And when, at long intervals, he saw this, he recognized it instantly.

He recognized it as a part of himself and set about appropriating it and subsuming it with an appetite and passion that were almost violent. There was so much time already lost. As he knew, the vital thing is to recognize the pretext, to be set up by the right question. Some artists seem always to ask the right question. After that, there is no end to the possibilities they have to go on. Get under way and *then* analyse and develop. Once started, there is no argument that is not worth following to its conclusion or that does not have in it the chance of a right answer. All this makes for urgency. According to his wife, who watched him, Bomberg would stand looking at a view for a long time before beginning to paint, but, once begun, the mysterious struggle towards self-discovery was one of fierce and prolonged activity in which he would not let up, even after the light faded. You can see this when looking at a landscape painting by him. The view is pitched peremptorily into a tumult of the picture's making. It seems at once to be at full force. There are no preliminaries. Some works of art have a way of taking you directly to the very height of what concerns them, as though you have missed the beginning and anyway have no need of it. Elgar's Introduction and Allegro for Strings, which is another form of landscape painting, seems to do this, despite its name. One chord, and at once, in the next few bars, you are pitched emotionally to the level of the centre of the work. Bomberg in full flight does the same thing. But what you see in the picture is not a finished statement:

you see a process, the history of an unequal struggle, the turbulent trail of thought left by an artist working in a heightened state to produce what he called a monument to a memorable hour.

I do not think it is possible to explain this process, which is a kind of journey. The pictures need to be seen repeatedly and experienced in all their force at first hand. They are very beautiful and very terrible in the risks they take, and often they have no conclusion, perhaps because there is none. Because the experience they contain cannot be expressed in any other form than their own, the best that can be done, as with other journeys, is to say where Bomberg was and what he believed. It is possible to do this because he stated his beliefs in a declamatory, almost biblical way, without necessarily elucidating them. He hated anyone writing about pictures, and who can blame him?

The landscape in which he recognized himself in the late summer of 1947 was at Zennor. He pitched his tent near the back of a field that sloped down to a barren gully leading to the bay, a steep view to the sea. Much of the best thinking has been done within sight of water. Its actions provoke a state that is naturally contemplative. If you look down at this view and then turn round to face inland, the bulge of the hillside presses up to the horizon in two equal curves. Bomberg would paint this, too, but later. It was hot. He liked bright light. The grass was burned. He had six weeks in which to work and he began to produce a number of big, difficult and dangerous pictures in a state of high excitement. Towards the end of his time there the weather broke and there were storms, but he continued to paint outdoors in the rain, stimulated by the way in which torrential downpours and enormous curtains of cloud shouldered their way into the pigment.

Struggling to paint this place, all his concerns were summed up together. He always said that he was a draughtsman first and a painter second because his excoriating method was to draw and re-draw in wet paint, as though repeatedly attempting to convey the meaning of a long sentence by trying its phrases and clauses in a different order and in differing forms until he could make himself absolutely clear. The virility of this lay in the immediate necessity to make decisions

and revisions as the drawing in the paint built up. The beauty is that the process flowed, when he was in luck or sufficiently inspired, from beginning to end of the picture with one sustained impulse. Drawing and painting are seen to be the same thing.

The subject of this repeated re-drawing was not just what he could see of the landscape but the scale and energy its form seemed to enclose. He had to sense this and find it out, so that the painting is a constant attempt to convey the mass of the landscape as truthfully as possible, and as grandly as possible, with as much taken into account by each gesture or slash of paint as the drawing will bear. Mass awed him. The idea that it might be even remotely possible to convey in paint the magnitude and weight of the view – 'billions of tons of living rock' – seemed to him humbling and mystical. His only hope was to break down and build up again the forms until he began to arrive at some kind of unified, consolidated and articulate structure. Its reality, to him, lay in the structure of the drawing.

But this violent process of engaging himself in the volume and sweep of the view, and finding out its rhythms, was never intended by him as an end itself. In some ways it was only a beginning because it provided the physical clue to what really concerned him, which was spiritual. All the process of re-making the scope and magnitude of the view, the fraught and exhilarating business of discovering the logic of its interlocking shapes, was only given point by the emergence of some kind of animating principle in nature to do with the spirit. He believed he could find this in the paint. 'Mass is nothing,' he explained, 'unless it is the poetry in mankind in contemplation of nature.' The mysterious crux of the whole matter is summed up by his insistence on what he resoundingly and beautifully named The Spirit in the Mass.

The spirit in the mass. It should be what all great landscape painting is about, but how would you speak of it? Bomberg was in some ways not at all a modern artist. Oil painting is an archaic form and you carry the past on your back. He saw the individual spirit reflected in landscape and tried to express it as something inseparable from the seasons and moods of the earth. He in effect shook his fist at an increasingly standardized and technical society and identified instead with the terrific pulse of nature. He once said that he wanted his work

to be part of the winds, the tides and the ocean swell. This seemed to him to be a humane proposition, a proposition so strong that it constituted something of a crusade against a spiritually bankrupt audience. Except that he had no audience. He was an isolated artist, at odds with current beliefs, and therefore entirely ignored. In a period long after Nietzsche's death of God, he thought that the human spirit as expressed through its communion with landscape was still an utterly valid subject for a painter.

When he seized on it, greedily, in the flame-orange pictures he painted on that slope in August 1947, he must have had a sense of liberation, even of salvation. It certainly looks like it. His intellectual choice had been made and he was painting right up against his temperament and intuitions. I have often wondered about this situation, where an artist is working impulsively, responding and improvising as he goes along rather than reasoning. In this state he could be said to be responding rather than thinking. According to Hume there is an important distinction between impressions and ideas. Impressions, like those aroused by Bomberg's excitable encounter with one of his recognized places, enter the mind as forceful and lively perceptions. Under this heading come all our sensations, passions and emotions. Ideas, by contrast, are a faint image of these in thinking and reasoning. Hume suggests that, in order fully to understand our ideas, we have to refer them back to our impressions. Something of this to-and-fro action, with the reason constantly referred back and tested against his responses to what he could see, must have been Bomberg's intuitive method. It must also partly explain why, although he was scrutinizing the landscape with almost obsessive attention, and would not touch the picture except in front of the motif, he described himself as finding its essence by *feeling* it rather than seeing it.

There is a poem by Auden in which he re-states his theme of unrequited love for the natural world, a love of the universe unreturned. It is an unequal, one-sided love, and better that it is so. 'Looking up at the stars, I know quite well / That for all they care, I can go to hell.' And later he says: 'If equal affection cannot be / Let the more loving one be me.' In the same way, Bomberg, the more loving one, releases his pent-up feelings into and on to the inert view.

He embraces it, devours it, is immersed in it. He does not just observe it and try to re-make it as some kind of equivalent. He becomes it. This dynamism was in his nature, but he could not paint it without a subject.

In the paint, he *feels* his way down an escarpment, twists through the gap towards the sea, stretches in ligaments of apricot and rose madder towards his tenuous hold on the horizon [VIII]. He is painting and re-painting, in high excitement, a view of himself. *His* exuberance, *his* energy, *his* passion are become the place that embodies them, and somehow, by constant turning and re-examination of the organism they have become, it may be possible at last to get at its spirit and its essential nature. Remember how Leonardo dissected bodies in search of the soul; but the spirit is not hidden in the mass, it is expressed by it, in the end revealed by it. This was Bomberg's idea.

He always resisted any definition of spirit in the mass. The nearest he would come was to say that it was 'something that in essence lives but is not life; beauty and truth which is near but is not God; something boundless, beyond measure; something unidentifiable but which yet has form – which is not synonymous with nor can exist as form only'. When he was struggling at last to paint landscape, this was his idea: but now let us look at the pictures.

It is impossible to say exactly what I mean. The pictures often feel as though it was getting dark and that in the end there was no solution. They are so much gathered up by Bomberg's imagination that even large paintings look as if they felt small to him. His big gestures went across them and re-modelled them rapidly many times in the excitement of discovering the architectural mass. You can imagine him painting with his eye on the view rather than on the canvas. He rolled his wrist, his whole arm, to screw paint back into a valley. Bulk in the view becomes direction in the picture. Each picture looks to have been painted at one blow with the greatest difficulty, the result of endless revision and a late risk.

Most outbursts have their precursor, the first distant roll of thunder. A year before he went to Zennor, Bomberg pitched his tent above Bideford Bay in north Devon. The weather was overcast and he did

not work long. But it was a high view of the kind he liked. His palette was plum and alizarin crimson, the colour of thunderheads over the sea, and yet the pictures are full of glints of light: light on water, light in the sky, silver light on wet mud [55]. With the same brush-stroke he could simultaneously push an estuary away from him in the paint and carry its strip of light. The slipperiness of white seemed to speed his brush. The zigzag mark that is the legacy of his first, mechanical style keeps asserting the underlying directions of the forms. How can so much information about mass, colour, movement, light and mood, especially mood, be conveyed in a single mark?

Having found the nerve to paint at such a pitch and on such a scale he had nothing to lose at Zennor the following August. As I have said, he had the urgent sense that he was at work in a spiritual desert. I think that in these anguished, incandescent pictures he was for once happy, temporarily fulfilled, at full stretch. Bomberg guzzled the Zennor landscape like a dog. He was fifty-six, and he had thought and felt enough to commit himself unreservedly.

But is it always possible or even necessary to come to a conclusion? The best art of the twentieth century is full of fragments, like fragments from antiquity. Is it always possible to finish with some kind of summing up or must the picture be taken as far as possible and then abandoned? Every man has several layers of reality and so does every landscape. The beauty of Bomberg's process is that the layers of revised drawing, revised thought, remain partly visible. It is their accumulation that is moving. It is a pity that poetry cannot exist in this form, or music, so that the difficult process by which they were taken to their final form is not just hinted at but becomes a crucial part of their effect. A sense of its process is characteristic of all great painting. With Bomberg the struggle often seems to go on until the light is sinking.

And as the light goes he sees the essential truth of the forms on which he has worked all day more clearly than he did in bright sun at the beginning. By the gloom, the way in which they interlock is simplified. Having drawn and re-drawn them in wet paint for so long, he is entirely familiar with them, as familiar as he is with himself. He has become both the picture and the view. It should be possible, with a last effort of imagination and with courage, to summon the forms

up in a condensed way that will, in the greatest simplicity, entirely encompass their meaning. The urge to sum up is irresistible. A summing up is what a painting is. Oil painting is made up of endless revisions on the off-chance of a fresh gain, and he must, as it were, paint the whole picture over again in his head at one gesture, as though he remembers it, a concluding, incontrovertible unity re-expressed: the grand form finally grasped. With an effort of will that is as plainly visible now as if he had just made it, he draws across the surface of all his thought a last time with a loaded brush. It is as though in his frustration he strikes the picture out.

In this exhilarating journey, and its final risk, the profundity of a Bomberg landscape resides. I can tell you this, and you can know something of his thought and intentions, but you can have no conception of their effect until you stand in front of the pictures.

How placid, by comparison, the bay looks, and how exhausted the rocky gulley now that the storm of his appetite has gone over them.

*

The landscape is meaningless again, and unresponsive. Nothing we can do will rouse it from its absolute inertia. Shout, and no echo comes. Love it lifelong, and not one blade of grass will change direction because of our feelings. The land will entrance us and in the end bury us, with impartiality. If it seems to have great beauty, that is because of what we are, not because of what it is. The appetite for life goes over us and dies out much as the artist's appetite goes over the landscape and dies out. The landscape remains; and the pictures remain. The pictures I have discussed have altered the way we look at many places, and yet to look in an artist's place for his inspiration is all but pointless because his source is in his own mind. You could say that this book is pointless. Any account of how they were seen like that, and of how they were re-imagined, is not so much about places as about *us*. The birds have stopped singing in the lost lands. The unquiet country is you.

List of Illustrations
and Index

Acknowledgements

This book is based, wherever possible, on conversations with the artists themselves, and it is to them that I am most grateful. I cannot acknowledge individually the writers of all catalogues and articles which I have read over the years but I am deeply indebted to them for their research. Mrs Ivon Hitchens, Peggy Angus, Ronald Blythe, Annette Stephens and Kay Hooper kindly showed me houses in which artists have worked, and told me about them. Clissold Tuely, Allen Freer, Andras Kalman and the late Jim Ede lent me painters' letters or recounted their friendships with them. I have benefited very much from discussions with Alan Reynolds and Jake Nicholson, and Helen Gunn helped greatly with the connections between pictures, poetry and music. I am grateful to the trustees of the estates of Ben Nicholson and Paul Nash for permission to reproduce their work.

List of Illustrations

All works are in oil unless otherwise stated.

8 F. L. Griggs, *Maur's Farm*, 1913, etching, 10·9 × 18·8, Garton and Co., London

9 Robin Tanner, *Wiltshire Rickyard*, 1939, etching, 21·0 × 22·9, Garton and Co., London

10 Stanley Spencer, *Rowborough, Cookham*, 1934, 76·2 × 61·0, private collection

11 Stanley Spencer, *Cookham Moor*, 1937, 49·5 × 75·6, Manchester City Art Galleries

12 John Nash, *The Blenheim*, 1947, watercolour, 57·7 × 47·0, Tate Gallery, London

13 John Nash, *Wild Garden, Winter*, 1959, watercolour, 40·6 × 57·1, Tate Gallery, London

14 John Nash, *The Lake, Little Horkesley Hall*, 1958, 59·7 × 74·8, private collection

15 Cedric Morris, *Lord Hereford's Knob*, 1939, 59·4 × 72·5, private collection

16 Cedric Morris, *Landscape of Shame*, c. 1960, 75·0 × 100·0, Tate Gallery, London

17 Cedric Morris, *Several Inventions*, 1964, 71·0 × 91·0, Michael and Valerie Chase collection

18 Walter Sickert, *Beechen Cliff from Belvedere, Bath*, 1917, 35·6 × 25·4, Victoria Art Gallery, Bath

19 Walter Sickert, *Belmont, Bath*, 1941, 53·5 × 80·0, private collection

20 William Townsend, *The Hop Garden*, 1950, 63·5 × 76·2, Arts Council of Great Britain

21 Claude Rogers, *Eclipse at Blandford*, 1951, 35·5 × 30·5, Tate Gallery, London

22 Joan Eardley, *Winter Sea IV*, 1958, 53·4 × 78·8, Aberdeen Art Gallery

23 Joan Eardley, *The Wave*, 1961, 121·9 × 188·0, Scottish National Gallery of Modern Art, Edinburgh

24 Graham Sutherland, *Corn Stook in Landscape*, c. 1945, ink, gouache and pencil, 60·3 × 42·6, Whitworth Art Gallery, University of Manchester

25 Graham Sutherland, *Study for Folded Hills*, 1943, watercolour and crayon, 49·0 × 77·5, Fischer Fine Art, London

26 Graham Sutherland, *Boulder with Hawthorn Tree*, 1974, 112·0 × 167·5, Picton Castle Trust

27 David Jones, *The Waterfall*, 1926, 55·5 × 37·8, Whitworth Art Gallery, University of Manchester

28 David Jones, *The Terrace*, 1929, 64·7 × 50·0, Tate Gallery, London

29 David Jones, *Major Hall's Bothy*, 1949, pencil, crayon and watercolour, 79·2 × 57·4, Anthony d'Offay, London

30 David Jones, *Helen's Gate, Dockray*, 1946, pencil and watercolour, 49·5 × 61·5, Anthony d'Offay, London

31 Winifred Nicholson, *Winter Hyacinth*, c. 1955, 62·0 × 62·0, private collection

32 L. S. Lowry, *The Landmark*, 1936, 44·5 × 53·3, City of Salford Art Gallery

33 L. S. Lowry, *Sea Trials at South Shields*, 1963, 50·8 × 76·2, private collection

34 L. S. Lowry, *Fylde*, 1953, 50·7 × 61·0, Crane Kalman Gallery, London

35 Graham Sutherland, *Pastoral*, 1930, etching, 13·0 × 19·5, Tate Gallery, London

36 John Piper, *Crib Goch*, 1947, ink, chalk and watercolour, 36·7 × 49·6, Fischer Fine Art, London

37 John Minton, *Harvest Moon*, 1944, ink and gouache, 45·7 × 57·1, private collection, Fischer Fine Art, London

38 Robert Colquhoun, *Marrowfield, Worcestershire*, 1941, 35·5 × 45·7, Glasgow Art Gallery and Museum

39 Keith Vaughan, *The Lighthouse*, 1944, gouache, 22·0 × 29·0, private collection, Thos. Agnew and Sons, London

40 Alan Reynolds, *The Copse at Dusk II*, 1952, 29·2 × 38·4, Thos. Agnew and Sons, London

41 Prunella Clough, *Seascape and Bone*, 1945, 53·3 × 43·2, Fischer Fine Art, London

42 Edward Burra, *The Allotments*, 1962–63, watercolour, 76·2 × 133·4, Alex. Reid and Lefevre, London

43 Edward Burra, *English Country Scene I*, c. 1970, watercolour, 78·7 × 133·4, Alex. Reid and Lefevre, London

44 Edward Burra, *Under the Hill*, 1964–65, watercolour, 80·6 × 134·6, Alex. Reid and Lefevre, London

45 Edward Burra, *The Ramparts*, 1959–61, watercolour, 76·2 × 133·4, Alex. Reid and Lefevre, London

46 William Nicholson, *The Hill above Harlech*, c. 1917, 53·7 × 59·4, Tate Gallery, London

47 Ben Nicholson, *1940 (St Ives, version 3)*, 26·0 × 36·2, Crane Kalman Gallery, London

48 Ben Nicholson, *1946 (Towednack, Cornwall)*, 39·4 × 49·5, Crane Kalman Gallery, London

49 Ben Nicholson, *December 1962 (galaxy)*, wall project, 27·3 × 61·3, Tate Gallery, London

50 Peter Lanyon, *Landscape with Greenhouses*, 1952, gouache and charcoal, 49·5 × 44·7, Whitworth Art Gallery, University of Manchester

51 Ivon Hitchens, *Triangle to Beyond*, 1936, 76·2 × 50·8, Ivon Hitchens Estate

52 Ivon Hitchens, *A Distant Lake*, 1970, 53·3 × 132·1, Ivon Hitchens Estate

53 Mary Potter, *Fishing Nets, Aldeburgh*, 1953, 76·0 × 101·6, private collection

54 Mary Potter, *Sun and Stones*, 1980, 76·2 × 81·3, private collection

55 David Bomberg, *Sunset, Bideford Bay*, 1946, 61·2 × 76·3, Laing Art Gallery, Newcastle upon Tyne

56 David Bomberg *Evening in the City*, 1944, 69·8 × 90·8, Museum of London

Index

INDEX